How we understand art

HOW WE UNDERSTAND ART

A cognitive developmental account of aesthetic experience

MICHAEL J. PARSONS

The right of the
University of Cambridge
to print and sell
all manner of books
was granted by
Henry VIII in 1534.
The University has printed
and published continuously
since 1584.

CAMBRIDGE UNIVERSITY PRESS

CAMBRIDGE

NEW YORK PORT CHESTER MELBOURNE SYDNEY

Published by the Press Syndicate of the University of Cambridge
The Pitt Building, Trumpington Street, Cambridge CB2 1RP
40 West 20th Street, New York, NY 10011, USA
10 Stamford Road, Oakleigh, Melbourne 3166, Australia

First published 1987
First paperback edition 1989
Reprinted 1990

Printed in the United States of America

Library of Congress Cataloging-in-Publication Data
Parsons, Michael J.
How we understand art
1. Art – Psychology. 2. Visual perception.
3. Communication in art. 4. Art appreciation.
I. Title.
N71.P29 1987 701'.1'5 86-21528

British Library Cataloguing in Publication Data
Parsons, Michael J.
How we understand art : a cognitive
developmental account of aesthetic
experience.
1. Aesthetics 2. Art – Psychology
I. Title
701'.1'7 N71

ISBN 0-521-32949-3 hardback
ISBN 0-521-37966-0 paperback

for Marilyn

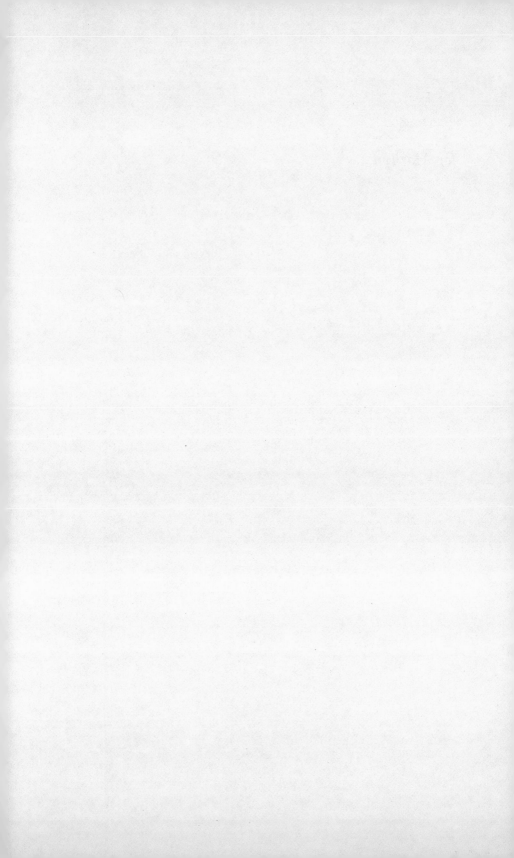

CONTENTS

PREFACE

This is the sort of book that does not fit neatly into a standard academic category. It connects with themes in psychology, philosophy, art, and education, but does not belong cleanly to any one of these. Yet it finds a unity in its focus on a subject, which is how people come to make sense of art. It describes a new theory of the development of aesthetic understanding and incurs a variety of intellectual debts in doing so, because the roots of the topic spread in several directions.

How do people come to understand art? We still do not know much in answer to this question. In the past two decades or so, there has been a dominant cognitive emphasis in the psychology of art and a number of studies of cognitive abilities connected with the arts. The marks of my debt to this tradition are scattered across the pages to come, and there is an obvious continuity of attitude for which I am grateful. But gratitude, of course, does not exclude dissent. In general, the cognitive emphasis does not seem to me to have gone far enough, primarily because of some limiting and unexamined assumptions about cognition and what it is to understand art. One of my own assumptions has been that, if we are to speak of how people come to understand art, there must be something serious in art to be understood. This assumption has not always been shared in the dominant stream of the psychology of art.

Most cognitive studies in the arts have had a limited conception of cognition, I think, in two ways. The first is that, for the most part, they have not taken art seriously, so to speak, on its own terms. Art deals with meanings that are sui generis and are not reducible to other kinds of meanings. Works of art are first of all aesthetic objects, and their significance is lost when they are understood as if they are just ordinary objects. Yet this latter is in general how the research has treated them, as if they were everyday products like soapflakes and armchairs, even, at times, like rocks and trees. Instead, I argue we should look at the understanding of works of art as aesthetic objects, and this will be a kind

of understanding different from the understanding of other kinds of objects.

The second limitation is a conception of cognition that does not require understanding. Instead, cognition is taken to be substitutable by some form of behavior, such as preferring, recognizing, categorizing, producing. But behaviors are not equivalent to understanding, and to look at behaviors is at best a roundabout way of finding out about understanding. Behaviors do not bear the essential mark of understanding, which is the giving of reasons. This is true also of speech regarded as "verbal behavior"; for only when we interpret speech as reasonable can we understand it as it was intended. One understands people only when one sees what they say as reason for their opinions, and not just as verbal behavior. This means that to write this book I have had to talk to people and try to interpret what they say. My interpretations of their reasons are my primary data. That is why the book has so many quotations of what people say about paintings, together with my interpretive comments.

The book presents a new theory of development in the arts – or perhaps I should say an application to the arts of a theoretical approach well established elsewhere. In particular, the work of Lawrence Kohlberg on the cognitive development of moral judgment has greatly influenced me. This is true of the construction of the developmental stages, for there are close parallels between my account of stages in aesthetic development and Kohlberg's in morality. He has described six stages of moral development; I have been able to discern only five in the arts. These five run parallel with Kohlberg's first five as I understand them, except that my fifth must be taken as a conflation of his fifth and sixth. This will be obvious to anyone who knows his work, and I will say little more about the parallels here. Kohlberg also first introduced me to cognitive developmental theories in general, and for that too I must acknowledge his influence. His conceptions of what a theory of the development of understanding is, of the need to take the cognitive domain seriously, and of how to research it have all influenced me greatly. For all this and more I am greatly indebted to him.

At the same time, I have come to disagree with him on smaller points. One of these may be worth mentioning because I fear its misunderstanding may influence the reception of this book. It has to do with the social or "dialogical" character of the later stages of development. Because understanding a painting is so obviously a matter of interpretation, requiring conversation with other people and participation in a tradition, one cannot imagine the later stages as the individual framing of judgments, or the monological application of principles privately known. This is a conception of postconventional stages of which Kohlberg has

been accused, whether justly is not clear. I think the extension of the
theory to the arts makes it easier to see that postconventionality cannot
mean postsociality, but is rather a further development of the social
character of cognition. I hope this is one small way in which my use of
the cognitive developmental tradition can add something to current dis-
cussion within it.

One way to understand the connections between these two traditions
in psychology – the tradition of the cognitive psychology of art and of
the cognitive development of moral judgment – is to refer to a third and
more general philosophical tradition that goes back to Kant. According
to this tradition there are three basic kinds of cognition: the empirical,
the moral, the aesthetic. A contemporary version of this view that has
influenced me is that of Habermas, according to which the three are
different because they deal with three different worlds: the external world
of objects, the social world of norms, and the inner world of self. These
different worlds provide us with different kinds of data and sustain dif-
ferent kinds of meanings. For this reason – this is my own conclusion –
there should be three corresponding streams of cognitive development.
Piaget is well known for his account of the development of our under-
standing of the outer world of objects, Kohlberg for his account of the
development of our understanding of the social world of norms; this
book provides a parallel account of development in the third domain.

This argument fits well with the traditional view in aesthetics that art
is basically the expression of – the coming to know about – self. Like
most people, I first came across this view in the work of the Romantic
poets and modern artists. In philosophy, I found it most powerfully
expressed in the work of Collingwood, Dewey, and Langer. The book
clearly adopts this traditional view: that a response to art is an implicit
exploration of self and of human nature. To this I add: It is so at every
stage of development. I hope the point is sufficiently clear in the com-
mentary, though it is not emphasized. In the end I think any psychology
of the arts has to have a coherent view of what the arts are and why they
are important. That is another thing I learned from Kohlberg.

Of course every work has not only intellectual debts but also a social
context. My immediate stimulus has been a perception of the relative
neglect of the arts in our culture. On the whole, we take the arts much
less seriously than science or morality. The average person in America
is not much engaged in the arts, and does not often discuss them seriously;
and newspapers and magazines pay much less attention to aesthetic ques-
tions than to scientific or moral ones. In general there is much less
conversation in our society about aesthetic matters than about moral or
scientific things. Of course this situation is reflected in our educational
system, where the arts have a notoriously marginal place in the curric-

ulum, and are rarely thought of as equal to what a recent national commission called the "solid subjects." In general we know less about teaching the arts than about teaching any other school subject. The result is that most people in our society understand the arts much less well than they understand science or morality. I hope that a theory of aesthetic development will help us formulate more clearly both the purposes and the instructional strategies of art education at all levels.

It remains to thank individual persons for their contribution to the work represented in this book. Bob Durham, Ann Taverne, and Paul Greene did studies that in different ways had considerable influence on what is said here. Ladd Holt, Bill Whisner, Milt Meux, Lois Erickson, and Ralph Mosher offered continuing support and advice. A number of colleagues critiqued parts of the book helpfully, including Larry Kohlberg, Dwight Boyd, Jim Rest, Andrew Gitlin, John Broughton, and Bob Howard. Most of all, Marilyn Johnston shared much of the process, did much of the interviewing, discussed most of the ideas, critiqued the writing, and offered encouragement for a project that often felt too large and unfashionable.

And if we look underneath the overt topic at the educational implications of the book, the influence of Harry Broudy, my old mentor, is apparent. Though his work is not actually referred to here, to spell out a structural developmental approach to aesthetic education would clearly be to repeat, with variations, the themes he has so eloquently urged.

INTRODUCTION

This book is about how people understand paintings. People can respond very differently to the same work of art. I remember talking once with two children, brother and sister, about the Picasso drawing *Weeping Woman*, which is reproduced in this book. Both children were bright and articulate, and they came from a family with artistic interests. Yet they responded very differently to the drawing. The girl, eight years old, was quite negative toward it. She thought it was done sloppily, and that it conveyed little feeling for its subject. "It would be more sad," she said, "if it was drawn better with more details, and not those weird eyes. It should show real tears, and then you'd know she's really crying." The boy, fifteen years old, almost exactly reversed this response. He thought the drawing was expressively powerful because of the way it was drawn. "The artist exaggerated everything," he said, "and that gets the feelings over. Her eyes look like they're coming out and she's biting her hand-kerchief, and that makes it stronger than if he did it like a photograph." Such differences in response to a work of art are common. This book attempts to create a structure with which to understand them.

The book quotes people of all ages talking about paintings. I have long been intrigued by what others say about art, friends in conversation, students during class, strangers overheard in museums. How do they understand paintings? What do they look for? How do they feel? Over the past ten years I have taken to showing people paintings and inter-viewing them in a more formal way, asking them what they think. I recorded these interviews, and the quotes in this book are from the transcripts. They are all from discussions of the eight works reproduced in this book.

Much of my analysis is concerned to explicate a few basic ways of understanding paintings that underlie what is said about them. My basic argument is that people respond to paintings differently because they understand them differently. They have different expectations about

1

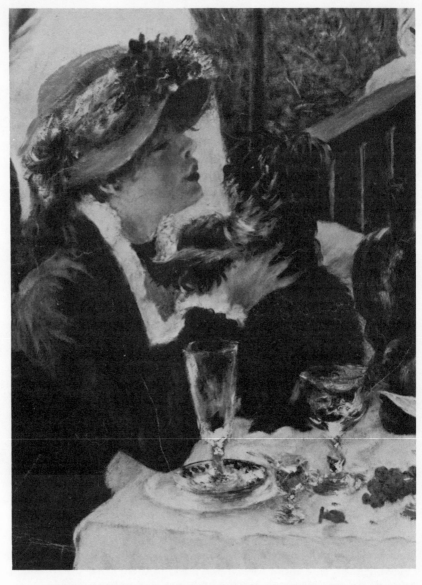

Figure 1 Renoir: *The Luncheon of the Boating Party*, 1881 (detail). Reproduced by permission of The Phillips Collection, Washington, D.C.

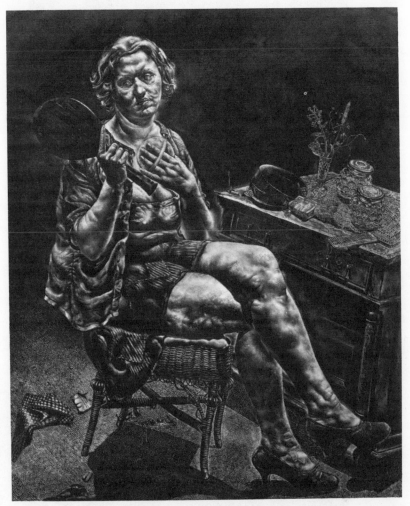

Figure 2 Ivan Albright: *Into the World Came a Soul Called Ida*, 1930.
Reproduced by permission of The Art Institute of Chicago.

what paintings in general should be like, what kinds of qualities can be
found in them, and how they can be judged; and these expectations deeply
affect their response. Assumptions of this kind are often implicit, not
consciously brought to mind. I try to make them explicit. I believe that
a knowledge of them can help us understand what people have in mind
when they talk about art. We understand people well only when we
understand the assumptions they make.

These ways of understanding paintings are arranged in a developmental

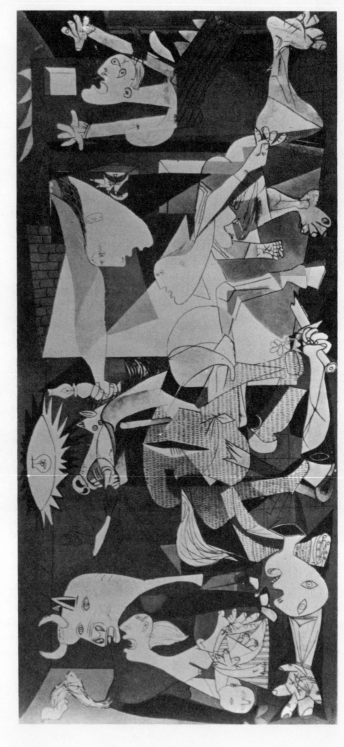

Figure 3 Picasso: *Guernica*, 1936. Reproduced by permission of The Prado Museum, Madrid; SPADEM, Paris/VAGA, New York; and Giraudon/Art Resource, New York.

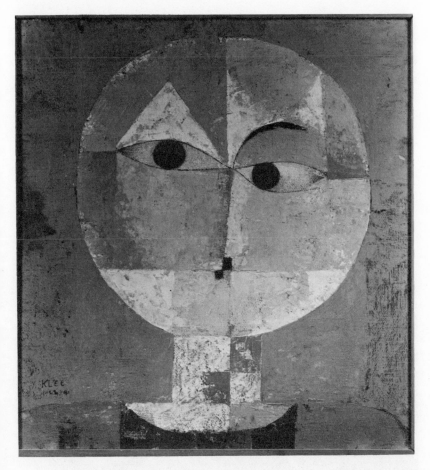

Figure 4 Paul Klee: *Head of a Man* (sometimes called *Senecio*), 1922. Reproduced by permission of the Kunstmuseum, Basel; ADAGP, Paris/ VAGA, New York; and Giraudon Art Resource, New York.

sequence. I argue that people adopt them in a certain order. Young children start with much the same basic understanding of what paintings are about, and they restructure that understanding in much the same ways as they grow older. They do this to make better sense of the works of art they encounter. The result is a common sequence of development built on a series of insights into the possibilities of art. Each step is an advance on the previous one because it makes possible a more adequate understanding of art. Where individual people wind up in this sequence depends on what kinds of art they encounter and how far they are encouraged to think about them.

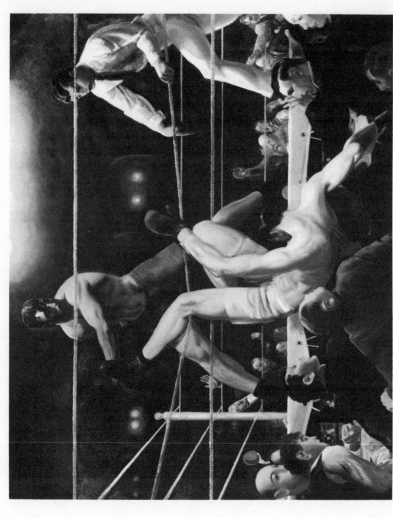

Figure 5 George Bellows: *Dempsey and Firpo*, 1924. Reproduced by permission of The Whitney Museum of American Art, New York.

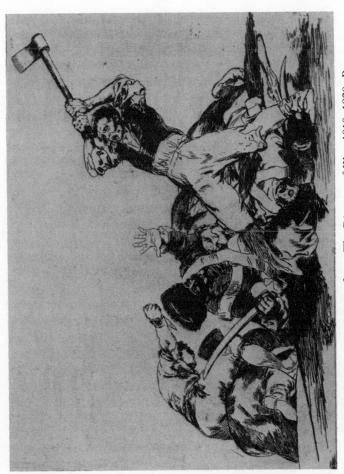

Figure 6 Goya: *Lo Mismo*, from *The Disasters of War*, 1810–1820. Re-produced by permission of Pomona College, California.

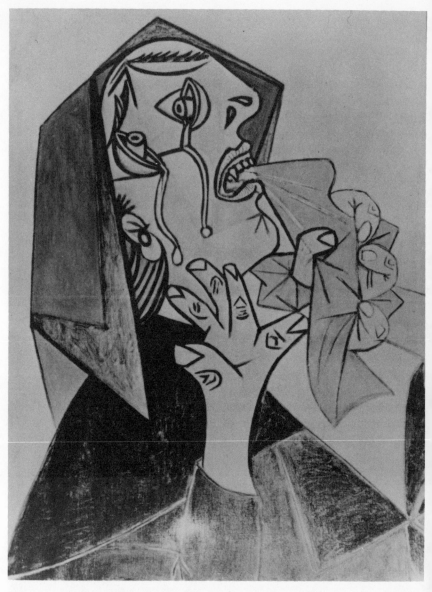

Figure 7 Picasso: *Head of a Weeping Woman with Hands*, 1936. Reproduced by permission of The Prado Museum, Madrid, and SPADEM, Paris/VAGA, New York.

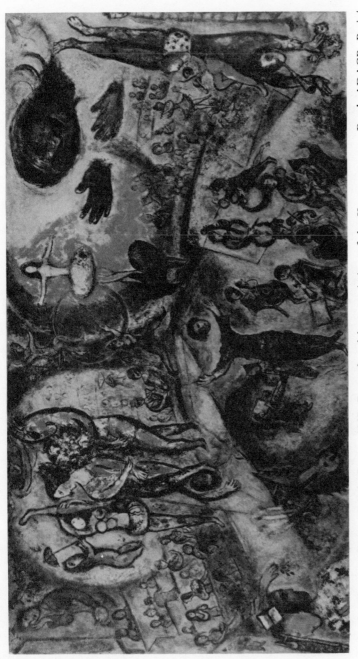

Figure 8 Chagall: *La Grande Cirque*, 1927. Reproduced by permission of the Kunstmuseum, Basel; ADAGP, Paris/ VAGA, New York; and Art Resource, New York.

What this sequence amounts to is a developmental account of aesthetic experience. The basic purpose of this book is to spell out this account. It is an essay in what is known as cognitive developmental psychology, an attempt to use a well-known approach in psychology to understand aesthetic experience. Cognitive developmental theories are an important part of modern thought, and have been used to analyze the growth of much of the human mind. They have had a marked effect on the way we understand ourselves, and a strong influence on education. The names of Piaget and Kohlberg are the best known in this movement, though there are many others. Piaget analyzed chiefly the development of our understanding of science and logic (Piaget, 1970). Kohlberg analyzed the growth of our moral understanding (Kohlberg, 1981). There are also cognitive developmental theories of religious thought (Fowler, 1981), of epistemological thought (Broughton, 1980), of social perspective taking (Selman, 1980), and of ego development (Loevinger, 1978), to mention only the best known. Such theories share a set of common attitudes and principles, though there is much debate about how to formulate them and which are the most important. I use these common attitudes and principles to analyze aesthetic experience.

Psychologists have always been interested in our responses to the arts, and there have been some precursors to this present attempt. Machotka used the Piagetian stages to analyze judgments of paintings (Machotka, 1966). Gardner has discussed the idea, and has his own analysis of development in the arts, though it is not primarily a cognitive one (Gardner, 1973). Most important is James Mark Baldwin, who predates Piaget, and is the only person to have tried a systematic cognitive developmental account of aesthetic experience (Baldwin, 1906-15). His analysis was ground breaking and full of valuable insights, but it lacked the benefits of recent work in both psychology and aesthetics. Furthermore, it was not based on empirical data. This book therefore attempts to fill what appears to be a gap in developmental theories.

Cognitive developmental theory

What is a cognitive developmental theory? A few remarks may be helpful. The most basic notion is that we reach the complex understandings of our maturity by a series of steps. An adult understanding of science, morality, or the arts requires some sophisticated abilities. We must, for example, consider the point of view of other people, and sort out subjective from objective influences on our experience. We are not born with such abilities. Developmentalists believe that we acquire them – some of them – gradually, i.e., in a sequence of steps, each of which is basically a new insight. These steps have a nonarbitrary sequence.

Some must be acquired before others. A developmental account identifies the steps that a particular domain requires, and the sequence of our learning them. It plots the growth of our constructions as we gradually come to understand a major area of cognition.

So far, I have spoken of steps, which consist of new insights, arranged in a sequence. In addition, these insights tend to cluster together in typical patterns, because they are internally related to each other. In the case of the arts, for example, when we come to understand a painting as an attempt by the artist to express a state of mind, we also tend to think of aesthetic response as reexperiencing that state of mind, and of aesthetic judgment as being largely subjective and inward looking. These ideas are related to each other, and we tend to acquire them at much the same time. Such clusters of ideas are called stages in the literature. I speak of stages of aesthetic understanding in this book, though I want to claim that sequences of insights are the more fundamental idea. I also worry that the use of the stage idea may be misleading.

What do I mean by "stages"? Basically, I think stages are clusters of ideas, and not properties of persons. A cluster is a pattern, or structure, of internally related assumptions that tend to go together in people's minds just because they are internally, or logically, related. To describe a stage is not to describe a person but a set of ideas. People use these ideas to make sense of paintings. If they were consistent in thinking about paintings, they would use a consistent set of ideas to interpret them. They could then be said to be "at" a particular stage of cognitive development. But this situation is rare. It requires us to think more carefully about art, and perhaps about our ideas about art, than most of us do. Many times in my interviews I have watched people stop to examine some idea they have just used, and question its meaning or validity as if for the first time. I have seen them become confused, or deny what they have just said, or develop a new idea, all in the course of an hour's gentle questioning. Some of this will be seen later in quotations. On the basis of such evidence, I do not believe that most of us are consistent in thinking about art, and therefore are not "at" a stage. Nor do I believe such consistency is desirable because it might hinder the development of further understanding. In short, what I describe here are not people, but sets of ideas, or stages. People are not stages, nor are stages labels for people. Rather, people use stages, one or more of them, to understand paintings.

It might perhaps be more accurate to say that we can use stages to understand people's understanding of paintings. Stages are, in the end, analytic devices that help us understand ourselves and others. A sequence of stages is like the generalized history that Habermas discusses: a history in which individuality is removed, where proper names do not apply, and where only the generic truth is told (Habermas, 1971, ch. 11). It is

of course based on data; in my case on interviews with real people. But it is not a statistical analysis of the data; it is a rational abstraction from it. Such a history does not describe or apply to a person, though we can recognize ourselves or others in it. It describes a sequence of abstractions that are useful for understanding what people say about paintings. That is my present understanding of what "stages" are.

My analysis results in the description of five stages of development. Their structure and content is summarized at the beginning of Chapter 1, and their analysis is the substance of most of the book. I claim that people acquire the ability to use these stages in sequence: first stage one, then stage two, and so on. However, for the reasons just given, we cannot associate stages closely with ages. To be twenty years old, or forty, does not guarantee being able to understand in a stage four, or five, way. To do that we must have had experience with art, experience in which we have worked at understanding a variety of paintings. This implies age, and also the right kind of exposure to paintings, together with some hard work trying to understand. Only in a most general way, therefore, does stage follow age, and only at the younger ages. In practice, virtually all pre-school children use stage one ideas. Most elementary school children use stage two ideas. Many, but fewer, adolescents use (at times) ideas from stage three. After that, circumstances become more important than age. I have attached ages or circumstances to most of my quotations to give a sense of who is speaking, but no regular correspondence is intended.

The basic purpose of this book, then, is to give a cognitive developmental account of our understanding of the arts. I have not argued for this account so much as articulated and illustrated it. It is true that the project raises theoretical and methodological issues, but I have not addressed them here for a number of reasons. The most important is that my purpose is to make a developmental account intelligible. That seems to be a necessary first step toward a sensible discussion. It is difficult to discuss what we find hard to imagine, and we can't easily imagine what has not been articulated. That, at any rate, has been my repeated experience when trying to discuss the topic with others.

Assumptions about art

To extend the cognitive developmental approach to the domain of aesthetic experience has necessarily meant taking seriously ideas about art. For it must also be an attempt to understand the varieties of aesthetic experience via developmental theory. I have tried to see art as different from science, morality, or religion, as a part of the human mind distinguished by its own characteristic concepts and concerns. That is why, after all, it has its own developmental history. For that reason too I have

been as much influenced by artists and philosophers of art as by psychologists, and the focus of my analysis is on concepts that we ordinarily use when we talk about art, rather than psychological concepts. For example, we ordinarily look to art for beauty, expressiveness, style, and formal qualities. Our aesthetic development consists precisely in coming to understand concepts like these in increasingly adequate ways.

It is philosophers, rather than psychologists, who help us think about these aesthetic topics and the nature of art in general. Inevitably, therefore, this book reflects some philosophical views about art. I will mention briefly three of the more important, which, fortunately, are quite common. Indeed, they may sound like clichés, which is good if it means that they are widely understood. If they seem empty abstractions here, I can only trust that the detail of the book gives them life. They are, in any case, mainstream views within the broad tradition of what is usually called the "expressionist" school in aesthetics. The philosophers in this tradition who have most influenced me are Collingwood (1958), Langer (1953), Dewey (1934), and Danto (1981).

What are these views? One is that art is not just a series of pretty objects; it is rather a way we have of articulating our interior life. We have a continuing and complex inner response to the external world, composed of various needs, emotions, thoughts, both fleeting and long-term. This inner life is not transparant to us, not self-interpreting; if we are to understand it we must give it some more perceptible shapes, and then examine the shapes. Art is one way of doing this.

A second belief is that what art expresses is more than what one person has in mind at one time. What art enables us to understand is not necessarily what the artist sought consciously to communicate. It is more a public property than that. Art is capable of layers of interpretation and may reveal aspects of its creators of which they themselves were unaware. That is true of all human action, but it is especially true of art because it is so much less constrained by practical demands. It follows that an understanding of expression in the arts, when it is at all complicated, is a social and historical construction, a joint product, though it must be individually grasped. The significance of a painting is not the private vision of the artist or the viewer; neither is it some eternal essence independent of society. It is something public, about which we may be more and less perceptive, and which may require more and less work from us to grasp. The stages of aesthetic development are levels of increasing ability to interpret the expressiveness of works in this way.

A third theme follows from this: Judgments about art are capable of being objective. Though art articulates our needs and emotions, interpretations of art can be more or less reasonable and judgments more or

less defensible. They may not be exactly right and wrong, but certainly they are more and less adequate. The stages are levels of ability to make reasonable interpretations and judgments.

I hope these themes become concretely apparent to the reader as the book proceeds. I mention them here to make the point that my account tries to take art seriously, and that attempt requires me to have some views about what art is. One cannot do developmental psychology without having some view of the domain in which development occurs.

Organization of the book: topics and stages

One way to understand how people think is to look at the ideas they use. For example, in thinking about a painting they may consider its subject matter, or its texture and form, or its emotional expressiveness. These are ordinary ideas about what is worth noticing, what makes a painting worthwhile. They are ideas of the sort that ordinary people use. And because they are not very clear ideas they are also ideas of the sort that philosophers of art discuss. From the present point of view, they are important because they structure our thinking about paintings, and, therefore, guide our perceptions and shape our responses. We can understand better how a person thinks about paintings if we know which of these ideas they use and how they understand them.

I organize my account in terms of four such ideas, or groups of them. The four are: the subject matter (including ideas of beauty and of realism); emotional expression; the medium, the form, and the style; and the nature of judgment. These four topics meet two criteria. First, they capture reasonably well most of the concerns people express when they talk about paintings. There is little in my interviews that cannot be classified into one of these topics. Second, they are responsive to the stages of development. Each topic is understood in several stage-related ways. One can identify a different version of each idea for each of the five stages of development. This situation could be represented by a matrix like the following. Across the top are the four topics; down the side are the five stages.

	subject matter	expression	medium, form, style,	judgment
stage one				
stage two				
stage three				
stage four				
stage five				

This matrix has twenty cells, each of which represents a different version of one of the ideas I have identified. One logical way to write this book would be to give an account of each of these cells in order.

In that case there would be two possible orders of exposition. One could go across the matrix, discussing the cells belonging to one stage, and then proceed to the next stage. Alternatively, one could go down the first column, discussing the cells belonging to the first topic, and then move to the next topic. Either way has advantages and disadvantages. I have chosen the latter, and have organized the four main chapters of the book in terms of the four main aesthetic topics. The basic structure of the book can therefore be represented like this:

	Chapter 2 Subject matter	Chapter 3 Expression	Chapter 4 Medium, form, style	Chapter 5 Judgment
stage one				
stage two				
stage three				
stage four				
stage five				

This organization focuses on the topics that shape our thoughts about paintings, rather than on the stages of development. The advantage is a more direct focus on what people have in mind when they talk about paintings, and the relationships between different versions of the same idea. It gives more attention to the movement by which our understanding of the four topics changes and deepens, and hence to transition and sequence. The disadvantage is a lack of emphasis on the coherence of stages as wholes. For this reason I begin Chapter 1 with an overview of the five stages and the psychological themes that underlie them.

I depart from the purity of this scheme in two other ways. One is to describe the first and the last stages as wholes. The first stage is internally less complex than the others, and it would be artificial to describe a distinct version for it of the four topics. The last stage is almost the opposite. It integrates so much of the material from the preceding stages that to give a separate account of its version of each topic would be repetitive.

My second deviation is to spend more time in the account of each

topic on the stage for which it is most salient. Each stage is shaped by a central new insight, and this insight centers in each case on a different topic. This makes a different topic more central than the others at each stage. For example, stage three is affected by the realization of the interiority of the artist and the viewer, and this makes the expressiveness of a painting the dominant topic. Subject matter, style, and judgment are all understood in terms of expressiveness at stage three. Hence the longest section of Chapter 3 has to do with the stage three understanding of expression. In short, some of the cells in the matrix are more important than others, and an equal exposition of each is unnecessary. Briefly, the idea of subject matter dominates stage two, expression stage three, medium, form, and style stage four, and judgment stage five.

The final result can be pictured as follows. The large crosses represent the cell where a topic is most important for each stage.

	Chapter 2 Subject matter	Chapter 3 Expression	Chapter 4 Medium, form, style	Chapter 5 Judgment
stage two	XX	x	x	x
stage three	x	XX	x	x
stage four		x	XX	x
stage five				XX

Methodology

I must say something about methodology. All method in psychology requires a significant interaction between theoretical and empirical work. In the cognitive developmental tradition this interaction is perhaps more obvious than usual, because the role of theory is more prominent and because part of the theory is more obviously derived from philosophy. My case is no exception. The roles of theoretical and empirical work vary also with the amount of progress investigation has made on a topic. On this topic, investigation is just beginning. What I say is certainly based on a large amount of empirical data, but it may best be thought of as the advancing of hypotheses. The point is that providing good scientific evidence for a developmental theory is a lengthy and elaborate process, and must follow the articulation of hypotheses. It requires the construction of a scoring system with which different

persons can reliably assign a piece of reasoning about art to the same stage. This must be based on, but be more specific than, the more hypothetical account of stages. And then, ideally, the scoring system must be used on interviews conducted with the same people over many years. In the course of doing this it is reasonable to change the initial hypotheses somewhat in light of the data being collected; and this then will require changes in the scoring system and perhaps the gathering of new interview material. In short, the process is a continuum in which hypotheses and data continually modify each other.

I do not claim to have done more than advance some rather elaborate hypotheses. The most elaborate is that our understanding of art develops in the particular way spelled out in these pages. Each chapter can also be thought of as advancing a lesser hypothesis, that our understanding of a particular topic develops in a certain way. Alternatively, one can think of each stage description as a hypothesis, that such an understanding follows the previous one and precedes the next in the normal course of development. The point of speaking of hypotheses in this way is to emphasize the beginning nature of investigation into the topic, and to argue that details might be changed and yet the general structure remain intact. In short, much remains to be done.

For these reasons I have not tried to argue quantitatively here. My discussion is primarily qualitative and oriented to explication. But explication is itself not wholly separable from argument because it requires at least the attempt to be plausible. This means that I aim at an accord of what I say with both our intuitive understanding of people and paintings and with the facts of how people actually talk about paintings. I also try to make the increasing adequacy of each stage clear to the reader who is familiar with the arts, and my account should increasingly coincide with the reader's intuitive understanding of the paintings discussed. This is a way of saying that the data has played an important role in the shaping of these hypotheses. I have tried out many others and abandoned them in light of facts. The ones that remain derive from a large number of cases.

Advancing hypotheses that may later be verified is not my sole purpose, however. There is also the hope to facilitate a more immediate understanding. The basic purpose of this sketch of aesthetic development is to help us understand each other as we talk about art. In particular I hope it will help teachers and parents and others who have to deal with young people. It seeks to provide them with a framework for interpreting what others say, and consequently to be able to respond more intelligently to them. The reason we can hope to understand others who use different stages is that we all go through these stages. They are the ways we ourselves – and not only others – think, at different times in our life. We have all thought like little children and for that reason can hope to un-

derstand them now. This is why, incidentally, I often speak of how "we" think and speak rather than how "they," or children, or, worse, "subjects" think and speak. It may seem less academic but it has more truth.

My account, then, is "based on" a large number of interviews with different people, in each of which five or six paintings were discussed. I conducted many of these interviews, and so also did one of my colleagues and several students. Altogether, there are over three hundred of them, completed over a period of almost ten years. Each time we thought we uncovered a new fact, we changed some feature of the general account; and each time we changed the general account we changed the interview to gather some relevant facts. For instance, we tried interviewing with many different paintings and drawings, depending on the topic we were interested in (most of the time we used large color reproductions). In this book, for the sake of continuity, I have quoted from discussions of only eight of these paintings. The eight are ones that stimulated interesting responses, that we have shown to many people, and that together form a reasonably varied set. They are:

Picasso: *Guernica*, 1936, Prado Museum, Madrid.
Picasso: *Head of Weeping Woman with Hands* (one of the studies done in preparation for the *Guernica*), Prado Museum, Madrid.
Goya: *Lo Mismo*, an etching from *The Disasters of War*, Pomona College, California.
Renoir: *Girl with a Dog* (a widely sold reproduction of the lower left hand corner of *The Luncheon of the Boating Party*, 1881), The Phillips Gallery, Washington, D.C.
Albright: *Into the World Came a Soul Named Ida*, 1930, Art Institute of Chicago.
Klee: *Head of a Man*(sometimes called *Senecio*), 1922, Kunstmuseum, Basel.
Chagall: *La Grande Cirque*, 1927, Kunstmuseum, Basel.
Bellows: *Dempsey and Firpo*, 1924, Whitney Museum of American Art, New York

The persons interviewed range from preschool children to art professors. They do not represent a careful sample of any population. They are, as far as I know, just ordinary people living in and around Salt Lake City. Many times convenience determined whom we talked to. For example, preschool interviewees are in short supply. Some of our interviewers were parents, and they interviewed their own children; other times we looked for the young children of friends. At the other end of the sequence, art professors and graduate students in art were also scarce, and we took whomever we could make arrangements with. In between, we went mostly to schools: elementary, junior high, senior high, and college. Usually we went to the classrooms of friends and asked to talk with any students who were willing to discuss our paintings. All of the

conversations were with individuals, one at a time, and most were audiotape recorded and subsequently transcribed. Of course the names used in this book are fictitious.

The interviews were "semistructured." We had in mind a number of topics that we wanted to discuss, and a number of questions with which to begin that discussion. At the same time, we felt free to follow up whatever was said, as long as it seemed relevant, and we allowed the order and introduction of the topics to come as naturally as possible in the course of the discussion. The basic purpose was to understand as well as we could what people thought about the paintings. Most of the interviewers' remarks and questions were "probes" intended to prompt further clarification of what had been said. We tried not to suggest particular answers. The process of interviewing became very enjoyable, though it was also demanding; and the best interviews became more like genuine conversations.

Some examples of neutral "probe" questions and remarks are:

You said X. What do you mean by that?
Can you give me an example?
Can you say more about that?
Whereabouts in the painting do you see that?

The list of standard topic questions was:

1. Describe this painting to me.
2. What is it about? Is that a good subject for a painting?
3. What feelings do you see in the painting?
4. What about the colors? Are they good colors?
5. What about the form (things that repeat)? What about texture?
6. Was this a difficult painting to do? What would be difficult?
7. Is this a good painting? Why?

It may help to look at one or two of the reproductions now, and ask how you would answer these questions if you were being interviewed. This may provide a better sense of the data from which the book grew, and what the analysis has done to them.

If you have an interest in analyzing your own aesthetic responses later, you might want to be more systematic. Look at the reproductions carefully, one by one, and ask yourself the questions listed above. Give reasons for your answers, and try to write them down. The point is to be as clear and as detailed as possible. Imagine that you are talking to someone who keeps asking you what you mean, and whether you can point to an example of what you are saying. You will surely recognize some of your thoughts in the quotations and analyses to come.

1

OVERVIEW OF THE FIVE STAGES

I begin with a brief overview of the five stages of aesthetic development. The book is not organized in terms of the stages but in terms of four major aesthetic topics, each of which is understood differently at the different stages. So it seems useful to give a brief picture of the stages as wholes to guide the reader through what follows. Each stage is a loosely knit structure in which a number of ideas are shaped by a dominant insight about art. This central insight is new for each stage and gives it its characteristic form. The overview stresses these few central ideas. In addition, I quote a few remarks about paintings that seem especially characteristic of each stage. This may help to make them initially less abstract.

I have kept this section brief. It is a schematic outline of the thesis of the book, a simplification on which to hang complications, intended only to help read the book as a whole. The emphasis here on stages and the abstractness of what is said are not characteristic of the whole, and I would be sorry to see this section used as a substitute for reading the rest of the book. If the reader can read only some parts, this is a section to skip. No author can wholeheartedly recommend skimming, but if it must be done then I think the most important parts to read are: stage 2 in Chapter 2, stage 3 in Chapter 3, stage 4 in Chapter 4, and stage 5 in Chapter 5. These sections discuss the key idea of each stage.

There are two ways in which one may think of a stage as being more adequate than the previous one. The first is aesthetic. Each stage understands paintings more adequately than the previous one. Each achieves a new insight and uses it to interpret paintings more completely than before. The account of changing understandings of each topic is therefore also an account of their increasing adequacy, stage by stage. In this summary I briefly indicate how each stage is more adequate aesthetically.

The second kind of adequacy is psychological. The stages rest on our increasing ability to take the perspective of others, the common dimen-

20

sion of cognitive developmental schemes. This theme is present in the descriptions to come, but perhaps needs a more specific explanation here.

We all begin in the same cognitive state. We are born into the world small, speechless, subject to an unorganized plenty of sensory stimuli, possessed of an individual body with pleasures and pains, unaware of our nature or abilities, socially oriented but unable to distinguish our self from whatever happens. We are aware of nothing except as it appears to us. This picture of our original state is common to the cognitive development tradition. From this beginning we construct the ideas with which we understand the world. As we do so, mentally we join the society into which physically we have been born. So the story of our mental development is also the story of our social development, of our membership in society. We learn our society's language, adopt its ideas and values, share its activities; and so both construct our own mind and become a member of our society. Later, if we are so lucky, we are able to think autonomously: to have original ideas, to be creative, perhaps to judge our culture from some independent viewpoint that is independent but still social in constitution.

The basic direction of development is from dependence to autonomy. It is the common theme of developmental theories: the story of the growth of both human freedom and human sociality. It occurs in two great movements. We earn our freedom from the domination of biological impulse by becoming good members of society; and freedom from the domination of society by constructing some viewpoint independent of society. This last movement is no less a growth of sociality than the first. When we are autonomous we are no less members of society, but we are more concerned to improve society than to conform to it. The growth of our social nature underlies the development of aesthetic understanding just as it does other kinds of cognitive development. It is consequently a theme underlying my account here.

Stage one can be thought of as a kind of theoretical zero point in this regard. It is the point at which we are more a biological than a social creature. Though we have immense social potential, we have not yet become a member of society. We are unable to take the perspective of others, and are not really aware of the difference between ourselves and others. We are not clear that others do not see and feel what we see and feel, because we have not distinguished between their point of view and ours. In short, we are aware of only one point of view, the one from which everything appears to us. In a sense this state is a theoretical construction, one which is needed to make sense of the direction of development. It exists, if at all, very early in life, and is largely prelinguistic. In my scheme here I have extended it somewhat, to avoid the unnecessary proliferation of stages. I include in stage one many of the

characteristic responses of young children, including at times kindergartners.

Stage One: Favoritism

- It's my favorite color!
- I like it because of the dog. We've got a dog and its name is Toby.
- It looks like a big pickle coming down from the sky.
- I don't believe in bad paintings. They're all mostly good.

The primary characteristics of stage one are an intuitive delight in most paintings, a strong attraction to color, and a freewheeling associative response to subject matter. Young children rarely find fault with paintings, no matter what their subject or style. They relish color, the more the better. They are often aware of the subject of a painting, i.e., what it represents; but they allow associations and memories freely to enter their response. The common characteristic is the happy acceptance of whatever comes to mind, not distinguishing between what is and is not relevant.

Psychologically, this is the stage where there is little awareness of the point of view of others. All that is occurs in experience; there is nothing else, and nothing to compare it with.

Aesthetically, paintings are a stimulus to pleasant experience. It does not matter what they represent or whether they are nonrepresentational. Liking a painting is identical with judging it, and it is hard to imagine a bad one. There are no distinctions of relevance nor questions about objectivity.

Stage two: beauty and realism

- It's gross! It's really ugly!
- You expect something beautiful, like a lady in a boat, or two deer in the mountains.
- You can see how carefully he's done it. It's really good!
- It looks just like the real thing.
- It's really just scribbling. My little brother could do that.

The dominant idea of stage two is that of the subject. Stage two is organized around the idea of representation. The basic purpose of painting is to represent something. It is true that some paintings are nonrepresentational, but they are not really meaningful. A painting is better if the subject is attractive and if the representation is realistic. Emotion is something to be represented, as in a smile or a gesture; and style is appreciated only as realism. Skill, patience, care are admirable. Beauty, realism, and skill are objective grounds for judgments.

Psychologically stage two is an advance because it implicitly acknowledges the viewpoint of other people. The notion of representation requires the distinction between what anyone can see and what one is merely reminded of. To stick to what is pictured is to understand that what one associates with the painting is not necessarily what others see.

Aesthetically stage two is an advance because it enables the viewer to distinguish some aspects of experience as aesthetically relevant (those having to do with what is pictured) from some that are not (those not having to do with what is pictured). For example, the Renoir may be judged good because it pictures a dog, and dogs are nice. But this latter has become a fact about the dog, and not about the viewer's tastes, as with stage one. Similarly, the color of the Klee is good; and this is a fact about the color, not about personal favorites.

Stage three: expressiveness

– That really grabs me!
– You've got to have a gut feeling for it. It doesn't matter what the critics say about form and technique.
– You can see the artist felt really sorry for her.
– The distortion really brings the feeling out more strongly than a photo would.
– We all have a different experience of it. There's no point in talking about good and bad. It's all in the individual.

The organizing insight of stage three has to do with expressiveness. We look at paintings for the quality of the experience they can produce, and the more intense and interesting the experience the better the painting. Intensity and interest guarantee that experience is genuine, i.e., really felt. The feeling or thought expressed may be the artist's or the viewer's, or both. It is always what is inwardly grasped by an individual person.

This insight affects most of one's ideas of art. The purpose of art is to express someone's experience. The beauty of subject matter becomes secondary to what is expressed, and may actually get in the way of expression. Similarly realism of style and skill are not ends in themselves but means to expressing something, and may not be better than their contraries. Creativity, originality, depth of feeling, are newly appreciated. There is a skepticism about the value of talking about painting, and about the possibility of objective judgments, because the important criterion remains the quality of some individually felt experience.

Psychologically, stage three is an advance because it rests on a new awareness of the interiority of the experience of others, and a new ability to grasp their particular thoughts and feelings. There is also a corre-

sponding awareness of one's own experience as something inward and unique.

Aesthetically, stage three is an advance because it enables one to see the irrelevance of the beauty of the subject, the realism of the style, and the skill of the artist. It opens one to a wider range of works and a better grasp of expressive qualities. An example is the difference between finding the Albright ugly and distasteful, and finding it powerfully expressive of empathy with Ida.

Stage four: style and form

– The way the paint is laid on here, and lets the bottom color show through – it sings!
– See the grief in the tension in the lines, the pulling on the handkerchief!
– Look at the way light strikes the tablecloth; the colors are so varied and yet the overall effect is white, and the cloth still lays flat on the table.
– There's a quirky humour in the face. It's basically frontal, but the eyes are done in a Cubist style.
– He's playing with the eyes. They're more like cups or boats, it's a visual metaphor.

The new insight here is that the significance of a painting is a social rather than an individual achievement. It exists within a tradition, which is composed by a number of people looking over time at a number of works and talking about them. As they talk, they find some things more meaningful and others less so. They help each other to see perceptively. The work exists in a public space; aspects of its medium, form, and style can be pointed to in an intersubjective way; in this way interpretations can be corrected and improved. There are relationships between different works – styles – and a history to their interpretation. All these aspects of a work are public and may have a bearing on its meaning. Its meaning is constituted by what can be discursively said by the group about it, and this is more than what is grasped inwardly by an individual at one time.

The insight affects many ideas about paintings. It places the emphasis on the way the medium itself is handled, on texture, color, form, space, because these are what are publicly there to see; and on style and stylistic relations, because these are how a work relates to the tradition. What is expressed in art is reinterpreted in terms of form and style, and is a public idea rather than a private state of mind.

Psychologically, the advance here is in the ability to take the perspective of the tradition as a whole. This is cognitively more complex than grasping the state of mind of one individual. An example is when one reads

several interpretations of a work, and sees how each makes sense in its own terms and yet is a part of the same tradition.

Aesthetically, this is an advance because it finds significance in the medium, form, and style, and distinguishes between the literary appeal of the subject and sentiment and what is achieved in the work itself. It finds significance in the stylistic and historical relationships of paintings, and it expands the kinds of meanings that can be expressed. It enables one to find art criticism useful as a guide to perception and to see aesthetic judgment as reasonable and capable of objectivity.

Stage five: autonomy

 – It seems to me that it breaks out of the limitations of the style by emphasizing the flatness of the surface.
 – It has a kind of tired feel to it. I can't be sure if it's because I'm tired of seeing that kind of thing, or if he got tired of painting it.
 – In the end the style is too loose, self-indulgent. I don't like that, I want more self-control.
 – I go back and forth on this. I used to think it too rhetorical; now I vibrate to it again.

The central insight here is that the individual must judge the concepts and values with which the tradition constructs the meanings of works of art. These values change with history, and must be continually read-justed to fit contemporary circumstances. Judgment is felt as both more personal and more fundamentally social. On the one hand the responsibility for judgment lies inevitably with the self. One's own experience is in the end the only possible testing ground for judgment, and one can affirm or amend accepted views only in light of one's best understanding of one's own response. The result is an alert awareness of the character of one's own experience, a questioning of the influences upon it, a wondering whether one really sees what one thinks one sees. In the same way the values that underlie our judgments are our own responsibility. Though they come from the tradition, they can be affirmed or amended only in light of our own sense of their value. If they fit us, we affirm them; if they do not, we must amend them.

On the other hand, while one is individually responsible, the responsibility is toward others. The reexamination of accepted views is an attempt to fashion a more appropriate judgment in light of the common situation, and it is meant as valid for anyone in that situation. It is important therefore to talk with others about works of art and the common situation. One cannot question one's own experience without dialog, without considering the response of others to the same works. Dialog provides the only leverage one has to question the tendencies of

one's own experience and to understand their significance. In sum, while judgment is accepted as an individual responsibility, there is also a clear sense of the need for discussion and intersubjective understanding, and of responsibility to the community for truth.

This insight affects the understanding of other aesthetic concepts. A style, for example, is no longer an established category but a grouping created for some purpose. The value of certain ways of handling the medium or of formal arrangements is no longer taken as a traditional verity, but requires a personal affirmation. What is expressed is no longer the established attitudes of the tradition but the personal choices of an individual made on behalf of others. Art is valued as a way of raising questions rather than as transmitting truths. Judgment is seen as capable of reasonable argument, and at the same time as dependent on personal affirmation.

Psychologically, this is an advance because it requires one to transcend the point of view of the culture. It requires the ability to raise questions about established views and to understand the self as capable of answering them. This implies a perspective on the culture itself.

Aesthetically, it is an advance because it enables one to make subtler responses, and to be aware that traditional expectations may be misleading. One also understands the practice of art, both its creation and appreciation, more adequately as the constant reexamination and adjustment of self in a common situation, as the exploration of values in changing historical circumstances.

STAGE ONE

Any scheme that connects our beginning with our mature abilities risks depreciating one or the other end of the sequence. I begin by addressing the first of these risks. A developmental scheme describes several stages, and the earliest is the one that may suffer most in the comparison. The description may focus more on what earlier stages can't do than on what they can. I have tried not to sound depreciatory. I hope my analysis makes it clear that young children respond aesthetically from the beginning, and that their response is strong and untaught. They naturally take delight in appearances, a delight that is aesthetic in character. The young child is a citizen of the aesthetic domain by birth and not by education. If it were otherwise, we could never get started in the arts. If we took no delight in what we see we would make no meaning of it.

Aesthetic experience, therefore, is not an unusual affair. We all engage in it, for much of the time, at whatever level we can, and with all degrees

of seriousness. We do this when we attend to the appearances of things and find them interesting. The quality of our perception and experience varies, of course, and the character of the meanings we find in it. But through all the variations, what we have in common is basic and quotidian: a natural aesthetiç response to appearances enjoyed for their own sake.

On the other hand, there is no point in pretending that young children have the abilities of adult artists or critics. It is romanticism to think that their experiences in the arts are equal to those of adults, or that their paintings are as full of meaning. There is a whole series of insights about paintings that they do not have and that are of great importance. For this reason many significant aesthetic qualities are inaccessible to them and their experience of art lacks the richness available to adults. Aesthetic development consists precisely in the gradual acquisition of these insights. We reach the later stages only with an education in which we encounter works of art often and think about them seriously.

The delight of young children in appearances is a good place to begin the discussion of stage one. Young children take pleasure in almost all paintings, and rarely dislike them. Their power of enjoyment is one of the pleasures of discussing art with them. What are the sources of their pleasure?

Long before we are aware of anything called art, we enjoy looking at objects. We are fascinated by the color of a stone, the shininess of a spoon, the lines of a feather. Such things have a natural attraction. We attend to them for their own sake – not for their meaning, but for what they are in themselves. In the same way, at twenty months we regard our own scribbles just as scribbles – that is, as marks pleasurable in themselves, having no further meaning. We make marks on paper mostly for the motor pleasure of doing so, and for the sense of achievement. We do not attend much to our drawings, but when we do it is for the appeal of the colors, the textures, the lines.

This appeal remains with us always. It is the direct sensuous appeal of color, texture, line, that the material things of this world possess and that art frequently exploits. It is more than beauty in any ordinary sense, though it includes the beautiful. It includes, for instance, the cool translucent green of the underside of a lime-tree leaf. But it also includes much else: for instance, the texture of rough-cut cedar wood, and the jagged lines of a shattered window. We all find such things interesting, and at stage one we have not learned to see some as beautiful and others as merely interesting. Art is based in a fundamental way on these kinds of qualities, and they are its first appeal.

Color

Color is particularly important. All studies of young children conclude that two kinds of things dominate their response to art: color and subject matter. I will speak of color first because I think it comes first. When we are old enough to talk about paintings, we almost always mention the colors. They are intrinsically attractive; we enjoy them for their own sake. They please us, and we find them pretty. For instance, Albert, five years old, is inclined to think the Klee is "funny" – he means unrealistic – but this is more than compensated for by the colors. He says:

> It looks kind of funny . . .
> Does it look good that way?
> It's kind of funny, but it's not bad, because it's pretty with all different colors.
> How can you tell it's good?
> Because they made it with all different colors; like, here's some color white, here's some yellow, here's some white with the other colors.
> Does that make it good?
> Yeah, that makes it really pretty, and it's really neat.

As we can see, Albert is inclined to think that the more colors a painting has, the better it is. Colorful works like the Klee have a natural advantage over black and white works like the Goya; though this usually does not mean that we dislike the latter, but only that we prefer the former. Sometimes we do actively dislike black. Albert said of the Albright, which he tended to like:

> (What about the colors?)
> They are pretty. It has yellow leaves.
> Do you like the background?
> I don't like the color black, so I don't like the black.
> How come you don't like black?
> Cause it is kind of a dark color. It is just a dark color like grey is a dark color.

In short, at stage one we like colors to be bold, bright, and plentiful.

It is a commonplace to say that, as young children, we like bright colors. It is interesting to note, parenthetically, that there is evidence to show that we like even more saturation of color – that is, vividness. Ellen Winner, in her encyclopedic survey of the psychology of the arts (Winner, 1982, p.139), reports a study that systematically varied colors according to hue, brightness, and saturation (Child, Hansen, and Hornbeck, 1968). The study found that young children consistently prefer highly saturated colors, whereas people over nine years do not. When brightness and saturation are held constant, almost everyone prefers cool

to warm colors. Of course, this study was not a study of color in the context of paintings, where things are much more complicated.

In these early years, we also like our colors simple. Internal variations of hue, tone, or vividness in a patch of color are not meaningful, and can interfere with seeing things clearly. It is often better if colors are plain. Brian, a kindergartner, said of the Renoir:

> The flowers don't look good. They're all fuzzy. They look a little funny.
> What about the girl?
> She looks fuzzy.
> What would make it better?
> Make it so it looks clearer. It looks like when the TV goes fuzzy.

And he compares it with the Klee:

> That looks better than the other one.
> How come?
> Because it's not fuzzy . . . He did most of the colors the same. That's why it looks good.

At stage one we have no trouble accepting colorful abstract or non-realistic paintings. They are justified by their colors, and perhaps their pattern. Though we also appreciate subject matter, its absence does not disturb us. We saw this in the case of Albert. Cathy, a kindergartner, shows the same generosity of spirit in her remarks on the Klee:

> I like the colors about it. It sort of looks like me.
> Did he do a good job painting this?
> Yes. He did so careful on the eyes.
> Is it OK even though it doesn't look like a real person?
> Yes. It's OK if the colors are different [from reality], and even if there's not a person in it, just oceans and fish.
> What if it's just a design, and not even any fish?
> I like it anyway, like I like this one.

Favorites

There is a notion, used particularly in connection with color, that expresses our sense of the appeal of color. It is the notion of having a favorite. Almost all young children have favorite colors. A favorite color is one that always brings pleasure, and for that reason a painting is better if it contains that color. For example, Debbie, eight years old, says of the Renoir:

> I like it. I like the blue and the yellow.
> Are they good colors?
> Yes . . . They are my favorite colors.
> Do you like a painting if it has your favorite colors?
> Yes.

How come?
I just like my favorite colors.
If it didn't have your favorite colors, could it still be good?
It depends what the painting looks like.
If it was like this one, but without your favorite colors?
Yes. I like this one.

Other colors bring pleasure too, and paintings can be good without our favorite colors. But favorites guarantee pleasure. The idea expresses the essential feature of stage one: egocentrism, the lack of distinction between the perceptions of self and others. Being-my-favorite is a property visible to no one but me. Yet I do see it in some colors, and it adds pleasure to my response. This implies a direct and personal relationship between myself and the favorite color, one that does not acknowledge the existence of other people. It is as if I have made a bargain with my favorite, to which others are not privy; the bargain is that we will favor each other, that if I take notice of it, it will give me pleasure. In favoring me this way, being-my-favorite contrasts with properties such as the brightness of a color, which anyone can see. The structure of stage one is such that this difference is not noticed.

The origin of particular favorites is necessarily idiosyncratic, having more to do with association than perception. The following makes this clear. It is also from the discussion with Cathy of the Klee:

(What do you think about this one?)
There's half a circle with blue inside of it. My favorite color is orange.
Is it nice he put orange in the picture?
Yes.
How can you tell orange is your favorite color?
Once my aunt gave me some bubble gum, and I liked that color.
Was orange always your favorite color?
Once my favorite color was red. Then I changed it to blue. Then I changed it to green. Then I changed it to orange. So now the three colors I like are orange, green, and blue.
Is a painting better if it has your favorite colors?
I like all paintings, even if they don't have my favorite colors.

It seems that Cathy is not concerned with what others can see in the Klee, but only with what she sees. Yet she does not disregard others for a reason; she is not "egocentric" in that sense. It is just that she is not aware that the experience of others is different from hers. She assumes that others see what she sees; she does not notice the difference between her thoughts and others'. Therefore she cannot distinguish "objective" from "subjective" influences on her response. This is the defining characteristic of stage one. It is what Baldwin called "a-dualism," the state where we have not yet divided the world into the dualisms of self and

other, thought and action, and internal and external. By the time we can talk, we must have come some way toward making those distinctions, because they are built into the language. For that reason the quotations above may not represent Cathy's thought accurately, though they do illustrate some aspects of stage one.

The idea of pictorial representation

What about the second great source of our early pleasure in paintings, their subject? There is no doubt that at a young age the subject of a painting is interesting to us. We take pleasure in knowing what the subject is, in inventing one if necessary, and in associating rather freely with it. How do we understand the subject at stage one?

We begin early to be interested in signification. Some things come to stand for others in our experience: they acquire meanings. Among these things are marks on paper. Winner says that a two year old child can typically see pictures as representations (Winner, 1982, p.114). Soon thereafter, we make the transition from scribbling to representational drawing. Nancy Smith says this transition typically occurs during our third year (Smith, 1979.) The meanings we assign to our drawings often bear no pictorial relation to the marks we make on the paper, and may appear to be chosen arbitrarily. We have little grasp of the idea of pictorial representation. Hence we feel free to choose what the drawing is about, depending on what we are thinking about. It is not unlike the situation with favorite colors. We are not perturbed by the failure of others to see what we are thinking about, nor do we feel a need to be consistent over time. At first a drawing is a man, then a flower, and an observer may see little suggestion of either. The subject is as much a matter of association as of representation, of invention as of discovery. This is the sort of behavior that Gardner (1980) calls "romancing."

We do the same with the paintings of others. If we cannot recognize what a painting is about, we read our own subject into it, guessing or inventing. Our suggestions are not meant as a basis for discussion, any-more than are the titles we give our drawings when we are "romancing." For example, Debbie, five years old, said of Kandinsky's *Rain*:

> It looks like all different colors. That looks like a big pickle coming down, and some food coming down on land: forks, knives and spoons, ketchup, even.

And she said of Pollock's *Autumn Rhythm*:

> It looks like different colored licorice. Who is it by?
> Jackson Pollock. It's called *Autumn Rhythm*.
> I like it.
> What do you like?

It looks like licorice.
Do you see anything else in the painting?
Not really.

The tone of enjoyment is plain enough here. The fact that the Pollock does not look very much like licorice is no reason to withhold the suggestion. We enjoy inventing subjects, and their associated pleasures.

Another way to describe this situation is to say that we are playing with the idea of representation. The idea is complicated, and it is not surprising that we take time to learn it. There are many kinds of symbols: letters, numbers, words, maps, samples, diagrams, pictures, paintings. All of these are ways that marks on paper may be significant. In some of them the shape, or color, or size is significant, and in others not. When shape matters, it matters in different ways, as with the letter *A* and a drawing of an apple. From all of this variety, we must figure out how marks on paper picture things.

We can say it another way: We have not yet grasped the test of the claim that a drawing pictures an apple. The test is to see whether there is a pictorial resemblance between some features of the drawing and some features of an apple. This requires us to know what pictorial resemblance consists in. It also requires that we distinguish what we see from what else we are thinking about: noises, sensations, memories, associations; for if we say that the drawing is about something, we imply that others can see what it is about. There is an intersubjectivity to perception, and hence to representation, that there is not to sensation or memory. To understand picturing, therefore, implies another ability: to imagine what someone else could see if they were also looking at the picture. I have already said the inability to do this well is the defining characteristic of a stage one structure.

To imagine what others see, we must recognize that their experience is not necessarily the same as our own, that what they think of is not what we think of. When we look at the dog in the Renoir, we may think of Fido and the good time we had with him in the park on Saturday. We need to understand that others will not think of this. This requires us to distinguish between two elements in our experience: those that are based on what can be seen, and those that are not. The ability to do this is part of cognitive development in general, but especially of aesthetic experience. This analysis explains why looking attentively at what is in a painting is such a hard discipline. The difficulty reappears in a different form at every stage, each time in a different form; and we find persons at stage five still asking whether what they see is really there.

It is sometimes said that we should not ask young children what their drawings are about, because it suggests that a drawing must be about something. As adults, we may find it natural to ask this question, because

of the importance for us of the idea of representation. But we fail – it is said – to recognize that this is not a concern of the child, who may be content with nonrepresentational drawings. We may be imposing on the child – according to this advice – a mode of thought that is not her own, and may thereby distort her natural aesthetic experience. The child may name her drawings only to please the adult, and so attend more to the expectations of the adult than to her own. Pushed to an extreme, trying to answer us, she might be made to talk meaninglessly. We find such a suggestion in Kellogg (1969) for example.

From a cognitive-developmental point of view this advice is misleading. Our aesthetic experience is not so fragile. On the contrary, it is vigorous enough to thrive on problems, and to ingest any material that lies in its path. It is true that, if we ask a child what her drawing is about, we may get a strange answer. But the child may be stimulated to struggle with the idea of representation – to find something that the drawing is about. On my analysis, this is a necessary step, a natural development and not a distortion of it. The question may be helpful; and if not most children will ignore it.

We can generalize the point. It is helpful to children to talk about paintings: it may get them to think about what they have not understood. Discussing paintings is probably the most helpful thing we can do with children, other than giving them materials to paint with. Our more common failing is to demand little in understanding the arts, and to avoid discussions of them.

Association with the subject

Stage one, as I conceive it, may be used by children who are beyond romancing with drawings. They may have little difficulty telling what some pictures are about, and can produce representational drawings. The key question is not whether they are comfortable with pictorial representation, but whether they freely associate other images with what they see. At stage one, we do not distinguish between the pleasure of what is seen and what is brought to mind; and our enjoyment is all the greater for it. An example is that of a four-year-old boy with whom I discussed a farm scene by Currier and Ives. He said he liked the painting because it had a horse in it, and the horse made him think of his cowboy hat, and he liked playing with his cowboy hat. The painting had neither cowboys nor hats in it, but the remembered pleasure of his hat was a lively part of his response to the painting.

A less striking but more common example is that of Fiona, four and a half years old, looking at the Renoir and being reminded of her cat:

(What do you think about this painting?)
I like it.
What do you like about it?
The dog on the table.
Do you like dogs?
I like cats better. We even have a cat.
Would the painting be better if it had a cat?
Yes. Our cat has black and brown mixes.

Both parts of this extract are characteristic. First, Fiona likes the Renoir because of the dog in it. Almost all young children like the Renoir because of the dog. And, second, she likes cats better because she has one at home; and the painting would be better if it had a cat in it. The pleasure of association would be greater if there were a cat in the picture, though there is pleasure anyhow. She would then be in the situation of Grant, four and a half years old, who did have a dog at home, and enjoyed the painting in part because of that. Grant said:

(What is this painting about?)
About a dog, and she's playing with her dog. Sometimes I let my dog crawl up on the table when my mom's not looking, but one day he knocked off a cup and that wasn't very good.
Do you like the painting?
Yes. I like playing with my dog.

Sometimes the subject is difficult to understand because there is a lot of it. At stage one we do not find this disturbing either. We are happy to identify the elements in a piecemeal way, looking at them serially, taking pleasure in enumerating them. We feel no need to relate the parts to each other, or to understand the painting as a whole. The enumeration is a pleasure in itself, and makes as much sense of the painting as we need. For example, Emile, five years old, enjoyed the Albright, and understood it very partially:

(What do you think of this painting?)
Oh, it's pretty!
It's pretty! How come?
Because it has a man, maybe a woman or something; then it has a chair, a rug, a table, and she has pretty shoes – it could be a girl – and she has a pretty dress. It just looks pretty.
Which part is prettiest?
This part [the table].
Where the bottle and the flowers are?
Yes, and the leaves and stuff.

We can, if we like, understand this failure to see the painfulness of the Albright as protection against its emotional demands. Even so, it rests on a cognitive structure in which the meaning of the whole plays little part. At stage one we do not organize our response to the painting in

terms of the subject as a whole. Attention moves from one part to another, and is satisfied as it does so. There is no felt incongruence of part with part, nor of congruence either, for there are only parts, one at a time. And attention to these parts, whether items of subject or of color, can shift easily to associated memory and back again without notice.

The enjoyment of paintings

I spoke of the strong sense of pleasure we take in paintings at this stage. It is very noticeable in interviews. We simply enjoy looking at paintings. Liking them is natural, and we have few reasons to dislike them. We do not complain if they are not drawn well, nor if they are hard to understand. We do not find subjects ugly or repulsive, nor care if they are inexpressive. And we do not distinguish between liking a painting and judging it good. Liking and judging are equivalent ideas. It is as if our intuitive response is already a judgment, and the judgment is identical with the only reason we could give for it: the fact that we like it.

It follows that we find almost all paintings good, and rarely make negative judgments. Helen, five years old, says forthrightly that there are no bad paintings:

> (Would you put all paintings in your museum, then?)
> Yes.
> Would there be any you wouldn't put in?
> I wouldn't do that.
> Are there any bad paintings?
> I don't believe in that.

It seems that a negative aesthetic judgment is not a mirror image of a positive one, but is a later and derivative idea. At the beginning, all paintings are liked and are therefore good. In the course of development, however, we construct standards for judgment, and by these standards some paintings will fall short. We may call these bad paintings, though it would be more accurate to call them poor ones: They have some value, but not much. It is as if a negative judgment expresses a poverty of positive value, rather than an actual negative value. In this way, aesthetic judgments contrast with moral ones. For in negative moral judgments, we imply not just a lack of goodness, but some actual moral badness.

For this reason, we see at all stages of aesthetic development a greater willingness to make positive than negative judgments. This is most pronounced at stage one. Some young children appear to be puzzled by the very idea of a "bad painting." For example, the conversation with Helen continues:

(Are there any bad paintings?)
I don't believe in that.
Is everything good?
Some things are bad. Most things are good.
How can you tell if it's bad?
For instance, my brother bit me on the back. That's bad.
But how do you tell if a painting is bad?
Most every painting is good.

Other children confuse moral and aesthetic considerations. It is as if the idea of an aesthetically bad painting is an empty one, and the only form of badness is the moral. For example, Ira, a five year old boy, said:

(Are there any bad paintings?)
Ones that say bad words like in movies are bad ones.

And Judy, four and a half years old, said of the Bellows:

(Do you know what they're doing?)
Yes, they're boxing.
Is that a good thing to paint about?
Uh, not to knock them through the ropes.
Not to knock them through the ropes? How come?
Cause it would hurt more.
It would hurt more than just hitting?
Yes. So it's not nice to paint about.

It is not surprising that we do not distinguish moral from aesthetic considerations at stage one. The distinction is a problem at almost every stage. The progressive sorting out of moral and aesthetic considerations is an important aspect of our cognitive development, and the interaction of the two reappears, in ever more complex form, at each stage. In stage one, the initial distinction is yet to be made.

2

THE SUBJECT

Is a painting better if it is about a beautiful subject? What makes a subject beautiful? Is it better if it presents its subject realistically? What do we mean by "realistically"? And what about paintings that seem to have no subject at all? These are some of the questions I have asked people, and in this chapter I analyze some of their answers.

In the early stages the subject is the natural focus of our response. Especially at stage two we ask ourselves first of all what a painting is about. We make sense of a painting, and organize our response to it, in terms of its subject. Often, not to understand the subject is not to know how to look at a painting, not to know what to find significant. We need to know what the subject is before we can appreciate the color or expression.

Of course there are different ways of understanding what a painting is about. I am thinking not of different interpretations of a particular painting, as when one might say the Renoir is about a girl and another about her dog. I am thinking of different understandings of the *kinds* of subjects that paintings have. In this sense a girl and her dog are the same kind of subject: they are both tangible beings. Happiness, on the other hand, would be of a different kind. At each stage we conceive paintings to be about a different kind of subject, and these conceptions underlie our interpretations of particular paintings.

Here are some examples from discussions of the Klee. At stage one, the Klee is mostly pretty colors; we may say it is about the colors. We also say it is about a man. At stage two, it is obviously about a man, or a man's face: a physical object which may be pictured. At stage three, it is about something like the balance of femininity and masculinity. At stage four, it is a universal symbol for humankind, and expresses a quirky humor and a sophisticated spontaneity. At five, it raises questions about how we see things, and can be said to be about the nature of perception.

One could say that at stage one we are still constructing our idea of

what paintings are, and of how representation works. We understand that paintings have meanings, but have no clear idea of how they differ from, say, maps and alphabets. Nevertheless, we recognize many of the objects pictured in paintings. At stage two, we expect that paintings will picture physical objects, and that these objects will be beautiful or interesting. At stage three the subject is something more abstract and subjective, such as a person's love for animals, femininity, or sympathy for old age. Paintings are about such things, though they do not picture them directly. At stage four, the subject is more closely connected with the medium of the painting, the paint itself, its formal arrangement, and with matters of style. For example, the Renoir is about the way local colors reflect from the surface of objects, the way light falls. At stage five, the subject becomes a question as much as a statement, a matter of process as much as of properties. Paintings reinterpret our perceptions, categories, and values.

This chapter is mostly about stages two and three. One reason is that my expository plan calls for a focus early in the book on the early stages, and later on the later stages. Another reason is that, by the time we reach stages four and five, our idea of the subject has become one with the way the painting is painted. When we speak of what the painting is about, we find it inextricably associated with considerations of the medium, form, and style. So it seems better to reserve most of that discussion for the chapter dealing with those topics.

Another way to talk about these different understandings is to say that the concept of the subject of a painting is very untidy. Paintings can be said to be about many different kinds of things, and can be about them in several different kinds of ways. Our natural language – as opposed to technical languages – is characteristically hospitable to the kinds of differences I have suggested because it glides so easily across them. We can use the word "subject" for them all. This is a great help to our cognitive growth. It allows us to go on talking to one another across our differences of understanding, and gradually to reconstruct our ideas without having to reinvent a vocabulary every time we make a new distinction. It means that sometimes we appear to say more than we understand; but it also prompts us to understand better what we say, and what we hear said. We find the same kind of fertile untidiness in the language surrounding other key developmental ideas like creativity, expression, and style. And it is notable that, in spite of our different understandings, we all speak of the subject of a painting, and most of the time we make sense to each other. Of all the people I have discussed paintings with, in and out of interview settings, not one has had trouble understanding the questions: " What is the subject of this painting?" or "What is this painting about?"

They have at times had difficulty answering these questions, but not
understanding them.

STAGE TWO

By the time we go to elementary school, we have typically
reached a clear understanding that paintings picture things. This is the
dominant idea of stage two. It allows us to understand paintings mean-
ingfully, and we organize our response largely in terms of it. Basically,
we want to understand what the subject is, and if we can't our response
is scattered. Here is Angela, nine years old, explaining how in difficult
cases she looks for intelligibility:

> Well, I like most things. Sometimes, if I see a painting far away, it
> looks kind of weird and stuff; but then I get up close and I look at it.
> I sit down, or turn my head around, and I look at it, and I figure out
> the figure in the painting. I look straight at it, and I figure out what it
> is, and then I like it.

This is a typical thought. The main thing is to figure out what the painting
is about. After that, we will generally like it.

At this stage, the subject is spoken of as a physical object, identifiable
independently of the way it is painted, as if it had a separate existence.
An image commonly used by commentators to describe this is that of a
picture window. It is as if the painting were a window through which
we look to see something else. We do not focus on the window, but on
what lies beyond it. We look through, but not at, the window. The best
kind of window is thoroughly transparent, and we will notice it only if
there are smears on the surface, or distortions in the glass. So it is with
paintings. We pay little attention to the medium – the lines, texture,
form – and a lot to the subject. This is possible because we understand
better than before the kinds of things paintings are about – physical
objects and events – and how they are about them – they picture them.
The image that children themselves use is more often that of a photo-
graph, an image which captures the same points. The painting is like a
photograph because it pictures things that exist independently of it; and
we do not notice the film unless it is too grainy, or fogged, and so on.

There are two further kinds of assumptions about the subject that
constitute stage two. One has to do with the kind of subjects that make
for good paintings; the other with how they should be pictured. They
can easily be summarized. A painting is best if it is about beautiful things
and if it pictures them realistically. I will divide my discussion into these
two topics: the beauty and realism of the representation.

Beauty

The ideas of art and beauty are complexly linked, and in the minds of some are inseparable. What do we mean by "beauty"? I believe there are several meanings, and they can be arranged roughly to correspond with the four central chapters of this book. There is the beauty of the subject, which is my present topic. There is the beauty of expression, which has to do with the strength of feeling or generosity of spirit expressed in a painting. This is the topic of Chapter 3. There is the beauty of the medium, rising from the allure of the paint itself, its color, shape and form. I will discuss this in Chapter 4. And, finally, there is the sense of "beauty" in which it is a general praise word for works of art, so that to call a painting beautiful is to judge it to be aesthetically valuable in some way. Judgment is discussed in Chapter 5. Here I discuss the first and most common of these meanings: the sense in which we think a painting is beautiful if it has a beautiful subject.

It is easy to give examples of the kinds of things thought to be beautiful in paintings. For example, Blair, twelve years old, said:

> Well, if you showed a woman sitting in a boat, and a lake behind her, and stuff; or a couple of deer in the mountains . . .

And Connie, who is also twelve years old, said of the Albright:

> (Is this a subject you'd expect a painter to choose?)
> No!
> Why not?
> Well, if a painter was going to paint something – most painters paint beautiful women, or they really look nice in beautiful surroundings . . .

The transparency view of painting is plainly at work here. The assumption is that a painting will be beautiful if it is about a beautiful subject. Beauty is transferred, as it were, from the subject to the painting. And in general, on the transparency view, we could say that a painting will have the qualities of its subject, whatever they are. A painting could not be beautiful if it pictured my old and rusting automobile.

Then we must ask what makes a subject, not a painting, beautiful. What is it that a woman sitting in a boat and a couple of deer in the mountains have in common? They are beautiful (in this sense) if they look good of their kind. Deer will be beautiful if they look healthy, and as if they can run well; a boat if it is well-appointed and looks seaworthy. The case of the woman is more complicated. I do not know if this is because what we expect of people is more than what we expect of deer or boats; or because fundamentally the home of the idea of beauty is with people. Certainly people give us the paradigm cases of beauty. That we think of beauty as centrally a property of persons was clear to Plato,

who used Alcibiades as his example in his analysis in the *Symposium*, and did not use the example of a work of art at all. In any case, we can say a woman is beautiful if she looks good of her kind. This means, roughly, if she looks healthy and admirable; and of course there are infinite variations on this theme, of which sexual attraction is only the most obvious; variations in which much may hang on the line of a neck or the shade of a cheek, and which carry an immense suggestiveness of emotional depth and ideal character.

A subject is beautiful, then, if it is good of its kind. Other examples commonly given by elementary school children include imposing soldiers, appealing children, playful dogs, colorful flowers, rich landscapes. With time the list is gradually extended to include nostalgic – but not painful – items, such as twilight in graveyards, large-eyed mal-nourished waifs, old deserted barns; and the mildly fearful – but not threatening – such as magnificent tigers, battles that are well-fought and tidy. Such things have charm, if not beauty, and the charm remains when they are translated into paint. There seems to be no point in asking why such subjects are good in paintings. The logic is: If we like to look at such things in nature, why should we not like to look at them in paintings?

As we learn what is beautiful, we learn also what is ugly. Ugliness is the shadow thrown by beauty; it is the failure to live up to the standards beauty sets. The shadow falls as much on paintings as on reality. At stage two, we increasingly find some kinds of things unattractive, both in themselves and as subjects of paintings, including not only the ugly, but also the painful and distressing. Of the paintings discussed in this book, this includes primarily the Albright, the Goya, and the two Picassos. For example, Debbie, aged thirteen, had an immediate negative reaction to the Albright:

> (What do you see in this painting?)
> There's a lady sitting in a chair with her legs exposed. They're bare and they're really ugly. They've got bumps all over them, and she's sitting there with a powder-puff in one hand and a mirror in the other . . . She sort of looks like a witch.
> What's the feeling in this painting?
> I don't like it.
> Why not?
> I don't know. It's just that the legs are getting on my nerves.
> Why do you suppose the painter painted it?
> He was angry with his mother-in-law [laughs]. I don't know. He just felt like it. He saw some lady going down the street, and he said:"That looks sickening," and so he decided to paint her. He was angry at her for some reason.

Debbie's sense of the ugly is as intuitive as her sense of the beautiful.

She does not debate whether Ida is ugly; she sees it as a fact. If the beautiful is good of its kind, the ugly is poor of its kind, and is almost as obvious.

For such judgments to be intuitive, things must fall into obvious kinds and there must be obvious standards that apply to these kinds. Clearly, such situations are the products of socialization. At this stage, we have acquired an intuitive sense of the categories that things fall into, and the standards that apply to them. They constitute an informally learned but deeply influential set of definitions, expectations, and admirations, without which we could not become members of society and would not know what is beautiful. To see the truth of this, we need only remember the reaction in Chapter 1 of Emile, five years old, to the same painting:

> Oh, it's pretty . . . because it has a man, maybe a woman or something; then it has a chair, a rug, a table, and she has pretty shoes – it could be a girl – and she has a pretty dress. It just looks pretty.

Debbie's response represents a significant development from Emile's. She has generalized her likings into norms, converted her reactions into values. She has done this by sharing them imaginatively with others. We could describe this in either of two ways. We could say she has taken over certain expectations from society, or we could say that she has imputed her own expectations to others. Either way, she takes them for granted, accepts them unreflectively as obvious, both to herself and to everyone else, and not in need of justification. It is not just Debbie's expectations that Ida fails to meet; it is everyone's. Debbie assumes that we will all react in much the same way to things beautiful and ugly. That is what standards are like. They are norms accepted as facts. Things are no longer just liked in an idiosyncratic way, as at stage one; they are likable. They are things worth liking, things it is reasonable to like; and that they are so is obvious, not something to be thought about but seen.

An example is the dog in the Renoir. At stage two, almost everyone sees the dog as lovable. Its lovableness is a factor in the happiness we see in the painting. For example, a twelve-year-old girl says:

> (What are the feelings in this painting?)
> Happiness, because she's with her dog.

And a seven-year-old girl says:

> (What feelings do you think are in the painting?)
> Happy.
> Why is that?
> It kind of looks like the dog and the girl are happy.
> How can you tell?
> They're just laughing and playing. You can see that they're happy.

At stage one we loved the dog; at stage two we see it as lovable, because

we assume that others will love it. This implies that it would still be lovable even if we ourself don't love it. And the painting would be good, even though we don't like it. This is rather unlikely, perhaps, a possibility rarely actualized but nevertheless significant. It lives in the small but crucial logical space between the liked and the likable, a space created along with the idea of the beautiful. It is not that at stage one we denied that the dog is lovable. Rather, we did not entertain the distinction; there was no logical space between what we liked and what is likeable.

The obviousness of beauty and ugliness comes from the sense of their shared character. Since this character is shared, it need not be discussed; it can simply be seen. As we convert our stage one pleasure into our stage two idea of the beautiful, we objectify it, locate it in the object. What we like is a quality of the object not determined by tendencies of our own. Beauty lies in features that we can see and point out to others. The lovableness of the dog lies in its fluffy hair, for instance, its long ears, vivacious eyes, and air of wanting to play. And this is not a deception, a trick we play on ourselves; it is a discovery we make, a new awareness of the qualities of things.

A painting does not simply possess its beautiful qualities, as a natural object does. It also displays them, draws our attention to them. A painting holds its beauty up for us to notice, and makes it significant. In this respect it differs from a natural object. A real dog might have the same qualities as the dog in the Renoir, but it does not celebrate them, or draw our attention to them. We might love the real dog without seeing why it is so lovable. That is what the painting teaches us. We cannot look at the painting, except at stage one, without seeing what is so lovable about dogs.

Paintings also teach us to admire things that we previously did not. I may not have liked dogs till I saw the Renoir. Now that I have seen it, and the lovableness of the dog, I do like dogs; or at least I understand why other people like dogs. This understanding is from the inside, as it were, a matter of empathy: I can see those qualities that dog-lovers love. This appreciation is not exactly liking, for it carries a normative tinge. I see that it is reasonable to like dogs: I recognize what deserves to be liked in dogs. We could say I admire rather than like it, as in general we could say we admire rather than like beauty. For beauty deserves more than liking; it deserves admiration. In this way, art teaches as well as reflects the values of a culture. It teaches us to admire what is admirable, at a level well below that of discussion and argument. And whether the dog was lovable before I saw the Renoir is only a matter of individual biography. It was, I think, Oscar Wilde who put the point in the epigrammatic form: Nature follows Art.

The same things can be said about our discovery of the ugly. In the

case of the Albright, it is not only that we do not like to look at Ida; it is that no one would like to look at her. Her appearance is not only disliked; it is dislikable. And of course the painting parades this ugliness, drawing our attention to it. The passage from Debbie above is an example of this perception. Here is another from Derek, fifteen years old:

> (What was the artist's feelings when he painted this?)
> Well, I'm sure he felt moved by this lady; he felt angry at her, seeing her wondering: "Oh, why am I like this?" . . .
> What are your feelings about the painting?
> I don't like it. No one wants to look at some fat cellulited lady sitting there and keep powdering, all slobbed out. You don't like to think of things like that.

The indefinite other

I said that we build our idea of the beautiful through a sense of the presence of others with whom we share our likings. Who are these others? What is the group with whom we assume we share our values? At stage one, we had no sense of the presence of other people with a separate interior life from ours. At stage two we do have such a sense, and it powerfully shapes our responses to things. Not that we think about how individual people actually feel; that would require more reflection than we give the matter. Rather we assume that we know how other people feel; they feel the same way we do, and we feel much the way they do. The other is not a particular person but an imagined plural, modeled on ourselves and on whom we model. Consider the use of "they" and "people" in the following extracts, both from a conversation with Emily, nine years old. In the first she is speaking of the Renoir:

> (How can you tell if it's a good painting?)
> You can tell it's good when they paint about nice things and if it looks nice.
> Do you think everyone would like this painting?
> They would like it because it's pretty and the girl and the little dog look happy . . .

In the second extract, Emily is talking about the Goya:

> (Is this a good thing to paint a painting about?)
> No, because it's scary. It would make people scared and then they won't like the painting.
> Do you think there are any bad paintings?
> Yes, the ones that make people afraid and feel bad, like this one does . . .
> Do you think everyone would dislike it?
> They wouldn't like it because of the fighting. It would make them afraid.

What Emily is saying here is clearly based on her own response. It is she who finds the Renoir happy and the Goya scary. But the phrases she uses ("they," "people") speak of the indefinite other with whom she shares her responses. Such a structure underlies stage two, and can be seen rising to the surface in usages like the following, all from elementary-school children:

- No one would want to see that!
- How could anyone like a thing like that!
- Who wants to see stupid things like that in paintings?

We continue to imply a consensus of values even when we know it is not complete. Even though we know that someone disagrees with us, we imply that our response is the obvious one. "Anyone," for instance, can see that Ida is ugly, for it is unreasonable to think otherwise. Yet we may realize that someone likes the painting. We may infer that the artist does, and perhaps some particular other, a teacher, a parent, or the interviewer. At stage two, we do not expect to understand such a person. We cannot see their reasons as reasons, for their state of mind is outside the shared response. They do not see what is obvious, and what they do see is unintelligible to us. All we can do is accept as a fact that they like what is unlikable. They are not exactly irrational, and of course not morally bad; but they are aesthetically erratic, "weird." Their response can be acknowledged, but cannot be shared and in that sense understood.

These points are implied in a conversation with Fran, nine years old. She strongly dislikes the Klee because it is sloppy. Yet she thinks others might like it because it is "modern art":

(What about the Klee?)
Yes, some people would like it. It's just their taste. It's just the fashion. They like weird things.

Liking what is obviously not likable is here explained as "taste," an idea which acknowledges simultaneously the facts and their unintelligibility. The point is also nicely captured in the paradoxical air of the statement that "they like weird things," where "weird" clearly means what it is not likable.

Another example comes from a discussion of the *Guernica* with Foster, aged eight:

(Why would he paint something violent like this?)
I'm not sure.
Is it a good thing to paint about?
If you like violent things, I guess it is.

Foster's thought seems to be that, in the same way he likes beautiful subjects, some other likes violent ones. He does not reconstruct the subject as a message or a feeling. It is therefore the violent things them-

selves that the other must like, the concrete ugly and abhorrent things that can be seen in the *Guernica*; and he must like them in the same way that Foster and his fellows like beautiful things. This is a liking that can be known only from the outside, not shared.

There is one more point before leaving the topic of beauty. It is that we often conflate the beautiful with the morally good. It is true that we connect the two ideas at every stage, each time in a different way. At stage two, we do not distinguish them, but make only one judgment. This is perhaps not remarkable with positive judgments, when the subject is a beautiful woman or two deer in the mountains. That kind of beauty always retains the suggestion of moral goodness, or, in the case of the deer, of innocence. It is more remarkable when the judgments are negative. For example, we do not distinguish the ugliness of Ida from her moral character. Consider the tone of Godfrey, fourteen years old:

> (Why did the artist paint this?)
> To show what people are like, people do this all the time. And they just sit around and vegetate and dwindle away. And they look in the mirror and wonder why. "Oh, I'm so depressed! Look at me now!" You know. She should fight it. It wouldn't be a bad time to start; she's not dead yet. Let me tell you, my mom goes to a health spa. So when I see a fat person like this, it really makes me squirm...

These judgments of Ida are partly moral, though not clearly so. They are aesthetic judgments suffused with moral overtones. The mixture can be seen most clearly in the sentence: "When I see a fat person like this, it really makes me squirm." Similarly, we have already heard Derek say: "some fat, cellulited lady... slobbed out," and Debbie, "He saw some lady going down the street and said: 'That looks sickening.'"

We can compare the judgments quoted earlier from stage one. There, the moral judgments were about the painting itself. It was the painting that was morally bad and to be disapproved, as with paintings that have bad words in them. Here there is a difference, made possible by awareness of the subject. It is Ida who is judged, not the painting.

The conflation of the moral with the aesthetic is perhaps even clearer when the subject is violent rather than ugly. Violence is morally bad, and its perception distasteful. These two run together to make violent subjects undesirable in paintings. For example, consider the reaction of Gloria, ten years old, to the *Guernica*:

> (What feelings are in the painting?)
> Sadness, help... I don't like having some of these things, when you look at it.
> Is is good to paint paintings about war?
> No. Not unless... it doesn't show any dead people or anything like that; if the war has just barely started, then that's OK.

Of course, there are many paintings of war in which Gloria gets her wish, in which the soldiers are in colorful uniforms, the dead and dying are not disfigured, and the focus is on heroic gestures. They may be called beautiful; the *Guernica* cannot.

Realism

Realism is the second important idea at stage two. The image of the painting as a picture window implies a primary interest in the subject; but it also has implications for how paintings should be painted. They should be painted so as to fasten our attention on the subject, and not to obtrude the paint itself. We want to look not at the window but at what it frames; not the how but the what. This calls for a style that is readily intelligible in terms of the subject, which in general we can call "realism." Here is an example of how intelligibility is connected with the demand for realistic treatment. Harvey, fourteen years old, is talking about the *Guernica*. He says:

> (What makes a painting good?)
> Well, it kind of depends on the person; but my idea would be the realism of something, the detail and the shadows and the hands: the detail of reality . . . Some of these paintings I just can't understand where an artist will take a fistful of paint and throw it on the canvas. A piece of junk!
> Do all paintings need to be realistic?
> Yes, I'd say so. If they're going to put across a point, what does a big red spot on a canvas do? My parents like to go up to the art museum on the university campus, and look at modern paintings that look something like this: They have like a bare figure of a hand, a box, with sunglasses and a cloud! Those pictures depress me. It's just so unrealistic! But my parents do like that, and I can't see why. But then they [i.e., the museum] have some very nice paintings. It'll have a Christ on the cross, and it's very detailed. It was painted about the year one thousand, and it shows the detail of the muscles and the expression on the face . . . What this particular painting hides [i.e., the *Guernica*] – the cheeks, the muscles in your cheeks – play an important part in your face, and they just aren't there. You can see what is missing in the face. You look at every face, and they just don't have what they're supposed to have.

Harvey connects the demand for a subject and for a realistic and detailed treatment. What he wants from paintings is a faithful and detailed image of something. What the *Guernica* lacks – and what paintings of big red spots on the canvas lack – comes directly from Harvey's knowledge of the subject, and not from a sense of form or style. The faces in the *Guernica* lack cheek muscles, not because the painting needs them for formal or stylistic reasons, but because they exist in real faces.

There have been many studies of the attitudes of children toward realism. In general these studies agree that during the elementary school years we increasingly prefer realistic paintings, and use realism as a criterion in judging them. For instance, Machotka (1966), who studied the comments made by children in several age-groups, found that realism was a concern in 3% of the comments made by seven-year-olds, 32% of the comments made by eleven-year-olds, and 19% of the comments made by eighteen-year-olds. Similarly, in a study by Gardner, Winner, and Kircher (1975), the eight- to twelve-year-old group thought of art as intended to be realistic, whereas the four- to seven- and the fourteen- to sixteen-year-old groups did not. Lark-Horowitz (1938) found a steady rise in the importance of realism between the years six and fifteen. The same general tendencies were found by Frances (1968), and Walk et al. (1971). My interviews are in accord with these findings.

From one point of view, the discussion of realism belongs with the discussion of form, which is to be found in Chapter 4. Realism is, after all, a set of assumptions about how the medium of painting is to be handled. "Form" refers to the relationships of the various elements of the painting with each other, including the composition, the repetition and variation of colors, shapes, lines, textures, and bits of the subject. It is primarily a matter of relationships on the canvas and in the picture space. Realism assumes that the formal relationships should be determined primarily by the subject. In this sense it implies a set of formal requirements. A curved line will be a smile only if it is in the right spatial relationship to the lines representing the face; and the latter will represent a face only if they contain a smile, or some other feature, in roughly the right place. At a more sophisticated level, the relationships are those implied by the rules of perspective, overlapping, relative size, chiaroscuro, and so on.

Realism, therefore, can be regarded as a set of formal demands. Machotka classifies it this way. He further argues that perception of form requires us to have reached the stage of concrete operations, in Piaget's well-known scheme of cognitive development. The perception of form requires us to compare one part of the painting with another, i.e., to hold one part steadily in mind while we look at another. This requires "concrete operations." Since this Piagetian stage usually begins around the age of six, we would expect realism to appear as a criterion around that age, and to grow in importance throughout the elementary school years. The facts meet this expectation. Machotka adds that realism also requires another kind of comparison, which also requires "concrete operations": the comparison of the subject with its counterpart in the real world. Machotka's work is an interesting application to aesthetic judg-

ment of developmental stages that originate in the study of scientific thought.

Machotka also argues that, for the same reason, we should expect a steady rise in the frequency of formal considerations other than realism. He groups these considerations as contrast, harmony, style, and composition. However, if we separate realism from these other considerations, it is not clear that his prediction is borne out. In his study, the frequency of comments concerning these other aspects of form rise from 8.6% at seven years, to 9.9% at eleven years, to 22.7% at eighteen years. The significant rise appears to occur after elementary school. My interviews also suggest that at stage two we do not take much notice of formal matters other than realism. For this reason, after all it may not be illuminating to consider realism together with other aspects of form.

On the other hand, the argument for putting realism together with the subject is simple. It is that that is the way we understand it at stage two. We think of paintings primarily in terms of their subject, and realism is the only kind of form that makes sense from that point of view. That is why there is an increase during the elementary school years in comments about realism and not about other aspects of form. What counts is not what we can notice, but what makes sense. I return to this argument in Chapter 4, in connection with the discussion of style. Meantime, we can say that the point illustrates the difference between applying Piaget's theory of scientific development to art, and looking at development in terms of the meanings of art itself.

Schematic and photographic realism

"Realism" does not refer to one view only, but to a family of views (see Goodman, 1976). Two versions are relevant here because they form a sequence within stage two. The first I will call "schematic realism," the second "photographic realism."

Schematic realism requires that a painting represent what we know about the subject, that it mention the important parts. A drawing of a face, for example, should include at least the eyes, and probably the mouth, as with a smile button. The mouth and eyes are typically the most important features, and must be in roughly the right spatial relationships to represent a face. A schema is just such a selection of features, placed in appropriate relationships, representing an object. It is an image that serves as a functional equivalent, rather than a faithful picture, of what it represents; it stands for something, though it does not exactly picture it (Gombrich, 1960).

A schematic picture can consist of one schema, or of a series of schemas

put together. In the latter case, the relationships of the schemas also represent what is thought to be important about the relationships of the things represented, rather than their visual relationships. So the most important person in a group may be drawn as the largest, regardless of the visual facts, and a woman may be as big as the boat she is in. The Klee, the two Picassos, and the Chagall are the most schematic of the paintings discussed in this book.

We come early to understand paintings schematically; only later, though still at stage two, photographically. We can think of photographic realism as a specialized version of schematic realism. It presupposes an understanding of schematic realism, and adds the assumption that visual appearances are the most important facts to represent. It assumes that the purpose is the accurate representation of how things look, rather than how they are; and it implies specialized techniques, such as perspective and the modeling of forms with light and dark.

The difference between the two kinds of realism can be illustrated by comments on the *Weeping Woman*. For example, the hands are frequently mentioned. At the schematic level, we usually think they are well-drawn. If we have a question, it is about the parts of the hand, but not the hand as a whole. For instance, we may count the fingers to make sure there are five. We know there are five fingers on a hand, and a functional equivalent needs all five, but their precise configuration does not matter. One five-and-a-half-year-old girl said:

> (What do you think about the hands?)
> He's got all the fingers on. I think it's good, because he's even got fingernails on each one.

A little later we condemn the hands for not conforming to the criteria of photographic realism. An eleven-year-old girl said:

> (What do you think about the hands?)
> Well, they have five fingers, and everything, but they definitely don't look like hands.
> What should he do to make them better?
> Just make them look like real hands. He even put the fingernails on the wrong side.

A similar contrast can be made with respect to the use of color. Schematic criteria require that the color be a functional equivalent of the object's color, that skies be blue, grass green, and people neither purple nor many-colored. We may object to the color of the Klee, for instance, because it has the wrong colors in the face, or too many. We imply that one plain color would have been better. For example, Ingrid, nine years old, says:

> (What would it take to make this painting better?)
> Make it look more like a real man.

What about the colors?
I don't like that. . . They're weird. You don't really have that many
colors on your face.

On the schematic view, color need not contain internal variations of
tone, saturation, or hue; such variations have no significance and are
usually not noticed. A plain unvaried patch of color is sufficient to convey
what is important about the color of an object. Faces, for example, should
be "flesh color." It is what we might think of as a coloring book approach
to color.

With photographic realism, it is different. Older children may dis-
approve of the Klee because it has the wrong colors, but also because it
does not blend one hue into another, or model the surface into three
dimensions. In the same spirit, they admire the modeling of the Bellows
and the Albright, and sometimes the Renoir. For example, Isobel, thir-
teen years old, said of the Albright:

(Is this a good painting?)
Yes.
Why?
The way the artist used shadows and darkness, like, to show how fat
the legs are. And showed the wrinkles and that.

The contrast is actually more complicated than this summary suggests
because at all stages we continue to like colors for themselves, for their
colorfulness alone, as we did at stage one. This pleasure may at times
override the requirements of realism, and in that case we will like the
color of the Klee because it is pretty. This response is an alternative to
the realistic disapproval just described.

The transition from schematic to photographic realism is gradual, and
can best be seen in children's own drawings. These have been studied in
great detail, and the facts are well established (e.g., Lowenfeld and Brit-
tain, 1970; Eisner, 1976; Gardner, 1980; Kellogg, 1969; Di Leo, 1970).
The typical sequence can be simply summarized. By the age of six or
seven, we have usually mastered a number of schemata for the important
things in our life: faces, people, animals, houses, cars, and so on. For
several years our paintings repeat, elaborate, and extend this repertoire;
and often they are very appealing for their freedom and spontaneity,
boldness of color, and unconscious sense of form. Gradually elements
of photographic realism begin to appear; for example, the "correct"
relative size of people, houses and trees, a base line on which things
stand, the overlapping of people and objects, and perspective and the
modeling of forms. By twelve years most of us attain an understanding
of photographic realism that we cannot match in our own drawings.
This sequence, much studied and documented, finds a natural explanation
in the present context: When we draw of course we try to meet the

criteria of realism that we think apply to drawings in general. Our draw-
ings are therefore first schematic and then gradually more photographic
in their realism. In this way a developmental theory accounts for the
changes in our own artwork as well as in our response to the work of
others. Both rest on the same understandings.

Excuses

In the foregoing I have laid emphasis on the beauty of the subject
and on realism, both schematic and photographic. These are the central
understandings of stage two. What determines stage level is not whether
we accept or reject certain paintings but whether we understand them.
Some people are more generous in their judgment than others; they will
not judge as poor paintings that they cannot understand. They may call
them good, even like them. This generosity varies a good deal. Some
children continue the attitudes of stage one and are reluctant to think
that any painting is poor. Even while they prefer realism, they find
excuses for a painting that does not conform. I use the word "excuses"
because such children do not speak of some advantage of the style in
question, and often acknowledge its inferiority, which they nevertheless
say does not matter.

Such children often speak as if there are different kinds of paintings
and realism is a set of criteria that should apply to only one kind. For
other kinds it is not a reasonable expectation. Their sense of what these
other kinds are is diverse; the key point is that they do not understand
them to have any positive advantage. For example, Jason, ten years old,
thought the Renoir somewhat unrealistic, but was willing to excuse it.
He said:

> [For example] that glass looks kind of strange. It doesn't look like a
> real glass.
> It doesn't look like a real glass?
> Right. It depends on if he wanted to make it realistic, or just a sketch.
> But otherwise I like it.

Here we have the category of "sketch" used to justify a lack of realism.
If the Renoir is a sketch, it is good; if it is not, it fails. There is no
suggestion that sketches have positive values of their own. It is implied
only that they do not have to measure up to the usual standards, and the
implication is that they are an inferior category.

Jason also suggests that a nonrealistic painting would be acceptable if
the artist meant to do it that way.

> (Is it – the Renoir – a good painting?)
> It depends on your taste. If you like sloppy art, where they splash colors
> on.

Some people like that?
Yeah.
It could be a good painting if you just threw some paint on the paper,
and hung it up?
Yeah, if there was a plan to do it.
A purpose in mind?
Yeah, if he meant to do it.

It seems that Jason does not have a way to understand a nonrealistic
painting. It is just that there is no point in using criteria that were not
intended, even though they are the only criteria one has.

Kate, ten years old, also thinks that the important thing is whether
the artist was trying to paint realistically. If she was, then there are some
things that would make it better. But if she was not, then the painting
is fine. Kate says (of the Klee):

> I usually see pictures that have the same color of face.... It's kind of
> strange.
> What could he have done differently?
> He could have made the eyebrow better.
> Anything else?
> Maybe a better mouth.
> What about all the different colors on the face?
> It's OK. Sometimes they do it just for the fun of it. It looks neat. I'm
> not really used to that.

Here the excuse is that the artist was painting "just for the fun of it."
Since she wasn't intending a realistic picture, it is unreasonable to use
those criteria. In cases like this, we do not seem to distinguish judging
the painting from judging the artist. We are reluctant to judge the painting
because it sounds like judging the artist's behavior. Since there is nothing
wrong (morally) with having fun with paint, there is also nothing wrong
(aesthetically) with the painting that results. Here is Lisa, ten years old,
saying something like this about the Klee:

> (Some people say it's not very well drawn.)
> I think it's still a good picture, because, I mean, he tried. If he hadn't
> done anything – just sort of slopped the paint on – it would have been
> one thing, but he worked on it. Whoever made it worked on it.
> If you try hard, is it always a good painting?
> Not really. But at least you tried.
> Would it be bad if he just slopped it on?
> Well, not all the time. Sometimes it makes a really pretty design. But
> sometimes it's just sort of weird.

The idea of a "design" is a common one to use of nonrealistic paintings.
Designs can be pretty and colorful, and in this respect we see a contin-
uation of the stage one appreciation of color for its own sake. But there
is little content to the idea. It is understood primarily in terms of what

it is not: It is not intended as realistic and should not be judged that way. Marcy, ten years old, says of the Klee:

> It's sort of a man's head. Maybe he was just making a design, and it turned out that way. I do that a lot of times. I do something, and it turns out to be something else.
> It's sort of an accident?
> Yeah, sort of like that.
> Would it be better if he had put in a mouth and ears, and a few things like that?
> No, maybe not. Because, I mean, it's sort of – it's more like – it's one thing if you mean to do it that way in the first place. But if you don't mean to, and you just finished and it ends up that way (it's OK). Like the eyes – it's sort of just an egg with a dot or something like that.

Finally, Margot, seven years old, also understands that there are kinds of paintings other than realistic ones. She has no word for them, but she sees that the Klee was not meant to be realistic and is unwilling to find fault with it. She says:

> (Does it look like a face?)
> Yes, it has the eyes. I don't see a nose or a mouth, but still it looks like a face.
> Is it good to not have a nose or a mouth?
> I think it's OK. But if it were [a painting of] a real person, it wouldn't be.

STAGE THREE

The subjective theme

Our understanding of the subject is transformed at stage three. At the heart of this transformation is a new grasp of the expressiveness of paintings; and we could say, summarily, that we now identify the subject with the expressiveness of a painting. How this latter is understood is discussed more fully in the next chapter, and so what is said here is a kind of preamble for what is said there.

There are three main points, each of them a contrast with our understanding of the subject at stage two. The first is that the subject, which was a physical object, is now something more inward and general. The second and third are that neither realism nor beauty (of the sort already discussed) continue to be important criteria of paintings.

The first point is that the subject is no longer something physical; it is something more like a theme. A theme is more general and abstract. For example, it is the fun of a circus, rather than a circus, or the pleasure of playing with a dog, rather than a dog. It is also more inward. For

example, it is how someone thinks or feels about a circus, or about playing with a dog. We could say that the subject is the meaning of the object pictured, not just the object – something subjective, some feeling or intent, some aspect of human experience. For example, Naomi, thirty years old, says of the Renoir:

> (What about the subject matter?)
> I think a lot of people have such a fondness for pets and they look at their pets as almost children, or an extension of themselves; and perhaps that is what he is trying to say – that she has got him up on the table, which is more intimate than perhaps – as far as a relationship between her and the dog . . . She looks like she is coochee-coo-ing him, or whatever one does with little animals . . . He is depicting a relationship that is more than just a person and an animal. There's a closeness there.

And Norma, in her mid-twenties, says of the Chagall:

> It's what I would feel if I were in the circus . . . You know, like, every time you blink you see something different, so it's, like, maybe, as you experience the circus as you're walking out of the circus. It's like you see all these things in your mind happening; like you'd see a hand drop out all of a sudden, this head, you know, this clown, even the different sizes of things, and then the people sitting out in the stands. Just all the impressions your eyes saw, but they're all mangled like in a dream. So I think it's a perfect depiction of the idea in your mind after the circus.

The second contrast is that realism is no longer an unquestioned good. By itself – i.e., unless it is connected with expression – realism loses its appeal. It can be seen as merely the exercise of skill, something well done but with little point, empty and perhaps even boring. For example, Olivia, an undergraduate, says of the Bellows:

> It doesn't seem to really – it doesn't say anything about humanity. I guess that's – the same thing could be done in a photograph, except with more realism in it. It might hang in a boxing arena, but I think as far as a gallery showing, something like that, I wouldn't give it a great deal of artistic value.
> I'm interested in the phrase you used: "It doesn't say much about humanity."
> Well, it doesn't say anything. It says: "There was a boxing match, and Dempsey won, and the other guy was knocked out of the ring." And it doesn't, it doesn't leave me with anything. When I look at art, I generally want to feel something about it, and I don't feel anything here.

This is the authentic voice of stage three, wanting art to say something about humanity, where at stage two we wanted it only to depict something accurately. The skill of painting is taken for granted – "the same thing could be done in a photograph" – and accorded little value in itself. It would be valuable only if it helped to express something more inward.

The idea of realism itself does not necessarily remain photographic. It may also become something more subjective, something having more to do with feelings and ideas. Realism may come to mean facing up to unpleasant things, acknowledging that reality includes the ugly and painful. We could call this emotional realism. At stage three, emotional realism replaces the photographic kind. For example, Pamela, an undergraduate, says of the Albright:

> There's a big difference between this and the Renoir lady, and yet you can love her too. I think it's a good thing to look at things that are unpleasant. Sometimes you can say a lot more.
> But it's ugly?
> To me her face is beautiful, it's something I can relate to. I'm not sure I'd want to hang it on my wall, but it's a good painting.

And Paula, in her twenties, says:

> As for the subject matter, good or bad, it's valid, because you can learn something from it.
> How would you reply to someone who said: "I don't want to deal with it"?
> Well, they don't have to hang it in their house, you know. I don't know if I would hang it in my house. But it's like to not look at it is to ignore reality, to shun that because you can't deal with it. You don't want to deal with it because you're – something like:"I might look like that someday. Those look like my mother's legs; my legs might look like that someday, too." You know, and how would I feel?... And for me not to look at that, I would be ignoring something that I may be afraid of, but I am working at it. Realizing that maybe might make me want to better myself, or to keep myself straight.

This leads to the third contrast with stage two: that unpleasantness of subject is no longer automatically bad. Whether the subject is in itself beautiful is no longer a prime concern; instead, we ask whether it is significant.

What this development requires is the ability to empathize with persons or situations represented in the painting. One gets beyond the surface unpleasantness by grasping what things feel like from the inside. This empathy is what the painting expresses, is the real subject. For example, Peggy, an undergraduate, says of the Albright:

> This is very emotional!
> Why is that?
> I think he's got it so detailed you can almost see your grandma, or someone, who has really had a tough life. She looks – there's just a sadness there. I don't know, it's how he's done the legs and the veins; I don't know. I react very sadly to the emotional tone... She wants to be beautiful and have the characteristics of beauty, and is kind of forlorn because she realized they've gone. Perhaps at one time she had them,

and can't accept the fact she no longer does. I don't know why. There's just almost like a forlorn look on her face. And the way she's got the powder-puff.

This passage contrasts strikingly with the responses to the Albright quoted previously; for example: "When I see a fat person like this, it really makes me squirm." The difference is the sympathy with Ida, the attempt to grasp her individual subjectivity, which takes us past the initial moment of repulsion. This movement, incidentally, helps us to distinguish aesthetic from moral judgments of the painting. We can see that though Ida is ugly she is not morally bad. We can also see that, though she is ugly, a painting of her can be good. Its value lies exactly in the expression of her state of mind so that we can sympathize with her.

We can also use the word "beautiful" of this expressiveness. In such a usage, what is beautiful is not Ida's appearance but the sympathetic understanding of her. For example, Rebecca, an undergraduate, said:

> (What about beauty here? Is this a beautiful painting?)
> In a sense it's not beautiful. When people think of the definition of beautiful, they think about flowers and light and love and happiness and all those pretty things in the world; and this is not that beautiful. But if you think about yourself, and you're in the position of her, what she's thinking about herself, if she were thinking about herself and past happiness, it could be beautiful.

Stage three sets no limits ahead of time on what a painting should picture; each must be considered individually to see whether it conveys a message. Our response becomes more relevant to the work, because it depends more on its character as an individual painting and less on the category of subject it represents. A set of prejudices have dropped away that previously prevented us from looking closely at certain kinds of subjects. The character of our response cannot be predicted just from knowing what a painting pictures.

This development enlarges the range of works we can appreciate. Human suffering and inadequacy have long been themes of Western art, and our tradition is rich in meditations on age, death, cruelty, ugliness, and pettiness of spirit. Art has often set out to shock, disturb, and challenge conventional attitudes, and some of this is now accessible at stage three. Emotional difficulties remain, of course, as they do at every stage; but we do not reject such paintings in advance. It is even possible to see that ugliness or violence in art needs no excuse, but may be the very point of a painting. Scott, eighteen years old, says of the Goya:

> It's almost demonstrating cruelty of one man to another, or a picture of war in the real sense, instead of what we get through magazines: what it's really like.
> What do you mean by "real"?

Well, from what I've seen of war – I've read Remarque's *All Quiet on the Western Front* – it tends to be almost glorified to the people back home – when they go out there, what it's really like to be in the action, being attacked . . .
Is this a beautiful work?
I don't think that art necessarily has to be beautiful – well, beautiful in a way, that it can express something that nothing else can – but not necessarily beautiful as in pretty. And I don't think that this is beautiful in that way; I think it's gross in that way, physically. So it isn't beautiful. But perhaps war isn't beautiful, violence isn't beautiful.
Does that add to the value of the painting?
Yes. How can you portray violence when everything is neat and clean and orderly, instead of knocked over and twisted?

This extract illustrates the three brief contrasts I have made with a stage two understanding of the subject. For Scott the subject is something general and subjective – what war "is really like"; emotional realism is more important than photographic; and a good painting does not need to be beautiful "as in pretty." If we must use the word "beautiful" – so Scott seems to say – it is the thought or attitude that is beautiful; but perhaps it is better not to use it. The point of painting is emotional power, not beauty.

Here the discussion of our understanding of the subject at stage three merges with the discussion of our understanding of the expressiveness of paintings. I will pick up the topic in the next chapter.

3

EXPRESSION

Art is often thought to have something to do with emotions. Many times the best description we can find for some quality of a painting derives from talk about our emotions, or other mental states. For example, we may say that the Renoir expresses a delight in the way commonplace things strike the eye, that the *Weeping Woman* conveys a sense of grief, and the Goya an outrage at the horrors of war. In talking about paintings we naturally talk about feelings, thoughts, attitudes, emotions, often in more complicated ways than these examples suggest. This chapter discusses many actual cases of such talk, and could be considered a compendium of the ways people speak of the expressive character of paintings.

The connection between art and emotions is what makes art important for many people. It shapes the way they understand paintings and organize their responses to them. It gives meaning to art so that they take it seriously, in a way that they don't take other things seriously that can nevertheless be "appreciated"; for example, wine or perfume. In this chapter, I present a developmental analysis of our understanding of this aspect of art.

There are several ways of speaking of the connection of art with emotion. I shall use the words "express," "expression," and "expressiveness" when in need of a general portemanteau mode of speech.

By way of brief preview of what is to come, I will summarize the differences in understanding expression that are related to stage. At stages one and two, we look primarily for the feelings of the persons depicted in the painting, and read them mostly in facial expressions, gestures, and actions. For example, the girl and the dog in the Renoir are seen to be happy. The feelings of people are a function of the depiction itself, and are not thought to be particularly important. At stage three, we attach more importance to expressiveness, and organize our response around it. We think of it as a subjective state of either the artist or the viewer,

or both. For example, Ida is commonly seen as trying to face reality, and the painting as expressing the artist's sympathy with her situation. At stage four expression has a more public character to it, being more closely related on the one hand to the detail of the paint on the canvas, and on the other hand to the art tradition to which the painting belongs. Expressiveness is something that can be discussed and pointed to, and it includes more than the state of mind of the artist or the viewer. For example the Renoir may be seen as expressing a delight in the fall of light and the richness of local color.

STAGE ONE

Feelings as behaviors

Of the reproductions used in my interviews, the Renoir was most easily understood in expressive terms by young children. It is a painting much enjoyed for its pleasant mood as well as its color. All my younger interviewees thought it was a happy painting.

There are two characteristics of a stage one reading of expression that this painting accommodates. One is that we read expression largely in terms of the feelings of the person portrayed. The other is that feelings are conceived in concrete, almost behavioral, terms.

Consider the following examples:

(What kinds of feelings are in this painting?)
Having lunch.
Can you tell if she's happy or sad?
Happy.
How can you tell?
Because there aren't any tears. [Four-and-a-half-year-old girl]

(What feelings do you see in the painting?)
I think she's happy.
How can you tell?
She's kissing the dog. [Five-year-old boy]

That's [the Bellows] more uglier than the other one [the Renoir].
Why?
Because the people are weirder.
Why are they weird?
They look weird.
Why do they look weird?
Because their mouths aren't happy. [Five-year-old girl]

These examples illustrate the two points mentioned above. The first is that the expressiveness of the painting lies in the feelings of the persons depicted. In these examples the question focuses on the painting, but the

answer on the persons represented. At neither stage one nor two do we conceive of paintings as being themselves expressive. We do not see them as the sort of thing that can "have" feelings; the chief kind of meaning they can have is representational. All they can do expressively is to represent people who have feelings.

The second point is that feelings are conceived concretely. They are represented in the same sort of way that people are: They are pictured. We can see people's feelings in much the same way we can see their noses. They are seen in faces, tears, smiles and gestures, and in events and behaviors, such as having lunch, hugging dogs, and raising eyebrows. Moreover, feelings are not the sort of things that persist over time; they are episodic, a part of the events occurring in the painting, more like temporary moods than underlying dispositions.

Faces are particularly important. The face in the Renoir is obviously happy. The face in the *Weeping Woman* is (less obviously) sad; but the hands and the handkerchief, which later are a focus for the painting's expressiveness, are not seen as expressive. The Klee is puzzling because it is hard to read an expression on the face. Albert, five years old, finds it strange but enjoys the colors:

> Just look at this: there's an eyebrow like this. It looks kind of funny.
> How would it be better?
> If it would have the same thing [i.e., matching eyebrows], then it would be nice.
> Is it bad like that?
> No, it just looks kind of funny . . . But it's pretty with all the different colors.

At times the expressive blankness of the Klee is not commented on; at times it is somewhat negative, as for Albert. But we spend most of our time at stage one enjoying its colors and not trying to read an expression. For example, Angela, five years old, enjoys it:

> (Do you see any feelings in the painting?)
> Sort of like color feelings. It makes you think of one color after another.
> Does that give you feelings?
> No, just regular happiness.

Colors, it appears, are pretty rather than expressive; for only faces and gestures can be expressive. In another example, Anita, a four-and-a-half-year-old girl, saw that Ida is sad and the colors are dark, but she did not connect the two:

> (What do you think of the colors?)
> They're kind of dark.
> How would it be if they used bright colors?
> It would be brighter.

Would it be better?
Yes. (Why?) Because we could see it better.

Sometimes the Albright is not seen as ugly or sad, but as pretty – a tribute to our powers of enjoyment at this age. Albert saw it this way, and had a hard time finding anything expressive in it:

She has a pretty dress. It just looks pretty.
Which part looks prettiest?
This part [points to desk] . . .
What kinds of feelings are in the painting?
Well, maybe this, or this [points to chair and carpet].
The chair?
Maybe this [the desk].
What does it make you feel like when you look at it?
It makes me feel like I am happy. It does, I like it.

The pointing behavior in this extract may be a case of the concrete conception of feelings; but it is more likely an attempt to satisfy the interviewer (his mother). I do not believe Albert found expressiveness in the chair; it was rather that he could not find it in Ida.

STAGE TWO

Picturing feelings

Our understanding of feeling in paintings undergoes the same change at stage two that we saw the subject undergo. Feelings have a more objective character; they are seen out there in the painting, and we expect other people to see them too. In the same way that the dog in the Renoir became lovable rather than just being loved, so the girl becomes happy rather than just occasioning happiness. Feelings are more firmly ascribed to the people in the picture, and are more conventionally conceived.

The result is that we have a more relevant response to many paintings. The difference is most noticeable in the case of paintings where there are several figures. We make a more sustained attempt to take account of each of the figures, to relate them to each other, and sometimes to elaborate a story that will make sense of the whole. Often there is an enumeration, a going around the painting, looking serially at each person and reading their feelings in light of the main event. The Bellows provides many examples. Brian, nine years old, says:

(What feelings do you see in the painting?)
Lots.
Like what?
This guy is probably hurt. This guy is angry. These guys are yelling

at him because they like one person more than the other. This guy is
scared. This guy is getting smushed.
Is there any overall feeling to the painting?
There's a whole bunch of feelings.

We also have a better sense of what the Albright is about. Instead of
finding it a pretty painting, we are now clear that Ida is ugly, unpleasant,
aging, or sick. In Chapter 2 we saw that usually we have negative feelings
about this; we dislike Ida and the painting as well. We do not empathize
with her, or attribute much in the way of feelings to her. Instead we
dislike her, sometimes quite strongly. We may assume that the artist also
disliked Ida, or was angry with her. For example, Beth, thirteen years
old, says:

> I would say he didn't think too much of her.
> He didn't think too much of her? How can you tell?
> No. If he thought much of her, why would he paint her to look as if
> she was dead? Like, she's a zombie, come back from the dead. She's a
> – it looks like her flesh has decayed on her.

This shows how much less likely we are to read feelings into negative
figures than into attractive ones. Unpleasant figures are emotionally more
difficult to deal with, and we are likely to recoil. That is why Beth
speculates more about the feelings of the artist than Ida's.

Other times we may see that Ida is sad. The sadness is hers, not ours;
and is located primarily in her face, and in the story she suggests. For
example, Bruce, eleven years old, says:

> She doesn't look too happy.
> How can you tell?
> Well, her face is just sort of – she's not happy. She's just sort of: "what's
> the difference?" . . .
> What feelings do you see in the painting?
> Probably sadness. Like sometimes you wish you didn't have to do
> certain things, or you wish you weren't what you were. Probably like
> that.
> Tell me a little more about that.
> Sometimes I wish I was some person who could whip through all of
> my work, and just be an A student. Sometimes you just can't. Whereas
> there are people who can.

Bruce's understanding of Ida's feelings here is not enough for him to like
the painting, nor to approve of the subject. He would prefer to see a
happy painting.

The same kind of increased objectivity can be found with respect to
the qualities ascribed to colors at stage two. At stage one we associated
colors with prettiness but not with feelings. At stage two we make this
latter connection. Carin, a seven-year-old girl, said of the Renoir:

(What kinds of feelings are in this painting?)
Happy.
How can you tell?
Well, because of the bright colors, the expression on the girl's face . . .
Anything else that makes it look happy?
The colors really stand out . . .
Do you have to have bright colors in order to make it a happy painting?
Well, you don't have to, but it really helps.

The connection made here is typical. It is understood in a general way: bright colors are happy, dark ones are sad. The particular colors themselves are not looked at closely, or individuated as to their character; they are recognized rather than examined. But their character is a different kind of thing from being a favorite; it has a place in the world for anyone to see. Carin assumes that anyone can see that bright colors are happy. It is as if the connection of colors with feelings is a regular and well-known one. It does not have to be individually established or subjectively reexperienced, but can be recognized. For example, consider the reference to the "color of mourning" in the following. Corey, eleven years old, is discussing the *Weeping Woman*:

(What are the feelings in this painting?)
Sad.
What about it being in black and white?
In Greece, if you wear black, that means someone just died. Black is the color of mourning.
Could it be sad if he put colors in it?
Yes, but you'd have to use the right colors. If he used a bright red, it wouldn't look sad.

The generality with which Corey discusses colors is revealing. He speaks as if there were only one white, one black, one bright red, and only one way to use them. The expressiveness of color can hardly be more finely discriminated than the colors themselves.

In part, this is a matter of ignoring context. At stage two, colors are considered by themselves, as having their expressive character regardless of context. They do not change their character as they change context, anymore than black ceases to be the color of mourning if it is worn outdoors. An illustration of this comes from a conversation about the Albright with Charlotte, twelve years old. Charlotte sees perfectly well that Ida is ugly and unhappy, but believes that brighter colors would make the painting more pleasant:

(What do you think about the colors?)
Well, the colors really make it look gloomy. I mean, if there were more brights, it would make it look a lot happier.
Could you turn it into a happy painting by making the colors brighter?

Well, they wouldn't make it a totally happy painting, but it would make it better.

Charlotte knows bright colors make things happier, and can see no irony in her suggestion. This contrasts with our typical perception at stage three, where we often see, if not irony, at least inconsistency in the way Ida dresses. Ida's clothes are already too colorful for her situation, and the inconsistency would only be heightened by their being brighter. For example, Christina, seventeen years old, says:

> It's kind of like harsh reality dawns. It's pathetic, because she's wearing this pink silk thing and the high heel shoes, and she's just disgusting . . . What do you think of the colors?
> I like them, they add. I guess it's like a contrast between her horrible agedness and her pink thing, little shirt.

In summary, at stage two we see feelings in the people and the colors in paintings. They are more objectively located in these features of the painting than at stage one, because we have distinguished them from the feelings that we ourselves happen to have. They are there in the painting in the same kind of way that beauty and ugliness are, obviously and publicly. These feelings are interesting, but are not a dominant focus of the painting. They are subordinate to our interest in the subject matter.

THE TRANSITION FROM STAGE TWO TO THREE

Connecting the artist with the painting

The transition from stage two to three on this topic seems to be a lengthy one, and is related to our understanding of the artist's state of mind. At stage two we are aware of the artist. We know that where there is a painting, there must have been a painter. We also realize that artists have motives, reasons for painting, and that they have a choice of what to paint. But our understanding of these motives, reasons, and choices is rather general, and does not connect them with the character of particular paintings. For example, here are some typical answers from elementary school children to the question "Why do artists paint paintings?"

> Mostly because if there weren't paintings the world wouldn't look as pretty.
> To put it in a place to make it look nicer.
> It's their hobby, it's what they do. Maybe they like doing it. It's neat that they have the talent to do it.
> To be happy, to make money.
> Maybe he wanted to show other people about boxing.

Answers like these give an account of the practice of being an artist: They name motives for adopting the role. But they do not connect the state of mind of an artist with the particular character of her work. They do not relate the artist's motives to the expressiveness of her paintings. With these motives an artist could paint any painting.

The missing connection emerges at stage three. Beth came close to it above when she speculated that the artist must have disliked Ida: "If he thought much of her, why would he paint her to look as if she were dead?" She attempted to connect the unpleasant character of the subject with some negative feeling of the artist. But her attempt was stimulated more by the nastiness of the subject, and the difficulty of accounting for the artist's choosing it, than by a general awareness that artists express their feelings in paintings. Other than this kind of speculation, we find no talk of artists' expressive motives at stage two.

The question of the relation between the artist's state of mind and the character of a particular painting is for most people both interesting and puzzling. It has been a standard topic in criticism and philosophy. What can we tell about Renoir or Albright from their paintings? What sorts of feelings and attitudes did they have? How are their feelings reflected in their paintings? Most adults who are interested in the arts have thought about such questions. Consequently, there is a large vocabulary available in which to discuss it. It is not surprising that children pick up and use this vocabulary often before they understand it well. Late in stage two, we may use terms like "imagination," "originality," "inspiration," "expression." All of these are related at stage three to the artist's subjectivity. For example, "originality" means having some deeply felt feelings of a kind not imitated from others. But at stage two the artist's subjectivity has not become a reality for us. We have the words, but not the meanings; we do not use them to connect a particular state of mind of the artist with the particular expressiveness of a painting. We understand them in more behavioral terms. For example, "imagination" may mean picturing a scene fully in mind before painting it; "inspiration" is the suddenness with which we think of something to paint; and "originality" is picturing something that did not really happen, or does not exist. I will give one example here. Dexter, a twelve-year-old, said of the Bellows:

> (Would you say this is an original painting?)
> Yes. Because, well, I could paint some person in a boxing match, but I don't think I would ever paint someone falling into someone else's lap.
> What if that really happened in the fight? What if he really hit him out of the ring, and the artist is painting a picture of it?

Yeah, that would not be so original. It would just be painting the picture
as you remembered it.
Would it be original if he just painted it out of his head?
To be original, you have to make up something...

This is another case of the hospitality of our natural language that allows
us to reconstruct our ideas while continuing to use the same words.

Conceptions of expression

"Expression" is the most important of this group of words,
because it refers most directly to the connection between the artist's state
of mind and the character of the painting. There are many ways of
understanding it. In the following example, Denise, twelve years old,
uses it as she develops a list of the motives of artists:

(Why do you think artists paint paintings)?
Well, sometimes they do it to express, to let out their feelings, and
such.
Can you give me an example?
If they're angry, they do two people fighting, or something.
Uh-huh.
And to show their talent.
To show they can paint well?
And sometimes they do it just to experiment with things, like imaginary
pictures. Because they like creating things that aren't really how things
are.

Denise gives three motives here. The motive of showing that we can
paint well fits a stage two structure. The talk of experimenting sounds
more advanced, but we can see that Denise's notion of "imaginary"
paintings is very like Dexter's of originality: It means "creating things
that aren't really how things are." The most interesting motive is the
first: expression. How does Denise understand this?

On the one hand, the phrase "to let out their feeling" suggests the
widespread hydraulic-relief view of expression. According to this view
we build up feelings inside us and sometimes they have considerable
pressure behind them. Then we make a painting and in doing so let the
feeling out. This relieves the pressure. It is a common stage three image
of the expression of feelings.

On the other hand, the rest of the extract suggests a stage two version.
The example Denise gives is tied to the subject: "If they're angry, they
do two people fighting." It is an unconvincing example (was Bellows
angry when he painted Dempsey and Firpo?). It is unconvincing because
it ignores the way the subject is treated, and considers only what the

subject (in a stage two sense) is, as if, after all, expressing anger means picturing it. I conclude the example is at best transitional between stages two and three.

Dunstan, twelve years old, explains a similar understanding:

It gets out their feelings.
Gets out their feelings?
Yeah, in a way. If they're feeling sad and unhappy, they could make a picture of a sad and unhappy person. The reason they are unhappy, they will just sort of express it and that will help to get it out. And then another reason is that, like, if they're happy, they enjoy painting. So they like to paint certain subjects and certain things . . . Because I know I draw pictures – just drawings – but it's usually the mood I'm in that I draw the picture, like. Unless someone asks me to draw something. If you would ask me to draw an elephant's head, if I could then I'd draw an elephant's head. But sometimes if I'm mad and angry, I draw a dragon. If I'm happy, I'll draw a meadow with some flowers and all sorts of things.

Again the connection between mood and painting is determined by the subject alone. Dunstan does not acknowledge that the way we paint dragons and meadows can make a difference, though no doubt he would agree that it can be done more and less realistically. It is an extension of the logic discussed in Chapter 2, whereby the properties of the subject are transferred directly to the painting. A beautiful subject makes a painting beautiful, and in the same way an angry subject makes a painting angry. Nor does Dunstan see the expressiveness as particularly important. There are good paintings where there is no expression, as of the elephant's head. At stage three, we find such paintings empty. On the other hand, Dunstan does have a sense that artists make a choice of subject in light of their feelings, and that a painting somehow reflects something of the artist's state of mind. This is a basic constituent of a stage three understanding. Again, Dunstan's case appears transitional.

Conceptions of expression vary even when we see that there is more to it than the choice of subject. Most people appreciate expressiveness in art but are vague about how it works. On most stage three accounts, the artist has some strong feelings and puts them into the painting so we can see them there. Depending on the version, the artist may and may not experience some relief by expressing the feelings, and may have more or less control over the process. Sometimes it is more like losing one's temper, sometimes more like speaking an angry sentence. Here is one version, from Elizabeth, an undergraduate, discussing the Goya:

Artists are very sensitive for the most part. Emotionally, to start out with, and then aesthetically. They have a need to express their thoughts and feelings . . .

Does an artist have to have the kind of feeling that he paints?
I think at that point he has to; maybe not the whole time when he is
painting, or the whole time when he is arranging the formal aspects of
it. But in some way he has to empathize with these people to be able
to paint them.
He has to know what their feeling is?
Yes. To be extremely well done, he has to know it extremely well. It's
going to have to be throughout the whole painting.

What makes this a stage three reply is the perception that there is some
relation between the artist's sentiments and the expressiveness of the
painting. The one depends somehow on the other. This is not an easy
thing to explain, or even talk about. Most of us find it puzzling, some-
thing to wonder at, that paintings can express feelings. We realize that
we cannot picture feelings the way we picture things. How can we put
something internal like feelings into something concrete like a painting?
It is hard to explain. Were it not so, philosophers would not have worried
the topic so much. Philosophy is said to begin in wonder; it seems that
only at stage three do we begin to appreciate this particular problem.

It is true that Denise, above, was aware of a difficulty. She suggested
that we can get our angry feelings out by painting two men fighting.
Later in her interview, she says that the Albright shows feelings too, and
that this was difficult to do. But for her the difficulty was a technical,
and not a philosophical, problem. She said:

When I've painted feelings, I can't really show feelings in people's faces,
but always just happy and sad.
What do you mean?
Well, anyone can do a picture of someone, but they can't put into it
real-life feelings and stuff.
You mean like being really sad?
Some people can make the face look really sad, but he's sitting up
straight and tall and proud and everything.
Then what's he done here that's good?
Well, she's slumping, and her face – it looks like she is looking at herself
in the mirror disgusted or something.

Denise, it appears, is aware of the many nuances of gesture that reveal
emotions. This is an advance over stage one, where painting a sad person
seemed as easy as putting a grimace on a smile button. But the difficulty
remains at the level of realism: how to paint a thoroughly sad-looking
person. It is primarily a question of skill. Emotions are still attached to
persons and not to paintings, and are pictured more or less as people are
pictured. Denise does not yet see that emotions can be expressed in
paintings of tablecloths and handkerchieves and so for her there is no
wonder, though there is admiration. Admiration comes with the per-
ception of depicted beauty, wonder with the perception that expression

is not the same as depiction, and yet there is expression. Once the question arises, it is hard to answer and does not go away.

At times, we can see someone struggling with the question. For example, Flora, a thirteen-year-old girl, said:

> Perhaps he [i.e., the artist] is thinking the same way it looks when you look at it.

And, Frank, eighteen years old, said:

> When you have strong feelings on a subject, to express it would be to paint a painting to portray your feelings just the way you want them to be portrayed, straightforward, yet disguised in a way, so you have to look at it to see what he wants. He puts it down so other people can look at it and see part of him.

The problem Flora and Frank are struggling with here is a consequence of the new understanding of the expressiveness of paintings at stage three.

STAGE THREE

Subjectivity

We saw in Chapter 2 how this new understanding transforms our response to unpleasant subjects and to nonrealistic styles; and now we have seen it change our understanding of the artist's motives. In fact, it affects every aspect of our response to paintings. It is the central insight that constitutes stage three.

How do we conceive expressiveness at stage three? To begin with, it is subjectivity. Paintings are not about concrete objects so much as about what can be thought or felt and must be apprehended inwardly. They express aspects of experience, states of mind, meanings, emotions; subjective things. This is obvious to us, though we may be unclear exactly what kinds of things these are. Often, we call them feelings; often, ideas or points of view. We know there are many kinds of subjective things that art can express without having a clear conception of what they are. Gladys, seventeen years old, reveals some of this range when she talks about the Goya:

> (What do you think art should do?)
> I think it should put a point across, and I think you should get a feeling about it.
> A feeling?
> Yeah; there should be an aura about it, something, a feeling that permeates it, a mood overall.
> When you say "put a point across," what do you mean?
> I think it should be almost didactic. It's so different, because there's so

many different kinds of art or painting, like portraits. There are kinds
that don't teach you or have a point to them, like people wandering
round in a meadow, or something. There should be an overall subject.
But I can't generalize and say that all paintings should have something
incorporated in them that brings across a point. But there are certain
ones that do.
You are saying there are different kinds of paintings?
Well, they all have a certain mood about them, but you have your
pastoral scenes, and the feeling that's put across by them is peace and
kind of slow moving. In this painting you can see what's going to
happen next. It's tense.
You say that some paintings teach us something. Is this a painting like
that?
Well, not even teach. I think a more appropriate way of saying it is to
put across something. For people who've never been close to anything
violent, it's really dramatic, this painting, I mean.
So what is it putting across?
An emotion, an idea. It's obvious what it's putting across. It's just what
it is: death; people dying, and about to be killed. In the man that's
standing up, you can read the fatigue in his face. There's an essence
about the picture.

Gladys is clear that the important thing about a painting is something
subjective, but she struggles with a variety of ways of saying it. It is,
and is not, something didactic; it is a point, a feeling, an aura, a mood,
an emotion, an idea, and an essence. None of these kinds of things were
important to us at stage two; now they are the key to the painting. I
will use the words "feelings" and "ideas" interchangeably for the sorts
of things that Gladys has in mind.

The extract illustrates something else: that at stage three we can know
with some assurance when we have seen the point of a painting. Gladys,
in spite of not being sure what to call them, says that the feelings in the
Goya are obvious. "It's just what it is: death; people dying and about to
be killed." At stage three, we usually know when we have grasped the
meaning of a painting because to do so is to experience it for ourself.
The criterion of success lies within our own experience, and is available
to introspection. All we need do is to ask ourself whether we feel the
feelings. We can tell, without need of discussion, whether we have under-
stood the painting and therefore whether it is expressive. We have an
internal, nonverbal, and infallible sense of the painting's meaning.

This does not mean that we always understand a painting, nor that
we are unwilling to search for it. It means that, when we do understand
it, we are not in doubt. This is true even when we cannot articulate our
insight very well. The sense of this is captured well by the analogy of
sight. Either we see something or we don't, and we know which is

which. Sight is a kind of knowledge by acquaintance that is hard to put into verbal form. Another helpful image is that of an electrical circuit. I am not sure if we intend this when we speak of "connecting" with a painting, as we frequently do, but the image is a helpful one. It is as if the painting is an electrical connection between the artist and the viewer, and what is expressed runs like a current from the artist through the painting to the viewer. If the connection is good we might imagine a light being turned on in the viewer's mind. The point of both these images – of sight, and of electricity – is that what is expressed is a matter of individual insight, and need not be articulated. This raises questions about the possibility of being objective about what the painting expresses, a standard problem at stage three. Harriet, an undergraduate student, says:

> No, I think it's so – it's your human feelings. I think you can say: "This one has great brushstrokes." You can say these things, but when it comes right down to it, I think, from my point of view – I don't know critics that well – I think it finally boils down to just your gut reaction to the painting.
> Is that more an emotional than a cognitive thing?
> For me, it is. I don't know, I am not exposed to a great deal of art. So for me it is a total emotional reaction, which is my reaction to stories, or plays, or anything. If I can connect with it somehow emotionally, then I can go with it, and become one with it. But if there's no connection emotionally, I would – you know, it can be the greatest Picasso, and I, generally, with his abstract ones, I don't connect at all. And yet he is considered one of the greats. He is all this, but I don't connect with it emotionally.

Harriet's remark is characteristic, that it "finally boils down to just your gut reaction." A gut reaction is immediate, felt inwardly, and carries its own warrant of authenticity. We feel that it is genuine, and contrast it with the acceptance of the conventional, the inauthentic or phoney response, which is how a stage two reaction now appears to us. And because our gut reaction is directly felt, it stands in no need of analysis or talk. True, we have a sense that you can talk about technical and formal matters, but that is really of little help, and also may be phoney. As Harriet says, you can *say*, "This one has great brushstrokes," but it won't make much difference. The gut reaction will not be affected by remarks like that.

Where Harriet is not altogether representative of stage three is in her stress on the emotional aspects of expression. It is true that the words we use most at this stage are probably "feeling" and "emotion," and that a dominant flavor of our discussion is its feelingfulness. But it would be wrong to conclude that we speak this way only; it is about half the

story. There are many stage three responses of a more cognitive cast, in which we talk about messages, views, and points to be made. For example, Irvin, sixteen years old, says this about the Goya:

> (Is this the way you'd expect an artist to deal with war?)
> If it's an artist, it's about the only way they can express themselves. Like, if they're writers, they write articles about it, either for or against.
> What does "express" mean?
> They put their view across to other people. Like, this guy's saying he's more for freedom than for being cowed.
> What's his view in this picture?
> In my opinion, his view is pretty bad against Napoleon. He doesn't like him because he's having the peasants winning . . . [His view] would be definitely against Napoleon, because if he was for Napoleon he would have the army defeating the peasants.

Harriet and Irvin illustrate, I think, the points I have made so far: They understand the painting to be expressing something subjective, and they assume that we can easily enough tell when we have grasped it. They do, however, sound a little different. One stresses feelings, the other ideas; one is more emotional in approach, the other more cognitive. From some points of view this difference is important, but from a developmental point of view it is not. Whether we approach a painting in an emotional or a cognitive style seems to be more a matter of personality than of development. In either case, we have the same understanding of how paintings make sense, and it is this that constitutes stage three.

The individuality of expression

The quotations from Gladys, Harriet, and Irvin illustrate another feature of stage three, perhaps the most fundamental of all. It is that the meaning of a painting is conceived in individual terms. It is the conscious experience of some one person, what someone thought or felt on some occasion or over some small period of time. There are only two persons whose experience can determine the meaning in this way: the artist and the viewer. The meaning of the painting must be located somewhere between these two persons. They are the two poles by which we navigate the sea of expression, the North and South by which we orient our understanding.

The figure of the artist plays an important role in our thinking about a painting. She is the North Pole, the one we think of first. We have already seen how, with the new awareness of expression, we have a new conception of the artist's motives. Where at stage two she was a skilled craftsman trying to manipulate difficult material, now she is a consciousness trying to express itself, a subjective origin, choosing, designing,

intending the means of expression. It follows that to understand the painting is to grasp what the artist intended. Even in our most descriptive and unpuzzled moments, we may speak of the artist's intentions as a way of getting at what is actually in the painting. For example, in Chapter 2 we saw Naomi say of the Renoir: "He is depicting a relationship that is more than a person and an animal." In the same way, Jill, an undergraduate, says of the colors in the Chagall:

> I think he's used interesting colors. I think they must mean something. There's a purpose behind it. He's got such a vivid yellow, and yet all blues.

At stage two, Jill might have said: "The colors are pretty. There's a bright yellow, and all the blue." It happens that she was quite explicit about her tendency to think in terms of the artist's intentions. She was asked to describe how she looked at paintings like the Chagall. She said:

> When I first look at a painting like this, I just try and glance over it, and I immediately want to try and interpret it. I want to see what it is he is trying to say, and what is his purpose for painting it, 'cause I grew up that you have to have a purpose before you do something . . . I think there is . . . a part of me ultimately that wants to say why. Why that area, why did he do that, and why was that portrayed in that way? Perhaps that's what's been frustrating to me about these paintings. I always want an answer, and you don't find the answers except within yourself.

When Jill interprets a painting she asks herself what the artist meant. In her first two sentences above she virtually identifies the desire to interpret the painting with the desire to understand "what is his purpose for painting it." It is interesting that she realizes how frustrating this strategy must be in the end. Because the artist's intentions are subjective, we cannot see them in the same way we can see the yellow and the blue; we must reconstruct them for ourselves. And in order to do that, we must construct the significance of the yellow and the blue in the first place. Jill recognizes that "you don't find the answers except within yourself," even though she persists in looking for them within the artist.

At times, the thought of the artist's intentions allows us to believe that the painting has a subjective meaning even when we cannot grasp what it is. It amounts to a kind of faith in the artist. This can be helpful because we may persist in looking at the painting, searching for its meaning, when otherwise we would be tempted to pass on to something more meaningful (as we do at stage two). For example, Jessie, eighteen years old, could not quite see the point of the Albright, yet she persisted with it:

(What do you think the subject of the painting is?)
I don't know. She doesn't look very happy. She's sad with the way she
is, with what she's becoming . . .
Is she young or old?
She looks old, but I can't place any age on her though. The contrast –
her legs look just like a real old lady's legs would, but her face doesn't
look as old as she does.
There's an inconsistency?
Yeah, but I don't know what that would mean.
Is it a good subject for a painting?
Yeah, because I think it's something you could expound upon that you
can just show the way the feeling's going.
Do you see feelings associated with aging?
Yeah, and she's just trying to fit into her past, or something. Her outfit
looks like she was a showgirl, or in the circus, or something. Maybe
she's realizing that she can't be that way anymore, but she's dressed up
anyway.
Why did the painter do this?
I don't know. I don't have any idea.
Then why do you think it's a good painting?
'Cause it puts a definite emotion across, and just because I don't like it
doesn't mean that some other people – I mean it's got some valid – it's
got some good thought behind it in the drawing and stuff.
What stuff?
The coloring, and the idea that it's putting across. But it doesn't par-
ticularly appeal to me. But it might to other people.

Jessie seems to think that the Albright is a good painting, partly because
of the drawing and coloring (i.e., the realism), but more because of the
"idea it's putting across." This is in spite of the fact that she thinks she
does not understand this idea. She is willing to believe that there is a
"definite emotion" there, though she does not know what it is. And she
says it is a good subject because "it's something you [i.e., the artist]
could expound upon that you can just show the way the feeling's going."
This seems to mean that it is a good vehicle for the theme, whatever it
is. In fact, Jessie comes close to articulating the theme; but she has a sense
that she is not properly connecting with the painting. The light has not
gone on in her head, though she continues to think that there is one to
be switched on.

Interpretation

At stage three we have a new awareness of the artist, and often
think of the expressiveness of a painting in terms of the artist's state of
mind. It takes time to coordinate this idea with its reciprocal: that a

painting must be reconstructed in the mind of the viewer. The North Pole implies a South Pole, though it takes time to see that. The subjectivity of the artist implies the subjectivity of the viewer. This insight completes the basic structure of stage three, which consists of the dyadic relation between the artist and the viewer, mediated by the painting. The following is from a conversation with Kathy, an undergraduate:

> (Why do artists paint paintings?)
> I've heard, and it makes sense to me, that they paint to express something; express dreams, explore fantasies. That probably makes the most sense to me that I've heard. Certain composers compose for the money. That makes sense to me, and is more real to me. I'd rather think that they paint to express something, and cause some feeling. That would be my wish.
> Is it possible to paint a painting that is expressive without having a deep need to do that?
> I would think it wouldn't be real, genuine.
> Can you tell that from the painting?
> I don't think, I don't think it would be [genuine], if the artist was just painting to just put something on the canvas. I tend to see through things like that. I don't have a trained eye [and] I wouldn't know for sure whether it was intentional [i.e., genuine] on a how-it-was-done point of view. [But] from an inner sense of myself I would know the artist wasn't trying to express; I couldn't relate to it anyway.
> You are saying you can tell by looking at the painting whether it's honest?
> Kind of an inner feeling about it.

The reciprocal character of the artist's and the viewer's roles is clear in this extract. There is the artist on one side of the painting, and the viewer on the other. They mirror each other. Each must experience the feelings that constitute the expressiveness of the painting. This idea is captured on the one side by the use of words like "real," "genuine," and "honest"; and on the other side by the idea of "an inner feeling." On the artist's side, the painting is expressive if the artist actually felt some emotion that she put into the painting. The alternative is that she is being conventional, insincere, faking it for the money. This latter Kathy wishes not to happen. And the artist knows which is true, whether or not she is genuinely having the feelings that she is trying to express.

On the other side of the painting, the situation is much the same. Either we genuinely experience the expressiveness of the painting, or we don't. And we too can tell from an inner sense, as Kathy says, from "kind of an inner feeling." This inner sense is another form of the gut reaction we met earlier. In both cases the meaning of the painting has turned inward. It has left the public space of the picture for the private

experience of the viewer, or the artist. In one sense, of course, it always was there. At stage three we have become aware of what always was the case: that we must grasp the meaning of the painting in our own subjectivity. Becoming aware of this is a major achievement, for it means becoming aware of ourself having the experience of responding to a painting. Behind the inner feeling and the gut reaction there is now a spectator watching: ourself. Where there was once only a response, there is now both a response and a self observing the response. This reflexive movement is of the greatest importance. It is a paradigm case of what is involved in cognitive development in general, one of those many successive steps of increased awareness by which we gain our freedom from the accidental and the idiosyncratic. Previously we had experience and, not being aware of it, we *were* our experience. We were virtually controlled by whatever happened to present itself in experience. Now we can make experience itself the object of attention. We can ask ourself what kind of experience we are having and what its point is. When we realize that the value of art has to do with the honesty of emotions, and not with the truth of realism or the goodness of morality, we prize expressiveness all the more. We can distinguish between these realms of meaning more clearly and respond more relevantly than before.

We realize, then, that the activity of the viewer is inevitably central in interpretation. Its importance can come to swamp that of the artist. Perhaps we need to imagine the artist in order to conceive the subjectivity of expression; but we do not need to continue doing so. Once we become aware of the viewer's own interpretive activity, the artist can be neglected. Kathy speaks of the relation between the artist and the viewer as if it were a balance: They stand on each side of the painting, mirroring each other's subjectivity. But it is not a stable balance, and it may tip either way. Either the artist or the viewer may outweigh the other in interpretive importance. I will give an example of both extremes.

Suppose we are impressed by a painting but do not quite understand it. What are we to think? We saw Jessie in this situation. Jessie, we may remember, thought the Albright was a good painting, although she didn't understand it, and didn't like it. She said:

> It [the subject] is something you [the artist] could expound upon that you can just show the way the feeling's going.

The fact that Jessie did not understand the painting was no bar to judging it good; it was sufficient that the artist understood it. If we pushed this logic just a little further, we could say that the viewer's response is not really relevant to judgment, because what matters is whether the artist is satisfied. If the purpose of painting is to let the artist's feelings out, it

does not really matter whether someone on the other side lets them in. Art then is more like therapy than communication, and the image of the artist has eliminated that of the viewer.

The opposite view is also possible: that it does not matter what the artist intended, for what counts is only the viewer's experience. Come to think of it, that is all the viewer has available anyway: his own experience in response to the painting. Even if we want to consider what the artist intended, we must first reconstruct it in light of our own experience of the painting. We saw Jill earlier reaching this conclusion.

Of course, coming to think of it is not easy; it is one of the central insights of stage three. Once we have done so, though, we can think of something else: that different people may have different experiences of the same painting. And each experience will make sense to the one who entertains it. People are individual subjectivities, each with their own experience and history, and they may have different states of mind when they look at the Albright. These states of mind have a validity that they did not have at stage two, because we now see them as genuine, i.e., as subjectively experienced. Each is a genuine, and therefore valid, response to the painting insofar as it is really felt by some person in his own experience. And why should a response that coincides with that of the artist have preference over one that does not, if both are genuine?

We can see Lewis, an undergraduate, working through this logic in the following exchange:

> (You say he wants other people to get what he is trying to say. Then in a way the success of a painting depends on whether people can get what he is trying to say?)
> Well, not necessarily success. But, like, the artist, the reason he painted it is he just wanted to. He likes to paint, and he wanted to get his thoughts and feelings on paper, and, you know, that's the most important thing. And, like, another thing, I would imagine an artist would like people to look at his picture and see, like, what the artist is trying to say. But they might not. They might see something he didn't think of. But that doesn't necessarily mean it's wrong. Like, that person's view could be just as important as the artist's.
> So even if the artist had something in mind, you couldn't say that someone else's view of it was wrong?
> Yeah. The artist knows what he's trying to say, and he's painted it out. That's what's important to him. But, like, a person that sees it, he sees something completely different, you know, really meaningful to him. His point of view is going to be just as important as the artist's.

In short, the mind of the artist can be a guide to the meaning of the painting, but it can also be replaced by the viewer's experience. Which is more important depends on whose experience we are more interested in. And at stage three we tend to be very interested in our own experience.

The central question about the painting – i.e., what expressive qualities does the painting have? – easily becomes a question about our experience – i.e., what feelings do I have as I look at the painting? We may appear to be as interested in the character of our own feelings as in that of the painting. I do not want to exaggerate this point. Not every adolescent is preoccupied with his own feelings, and certainly no one is all of the time. But at stage three we cannot be sure of the difference between an interest in the painting and an interest in our feelings. This lends a flavor of self-preoccupation to our discussions at times, especially of paintings like the Albright and the Goya. They are powerful, emotional, somewhat difficult works, and we have to struggle at times to control the thoughts and feelings they arouse. For example, Mavis, eighteen years old, says of the Albright:

> It tries to put across the thing with beauty, and it's all so superficial. You get old, and it's putting across the pointlessness of the whole looks thing, the obsession with beauty . . . I admire the painter, if that's what he was trying to put across, for seeing through that, because it's hard for people to do. I mean, they know it. But everyone is as guilty as the next person, as being vain or concerned about how people look . . . I like it a lot, I really do. It's depressing, but that's also something that I'm obsessed with, the fact that people are so superficial and materialistic. And I'm not exempt from that. But I catch myself being that way, and it frustrates me, and this just illustrates it again.
> Is it a good painting?
> Yeah, I like it . . . more than any other. It's closer, more intimate. I can imagine myself maybe looking like that. I just wouldn't want to feel like I've lost everything when my looks went.

Passages like this illustrate a tendency to identify with the painting, leaving little distance between its meaning and our response. We read our own feelings into the painting. There is a self-revealing and personal flavor, more varied and freewheeling, a response in this respect more like stage one than two. But it is not that we have traveled in a circle, and have arrived back where we began. For we are now reflectively aware of what we are doing – i.e., looking at a painting – and we know that there is a difference between talking about the painting and talking about ourselves. It is just that we cannot be sure which is which. To be clearer we would need some way of checking the relevance of our feelings against something else, another criterion of its meaning in addition to our own response.

 We are only vaguely aware of what this other criterion might be. We think of it as the "technical side" of paintings that "experts" talk about. We know that the technical side exists and that experts base judgments upon it, but we have little sense of its meaningfulness. Sometimes we

wish we could see the point of such talk, and distrust our own feelings where they conflict with expert opinion. Perhaps more often we dismiss this side of things. As Harriet said above, you can say things like "This one has great brushstrokes," but it doesn't make much difference. Our feelings give us a more genuine access to the painting's expression than does the talk of experts. A nice example of this idea, coupled with a knowing sense of irony, comes from a review of a Bellows boxing painting. The sports column in the *Times-Herald* in New York carried the following in March, 1947:

> If you're a fight fan it's worth visiting the National Gallery of Art just to see George Bellows' painting. Never been anything like it done in oils and you'll get a kick out of its brutal contrast to the long-hair arty stuff hung near it.

STAGE FOUR

The corrigibility of interpretation

A principal achievement of stage three is to become aware of our subjective activity as a viewer. But we construe this activity more as direct insight than as discursive construction, and more as a private than a communal affair. This suggests our main achievement at stage four: the further insight that interpretation requires a dialog in the context of a community of viewers. I will discuss two aspects of this insight separately, though they are related: the discursive character of interpretation, and the public world in which it takes place.

At every stage we interpret paintings. But at stages one and two we are not aware of this; we are aware only of seeing the painting. At stages three and four we are aware of interpretation, and the awareness changes the way we do it. The difference between stages three and four is that at the first we are aware of our subjective activity but not of its corrigibility. We are impressed by the genuineness of our own gut reactions and have no further questions about their accuracy. At stage four we realize that we can check interpretations against the facts of the painting, and that the comments of others are helpful in doing this. Interpretation becomes the attempt to relate together different views of a painting, and to make a whole of its various elements. Gadamer has famously described this latter aspect of interpretation in connection with language. What he says seems appropriate here:

> The process of interpretation itself has a hypothetical and circular character. From the perspectives available to him, the interpreter makes a preliminary projection of the sense of the text as a whole. With further

penetration into the details of his material, the preliminary projection is revised, alternative proposals are considered, and new projections are tested. This hypothetico-circular process of understanding the parts in terms of a projected sense of the whole, and revising the latter in the light of a close investigation of the parts, has as its goal the achieving of a unity of sense: an interpretation of the whole into which our detailed knowledge of the parts can be integrated without violence. (Gadamer, 1975, p.172)

This passage can be applied to the interpretation of paintings as well as of texts. We make a projection of the meaning of the painting, and look at the "details of the material," which include both the subject and the elements of the medium, such as the colors, lines, shapes, forms. We go back and forth between all these as we interpret the painting. We have seen this happening in some earlier passages, but not yet as self-aware process. This awareness comes at stage four.

In the passages quoted so far we have seen the expressiveness of the painting related to the subject and the color. Rarely at stage three is expressiveness related to other elements of the medium, such as the character of lines, texture, shapes, form. At stage three we do not find these relationships meaningful. The result is that our interpretive effort is partial: We focus on the subject and the color, but not on the medium itself, the "technical side" of things. I will give one example of this, for the sake of the contrast with stage four. Nan, an undergraduate, is puzzled by the Chagall. She connects its meaning with the subject, but, in spite of being pushed to do so, cannot easily connect it with other aspects of the painting. She says:

> It's kind of frantic. You go to a circus and you never relax. You are always kind of kept on the edge of your seat with the different activities, and I think that is what he is showing here. Like, you feel that level of energy you feel at a circus . . .
> Where do you see that?
> I pick up different feelings with different – there's parts of it I don't understand. I don't know what he is trying to portray up here [the hands], or what he wants us to think of. But I feel in this area, the dancers, the acrobats, he has shown that. But with this figure, I don't know what he is trying to say with that . . .
> What about this guy here with his head off?
> It's interesting that's right in the center. That's where my eyes keep going, wondering why he is beheaded. Meaning it's just some magical trick, or he's depicting the area of the circus. I don't understand it.
> Do you think he is trying to say something with it?
> That's a hard one. I'm kind of split down the middle on that one. I kind of think he must be trying to say something, because he is so definite in the abstractions he has done, the violin not really being a violin, the two-body person. You almost feel like he's trying to say

something about this floating kind of head and hands above the crowd. I would say that he's trying to say something, but I couldn't put guesses to what he is trying to say.

In the first paragraph Nan seems to understand the painting quite well, and yet continues to be puzzled by many of the details. She thinks of these details as items of subject matter: "this figure," "a violin," "the two-body person." She tries to make sense of them in those terms. She does not consider aspects of form or medium, except in the one remark that the "guy with the head off" is in the center. This fact is interesting but she does not make it significant. There is no other mention of the paint, the color, the texture, or the formal relations.

There is also no sense of how to proceed when puzzled, or what to look for. It is as if Nan is aware of the hypothetical part of the circular process described by Gadamer – that one needs to "put guesses" to the painting: but not of the complementary activity of checking one's guesses against the facts – of "revising the [guess] in the light of a close investigation of the parts." Nan does investigate the parts, but they are only subject matter parts (and, at other times in the interview, colors). It is as if the form and medium are not relevant to the meaning of the whole.

It is different at stage four. Olive, a graduate student in art, also discussed the Chagall. Notice the kinds of things she points to in the following:

> Chagall tried to deny the reality of his own life. He was Jewish and persecuted, so he created all these fantastic, childlike images. That's what he's doing here. It's sort of a fantastic, imaginative world. There's no sense of cohesiveness. It's scattered all over the picture plane. But it's not lost all sense of organization. I think there's some consideration of it here, because you tend to follow around, and the bigger figures are grouped in the middle, and the more intense colors are concentrated there. There's a surface kind of energy that implies action, and a bustling business. There's lots of things going on. I think the whole thing is organized around this figure balancing his head and balancing the painting at the same time, and there's all these little figures floating around it. It's pure fantasy, an inner fantasy; it's an image that's entirely personal, a personal statement, an escape from reality... And see here, this makes a nice triangle, this here with these three large figures. But it's a triangle that's out of balance because it's standing on its point. The base is up there. It's interesting. It creates a lot of movement.

In one sense, Olive reaches the same conclusion as Nan about what the Chagall expresses – the movement and energy, the fantastic world of the circus. But she sees this energy in different kinds of things. Like Nan but more briefly, she notes items of subject matter: "all these fantastic, childlike images." But their arrangement on the canvas is much more significant than their exact character. She notes not what the figures are

but how they are grouped – in the middle, in an inverted triangle – and the relation of this to the sense of the whole – it creates a sense of being precariously in balance. In short, she attends more to the organization and the fantastic style. Such things have qualities of their own that are related to the meaning of the painting as a whole. This attention to these kinds of facts, this completion of the hermeneutic circle, is characteristic of stage four.

The "close investigation of the parts" continues to be interesting even after we have understood the sense of the whole because that understanding is never wholly finished. As each detail is reconstructed and made intelligible in light of the whole, it offers in turn the opportunity of revising our understanding of the whole. Interpretation is no longer an all-or-nothing affair, a matter of reaching the one insight that illuminates everything. It is a series of insights that continue to complement and modify each other, and have no obvious end. If the painting were rich enough, we could go around forever in the hermeneutic circle, reinterpreting its significance and enriching our experience of it.

The publicity of the painting

These newly significant aspects of the painting have an obvious public character. They can be seen by anyone. They are actual parts of the painting, and their arrangement on the canvas is a matter of fact. Such things may not be noticed by everyone, but they could be. They are completely accessible; they can be pointed to, described, compared, analyzed. They are a part of the world out there on the canvas, and we can help each other see them by talking about them. As we do so, the meanings that once were only subjective become intersubjective, what once was private becomes public. The significance of the painting is no longer just the content of an individual consciousness, whether artist or viewer. It must be subjectively grasped, but it is not restricted to the subjectivity of any one person. Instead it is constituted by our collective understanding of the actual qualities of the painting. This collective understanding is no one person's property. Like the meaning of words in a language, it is a public affair, independent of any one person.

The following illustrates how expression depends on the medium at stage four, and its public character. Pamela, a graduate student in art, says of the *Weeping Woman*:

> (What about its expressive character?)
> Well, it's very emotional, and it's obvious. The lines, look at those tight lines, the fingers, the clenching, and the woman tearing her teeth out with that, the angles, I think the angles, the straightness, just those lines. It's amazing you can do something so simple to get that tension

in there, in those lines, the pulling on the handkerchief, the feeling in these hands – give that tension and anguish.

Pamela refers to many details here. She points to them with both gestures and words, as did Olive in the piece previously quoted. Pointing is of course an invitation to see for ourselves, and presupposes the publicity of what is pointed to. Pamela points particularly to the lines, and relates them directly to the expressiveness of the whole: the tight lines, their straightness, the angles, their tension; as well as indirectly via the subject matter: the clenching, the pulling on the handkerchief. The expressiveness can be seen in the lines themselves as much as in the subject matter. This, she says, is obvious. She means, presumably, that anybody can see it, that it lies on the surface to be seen. Our sense of what is obvious has changed. We may remember that what was obvious at stage two was, often enough, that the hands in the *Weeping Woman* were not much like real hands. At stage three what was obvious was the sense of anguish present in the subject but not in the lines. For example, in the previous section we saw Gladys make a claim about what was obvious in the Goya:

> It's obvious what it's putting across. It's just what it is: death, people dying and about to be killed. In the man that's standing up you can read the fatigue in his face.

The basic proof that the sorts of things that Pamela points to are truly obvious – visible to anyone – is the very practice of pointing and describing that she engages in. She points and says things, and is understood. Others say them and she understands. What better proof of intersubjectivity could there be? The continuing practice of dialog of this sort – what in general we could call critical discussion – presupposes and also ensures the meaningfulness of the kinds of things pointed to. But one must join the conversation to find it meaningful.

Another proof – but it is really the same one – is that, as we talk about them, we continue to see more in paintings. Others point to new details, establish new relationships, suggest new interpretations, and a work becomes richer. This suggests that the significance of a painting, if it is at all complex, is more than the conscious content of our mind at any one time. It is rather what can be publicly articulated in a discursive and serial way, and is always subject to change in light of what others may say later.

The second point, then, is that, as we look at a painting, we presuppose the company of others who are also looking at it. We are imaginatively one of a group who discuss the painting because they see the same details, and can help each other to understand them. The painting exists not between the two individual poles of the artist and the viewer but in the

midst of an indefinite group of persons who are continually reconstructing it – a community of viewers. Its significance is constituted by the discussion of a community of which one is now oneself a member. As Michael Oakeshott said somewhere, a cultural tradition is like a "great conversation" constituted by the writings of artists and philosophers who have been talking to each other across the centuries. This conversation can be joined by whoever is willing to listen to it.

The community includes the artist herself. The role of the artist acquires more stability but loses some drama when we see the painting in the midst of a conversation. At stage three, the artist was sometimes the principal dictator of the painting's meaning; and sometimes she was banished as irrelevant to the sovereign consciousness of the viewer. Now neither alternative makes much sense. On the one hand, the artist cannot determine a painting's significance simply by intending it. We cannot always do things the way we intend to do them. She may have done more, less, or differently, than she intended. After it is done, she can be no more than one of the group that is discussing the painting. She can add her insights, but can be corrected by others. On the other hand, she is herself part of the public tradition within which we interpret the painting's meaning. The more important the artist, the more this is so. Consequently the facts about the artist, including things like her training, the styles she was affected by, her ideas about art and life, are part of what we use to interpret the painting. Her intentions are helpful, therefore, not as determining its meaning, but as part of the context of interpretation. A simple example is the remark about Chagall by Olive in the extract quoted above: that he used his painting as a fantasy to escape the harsh reality of his early life. This remark helps to establish, though it does not determine, Olive's interpretation.

Other members of the community from whom we can learn are critics, art historians, teachers, connoisseurs. There is an indefinite number of persons who have studied art and whose opinion is worth taking seriously. At stage four it is reasonable to be guided by what they say and by the tradition that they embody. This is not now a form of domination by outside influences; it is listening to the great conversation.

The next chapter, which is on the medium, form, and style, discusses the stage four structure of understanding at greater length. For these are the topics that have freshly come into focus at stage four, just as expression did at stage three.

4

THE MEDIUM, FORM, AND STYLE

This chapter discusses our understanding of the medium of paintings, i.e., what they are made of. The medium is the stuff the artist works with and what the viewer looks at. With paintings, it is primarily the paint; sometimes it is the canvas as well, or, with watercolors or prints, the paper. Such things have qualities of their own, and these qualities are part of a successful work. The most obvious examples are the beauty of color and the sensuousness of texture, which many paintings exploit, though others eschew such obviousness.

The medium of painting is not a means to an end. A means disappears or is of little importance once the end is reached. But in a painting the paint is exactly what appears and is important. The medium is not something distinguishable from the painting as a means is distinguishable from an end; it *is* the painting, what we look at. And all the qualities of the painting must ultimately be qualities arising from the medium.

The medium is concrete, some particular stuff, an actual color, a line, a texture. We could say that each individual detail of this sort is an element of the medium. But such elements do not exist in isolation; as we look at them on the canvas, they combine to make form. Form consists in the relation between the elements of the medium: their juxtapositions, contrasts, variations, repetitions. It is not always easy to decide when to speak of elements and when of forms, but fortunately it is not a crucial question. Form and element are interdependent concepts, like large and small; one can hardly have one without the other. A color, for example, must be laid next to another, and immediately we have differences and similarities of hue, tone, and intensity; in a word, variation. We also have shape, well-defined or not, and composition.

Form – elements-in-arrangement – is found at the micro- and the macrolevel, and at all levels in between. At the macrolevel, it is composition: the webbed, radiating lines of the *Weeping Woman*, for example, or the organized scatter of the Chagall. At the microlevel, it is texture:

86

the brushstrokes of the Renoir, the lumpiness of the Albright. And at all levels form possesses qualities of its own, qualities which are in addition to those of the elements considered by themselves; and these qualities are also qualities of the painting. For example, there is the centered, full-front circle of the Klee, which we will see described as "confrontational." There is also its texture; for example, in the top left hand corner where a warm orange overlays a pale lavender, of which Karen will say: "It doesn't exactly sing, it doesn't vibrate; it has an active quality because of the way he's handled the surface."

It is not surprising, therefore, that at the later stages we pay close attention to the qualities of the medium and forms of a painting; these are literally the qualities that constitute the painting. The character of this attention is developmentally new, because our understanding of the medium is new. At stage two we tried to look through the medium, thinking the painting consists in its subject matter. At stage three we looked at the medium mostly as a means of expression, thinking the painting consists of emotions and ideas. At stage four we look at the medium itself and its qualities, attending to it, so to speak, for its own sake – which is also the painting's sake – understanding that the painting consists in just those qualities.

The chief exception to this brief summary has to do with our response to color. At every stage we love color for its sensuous beauty, in and of itself. I discussed our response to color in Chapter 1. There is, however, a difference between that early romance and our later one, the difference between color seen as an element and as form. Early, we see colors as individual beauties, complete in themselves; later, as set in contexts that are rich, complex, and meaningful. An example is the contrast between Cathy's description in Chapter 1 of the orange in the Klee as her favorite color, and Karen's description of it just referred to. The former represents an isolated pleasure, the latter is integrated into the context of the painting as a whole.

At the same time that we see the medium as concrete material with its own objective qualities, we also see it in its social context. A painting is significant because it is related to other paintings and to ideas about paintings. It exists in what is sometimes called the "artworld" – a convenient phrase for that community of viewers whose conversation creates and keeps alive the significance we find in paintings. And these relationships, social, historical, and ideological, are as public as those that we see in the medium itself.

One way to speak about the relationships between paintings and paintings, and paintings and ideas, is in terms of style. A style is basically what two or more paintings share in a significant way. A knowledge of styles helps us see relationships between paintings and to make these

relationships significant. The perception of style is often thought to be a mark of sensitivity to paintings, and is a common educational objective. At stage four, we can hardly respond to a painting without considering questions of style, for to do so is just to see it in an art world context and to bear that context in mind when interpreting it. Style is an important concept developmentally, closely related to form and medium, and it is much used in the later stages. At stage two, we typically conceive of style as realistic representation, and everything else as simply what people, rather mysteriously, do; which is to say that we understand the context of art as essentially nonsubjective. At stage three we conceive style as what is characteristic of a personality, or else, rather mysteriously, as technique; which is to say that we understand the context as subjective but nonhistorical. At stage four, style is characteristic of an attitude held in a time and place. This is to say that the context is cultural; it is the greater community in which the painting exists, a public space bigger than the horizons of any individual subjectivity. Style, we could say, is that cluster of qualities of medium and form which this context makes publicly significant.

STAGE TWO

Difficulty and skill

Earlier we saw that form is understood at stage two primarily as a function of the subject: that we appreciate form insofar as it contributes to realistic representation. There are two points to add to this; both also take their meaning from the notion of realism.

The first point has to do with the ideas of difficulty and of skill. At stage two, we have a growing appreciation of the difficulties involved in making a painting; and especially of the difficulties of making accurate depictions. Painting takes care, manipulative skill, and patience. This appreciation shapes our first understanding of the interaction of the artist and the medium. The medium is recalcitrant stuff, the work is difficult, and the artist must be skilled and patient.

Consequently, the idea of mistakes is common. Andrew, a kindergartner, said of the Bellows:

> (Was this painting hard to do?)
> Yes.
> What would be hard to do?
> Painting it without going out of the lines, not doing a mistake.

Another kindergartner noticed the headless figure in the Chagall, and thought it was a mistake:

Look, it has, like, the face away from the body.
Why do you think that head's not on the body?
I don't know. Maybe he forgot to make a man.

Similarly, Annette, nine years old, suspected that mistakes may lurk anywhere. She says:

(If you were in charge of a museum and had to buy paintings for it, and you had a whole bunch to choose from, how would you decide what to buy?)
Well, I would get up very close to them, and look at them with my magnifying glass, and if I found any mistakes I wouldn't buy them.

Another nine-year-old child condemned all sloppy paintings because you can never be sure the sloppiness isn't the result of making mistakes:

(How can you tell if a painting is good or not?)
Well, some of them are sloppy and they go all over the place.
What if the artist meant them to be sloppy?
Well, I wouldn't know about that.
So, if it's sloppy, you don't think it's a good painting?
Right.

Because we see painting as difficult, we admire the ability to do it well. The more difficult the painting, the more we admire it. In general, we may say that at stage two we admire aspects of medium and form insofar as they are difficult to manage, and when it is clear that they took a good deal of time, care, or control – so long as they contribute to the representation. Annette, for example, admires the brushstrokes in the Renoir because of their tininess. The flowers catch her attention:

(Would this be hard to paint?)
Yes, 'cause everything's so little, you can't get in there, and it would be really hard.
Because everything's so tiny?
Yes, and like right here, that's just little, and there are two different colors right in there.

By these criteria the Klee and the Picassos do not do very well, and the Bellows, the Renoir, and the Albright are much admired. For example, an eleven-year-old girl said of the Bellows:

It's a good painting.
What makes it good?
The faces. I could never do faces. It looks like a real face. And the ropes. It's just a neat painting; I like it.

An example of the same point with respect to form comes from Andrew, ten years old:

(Do you think it's well arranged, the way he put it together?)
Yes, because people aren't going over other people. This person isn't going over that one.

You think it's a good painting?

Yes, it looks like it took a lot of time to organize it, to decide where to put everything, and what colors to use.

In short, we understand the artist's interaction with the medium as the difficult exercise of control. The problems that confront the artist are the universal problems of getting the medium to behave correctly, i.e., so that the painting will be realistic.

Modern art

My second point has to do with how we understand paintings that are not realistic. At first we understand them to be due to mistakes or to the difficulties of being realistic. But we cannot long persist with this view. In cases like the Klee, Chagall, and Picasso, we come to see that their deviation from realistic standards is deliberate. We tend to lump all such paintings together, and call them "abstract" or "modern," a category constructed by contrast with realism, defined in terms of what it is not. For example, Bernard, thirteen years old, says:

(What do you mean when you say abstract?)

Abstract is that it's not all put together. It's all cut apart and there's different pieces of everything in there. When I think of nonabstract I think of orderly, put together in one piece, something you can identify. And I really can't identify that [the *Guernica*] with anything that I've seen before.

The question is, then, how at stage two we understand such paintings. If the purpose of painting is to show us things, what sense can we make of "abstract" paintings?

Sometimes it seems we do not understand them at all. We see them as wilful but purposeless activity. For example, Boyd, twelve years old, became somewhat indignant about it. He said:

(Are there any subjects that are not good for art?)

Oh, I don't know; I don't think so. I think most things are art. The one thing that I don't like, personally, I don't like just scribble for a painting, like Modern Art.

You don't like Modern Art?

No, I think they scribble all over the painting, things like that. In other pictures, they take longer, and the person who does it has to really think like a real artist, not just someone scribbling on a paper . . . Sometimes art is, I don't think art.

What kinds are they?

Well, like I said, Modern Art. All it is is just splattering paint on a piece of board, or scribbling with a pencil. I mean, anybody can do it. And there's no artistic form.

Tell me about that a little.

It's not like you have to draw a human being, or something that actually requires skill. I mean, like, in Modern Art they don't say: "Well, I'm going to draw a person with a table . . . sitting in a chair doing this." They don't have a pattern, and say: "Well, today I think I'm going to put this line here and this line there; and I'll make this line curved." They just sort of say: "Oh well, let's just scribble."
They just sort of scribble, huh?
Yeah, it's just whatever comes out. Now, I know some people like that sort of art, but I personally don't.

There are a variety of more sympathetic responses to abstract art, but none of them are very complimentary. One is that we paint them because they are easier. An abstract painting may be a good painting, and it may be hard to do, but it is easier to paint than a realistic one. The reason is that the details don't much matter, because they won't be noticed. Moreover, mistakes can't be detected. If you do make a mistake, you can even go on making the same kind of mistake and it will be thought part of the abstraction. In general, you do not need the time, care, or control to get things right as with a realistic work. For example, Chagall may not have had much time, or didn't want to spend it, for *Circus*. Bruce, a ten-year-old boy, said:

(Is there a way to tell which are good paintings?)
The neatest ones.
The ones done most carefully?
Yes. I'd ask him what he is trying to paint. Because it depends if it was just a sloppy picture he didn't want to spend much time on, or whether he spent hours and hours on it. If I just slopped a picture together something like this [the Chagall], and someone else could have taken years on that [the Bellows].

Another thought is that perhaps no model was available to paint from. If the artist has no model, she is forced to omit detail, because she can get it accurately only from reality. The Klee is an obvious candidate for this explanation. As an eleven-year-old girl said:

(Why do painters choose to use an abstract style rather than painting realistically?)
If I didn't have something to look at, it would probably become an abstract, because I couldn't do any better. That may be a reason for some people.

A different kind of reason for going abstract is more positive: It can soften the emotional impact of difficult subject matters. In paintings of wars or weeping women, too much realism might be offensive. It might reveal such subjects too clearly, and we know that they are unpleasant in paintings. If the artist must take them on, it is best to suggest them without being too explicit. This will make them more tolerable. For example, Brian, eleven years old, said of the *Guernica*:

If all these people had regular faces, it would look too violent. It would just look too violent. I know it is violent, but if their faces were reaalistic it would look very real.
And that would be worse?
Yes.

A third kind of reason for painting abstract works is the desire to be different, and so to attract attention. Bradley, twelve years old, said of the Klee:

[It's] different colors all over the place making up a good picture. They are just staring at you. They are just blocks. They are not anything in particular. They are just there . . . I think it is a very original thing.
Is it good to be original?
Yes, it is very good. Because if you go along, you see lots of things. But if you see something ordinary you just pass it by. You see it everyday and it's not exciting. But if you see something unordinary, you stop to examine it, to see what it's all about . . .
What do you mean by original?
I think a lot of painters want to be famous, they want to be original. [For instance], if you take a field and paint it purple, it's just there. But if you put green and blend things together, then it looks natural . . .

Clearly Bradley has a sense that Klee's style – of colors "just staring at you" – is a deliberate departure from realism, and is different in a positive way. He suggests that it is interesting, almost that it is exciting, and seems to feel some of its appeal. But he has no way to understand this, cannot get beyond the fact of difference to what makes the difference valuable. In this way he is like others I have quoted. He is using language – in this case, "original" – that has more meaning at stages three and four, but uses a stage two structure to understand it. He knows that abstraction is often deliberate, and can be good; but he has no insight into how it is good, no way of understanding why it might be preferred to realism.

In short, abstract art is not well understood at stage two. It is considered primarily in contrast to what is understood: realistic art. Even when we do notice the formal features of abstract paintings, they have little significance for us.

Many of these points are illustrated in a conversation with Connie, twelve years old. For example, in discussing the Klee, she notices a number of formal features without prompting and labels them "abstract":

(What do you think of the way it's painted?)
It's abstract, not very real. The eyes are sort of at an angle . . . This eyebrow is curved and this one is pointed. This eye is up and this eye is down. This is with that. That goes with this.
The eyes are different?

And there's different colors in different places. The mouth is down here
on this side, and up here on this side.
Why would he do it like that?
To make it look abstract.

Connie has shown that she understands the abstraction of the Klee to be
deliberate. But she has a hard time explaining its purpose or its value.
The extract continues:

(What does making it look abstract do?)
It sort of changes the way it looks.
Is it a good way to paint?
I'd prefer stuff like this [the Renoir].
So why do artists do that, then?
To make it look strange, a little excitement. You're looking around an
art gallery, and all of a sudden – to surprise you.
Is it difficult to paint like this?
Probably not. All you have to do is go [mimes long strokes].
It's pretty easy?
Yes, except for finding the colors.

Connie has repeated the theme of wanting to be different, and of ab-
straction being easier. She goes on to show that she thinks the style
cannot be expressive because it is not realistic. The discussion continues:

(Are there any feelings in the painting?)
Just a regular face feeling.
But faces can have lots of different feelings.
It's just a plain face.
No feelings?
No.
Why not?
It doesn't look much like a real man.

This last answer makes it clear that none of the formal features Connie
mentioned earlier are related to expression. To be expressive, the painting
would need to be realistic – i.e., to drop the very things that Connie
enumerates at the beginning of the extract. As a realistic painting it could
be expressive; as an abstract it can't. Connie repeats this view a little
later, in connection with the *Guernica*. In this case also the abstraction is
seen as being nonexpressive, and since the subject is unpleasant, fortu-
nately so:

(Why would he paint it like this, then?)
Probably he didn't want to show the death and stuff all over.
But you can see a lot of gory stuff, knives and heads cut off?
Yes, but it could have been worse.

STAGE THREE

The expressiveness of abstract art

I have already discussed the basic new development of stage three: the "inward turn," the adoption of expressive criteria for paintings. Changes in our understanding of medium, form, and style are related to this development.

One contrast with stage two is that we can now see an expressive purpose for nonrealistic styles. This happens frequently with the *Weeping Woman* and the *Guernica*. For example, Dora, an undergraduate, finds the *Guernica* very powerful. She says:

> I think in this case the abstraction is good, because it does make you look at it more closely and try to put the pieces together. It gives you the feeling of what's happening. It gets it out better than a realistic painting or photograph. It gets more at the feeling of what's happening.

In this passage Dora gives two new and characteristic reasons for the style of the *Guernica*. One is its expressive power: "It gets it out better than a realistic painting." This is the opposite of what Bruce said earlier, that "if these people had regular faces" the painting would be more expressive (and therefore too violent). At stage three, of course, it is an advantage to be more expressive, whereas earlier we assumed that it would be better to tone down the feeling-level in the *Guernica*.

Another example comes from a conversation with Dana, a schoolteacher in her twenties, about the Klee:

> (What do you think about the use of abstraction?)
> I think in this case it expresses more than a realistic painting... That's his medium [i.e., his style], so that in this case he expresses more than he could in realism. In the abstraction he gives this feeling of bewilderment, like a hopelessness on the face you wouldn't be able to capture on the face of a realistic painting. Block shoulder, block neck. I think it really adds to it, the abstraction.
> Why do you think he paints like that?
> Looks to me like he has a reason for doing it. That is the way he can best express. Otherwise, because of the feeling I get, he would have done it realistically, if he felt that would better express.

The second reason Dora gives for preferring a nonrealistic style is that it encourages thought: it "makes you look at it more closely and try to put the pieces together." Because it does not picture things so obviously, it invites more imaginative reconstruction. You must work harder to understand it, and that is more interesting. This reason is frequently cited for liking the style of the Chagall and the Klee. They invite participation;

the longer you look at them the more you see in them. For example, Doreen, in her thirties, says of the Chagall:

> I kind of like that [the nonrealistic style] in a sense, because the abstraction, with me, it forces me to – I picture what is in my own mind of circuses; and if he were extremely detailed then it would be his circus, and not the circuses I have been to in my life. Perhaps keeping it more abstract helps to keep it more vague... Plus I think it would be hard to be extremely detailed and cover so many aspects as he has shown.

In short, at stage three we can see nonrealistic styles as more expressive and more involving than realistic ones. Where at stage two they were at best harmless deviations from realism, they now have positive advantages.

This change in understanding abstract art is possible at stage three, but it is not always achieved. What is fundamental is thinking that expressiveness is more important than realistic portrayal; but sometimes we think that realistic art has the expressive advantage. For example, Erica, an undergraduate, says of the Klee:

> I personally don't like it. I guess I don't understand why they would want to do that, and as a result I have a basic bias against modern paintings... I look at it and say: Arghhh! Modern Art! I don't like it – without giving it a chance... I think it would be a lot more readily accessible to people who look at faces, and are more able to recognize that face, that look. Whereas this, unless you are really trying to figure out if or what it says, you'd probably just dismiss it.

In spite of this opinion, it is clear enough that Erica is thinking in a stage three way: She does assume that expressiveness is what to look for in paintings. For example, she says you might dismiss the Klee "unless you are trying to figure out what it says." It is just that she does not find expressiveness in "Modern Art." In the rest of her interview she discriminates between realistic paintings in terms of which is the more expressive. For example, she thinks the Albright is good because "it says something," but the Bellows uninteresting because it does not. The difference between Dana and Erica is not whether they look for paintings to be expressive, but whether they see nonrealistic paintings as expressive. This difference seems to be more a question of education than of basic understanding. It suggests an obvious minimal aim for our public schools: that, by the time we are adolescent, we do not write off nonrealistic art in Erica's way: "Arghhh! Modern Art!" With a little help, she could do better than that.

Expressiveness and the medium

Another feature that Dana and Erica share is a vagueness about how paintings are expressive. In particular they cannot easily relate the

detail of the medium, of form, or of style, to expressiveness. Erica seems to suggest that a realistic painting is expressive because you can better recognize "that look"; i.e., that a realistic painting would better picture the expression on a face. Dana is simply vague in her discussion of the *Guernica*. Her response to it, though complimentary, is quite general; she uses a variety of nonspecific phrases about it. She says: "It gets it out better than a realistic painting," and: "It's real powerful, . . . the feeling that you get from it. I think it's an honest painting; it really does say something . . . I get a reaction out of it." These phrases are characteristic of stage three in their avoidance of specific mention of the medium itself.

We can at times be more analytic, especially if we are questioned more closely. But even then our analysis is in terms of the subject matter and not the medium. Here is another example, in which Faustine, an undergraduate, is talking about the *Guernica*:

> It's very aggressive and sad. There's pain.
> Where do you see that?
> In the people's eyes and faces and wide open mouths, like they're just screaming and yelling and crying for help.
> And what about the aggression?
> It's almost like they're moving. It's really hard to express, but it's like almost everyone in the painting were about to come out and start screaming at you, and take over your emotions.
> What makes them look like they're moving right out?
> It's the way Picasso uses shadow and light, and the arrangement of their bodies, and facial expressions. Like the hands – there's scratches all over their hands – and there's people grabbing a stick or something over there.

It is noticeable that the only reference here to medium, form, or style is the phrase "shadow and light and the arrangement of their bodies"; a phrase that is quite vague in the context. This difficulty is characteristic. At stage three we are interested in the expressiveness of paintings, but we find it very hard to relate it to details of the medium. Our response is genuine but not analytic. The medium is not interesting in itself, and certainly not a focus of attention. We care about the expression, not the medium. We presume that the artist is aware of the medium and the technique it requires, but we do not need to be.

It is difficult, therefore, to explain the expressiveness of nonrealistic paintings. When asked, we are likely to say that they can omit irrelevant details and focus on what really counts; and perhaps that they can exaggerate what is important. An example might be the hand with the broken sword in the *Guernica* or the eyes in the *Weeping Woman*. But again these examples have to do with the subject of the painting and not with the medium.

The chief exception to this generalization has to do, once again, with color. In fact our new interest in expressiveness has a marked effect on our appreciation of color. It is no longer conceived as a separate element that is good, or pretty, in itself, nor need it be realistic. Its value is related to expression, and it is integrated into the painting as a whole.

This development shows itself in a number of ways. One is that color is much less frequently mentioned as a separate item. This is suggested by some brief written sentence-completions. About thirty children in each of grades 3, 7, and 11 were asked to complete the sentence: "A work of art is good because..." In reading the completions we cannot straightforwardly translate ages into stages; but it is likely that the third-graders used mostly stage two structures, the eleventh-graders mostly stage three structures, and the seventh-graders a mixture, with stage two predominating. The sentence completions reveal clearly the importance of color at the earlier ages. Almost every one of the third- and seventh-graders mentioned color as a separate item; hardly any of the eleventh-graders did. Here are some typical answers from the third grade:

A work of art is good if:

– it is carefully done, with nice colors.
– it has many good colors and figures.
– it has bright colors and makes sense.
– it has color contrast and something to really look at.
– it has detail and color, and doesn't make you sick when you look at it.

In the seventh grade, color remains a priority, and is still thought of predominantly as good, pretty, and bright. But there is an additional interest at times in the artist's intentions. The relation between these two kinds of things is not at all clear:

– it shows emotions, and has pretty or eye-catching colors.
– it has good color, imagination, and feelings.
– it has a story of some sort and a lot of good color.
– it is creative, with bright color and nice drawing.
– it has what the artist wanted us to see, and if the color is good.

In the eleventh grade, color does not appear as a separate item:

– it shows the talent of the artist and is an experience of beauty.
– it pleases the eye and forces the mind to comprehend its meaning.
– it expresses ideas and thoughts and feeling in a pleasing way.
– the painter paints what is in his mind at a particular time and that comes across to you.

The same subordination of color to expression is also obvious in interviews. For example, black and white is no longer seen as inferior to color; it depends on the theme. The Goya and the Picassos are usually

thought to be more powerful in black and white. In the following, Gloria, an undergraduate, is only a little uncertain of this, suggesting that maybe, for some people, red might make it stronger. Parenthetically, I might add that this particular suggestion is not uncommon. The color red has two faces: It is bright and cheerful, and is also the color of blood.

> (What do you think of the use of black and white?)
> It shows contrast. I think it is powerful without having color in it.
> Would it be more powerful with color?
> For some people I think it might. If it has blood, like red, then it might be more powerful.
> Then why did he choose black and white?
> I guess he thought that is all it needed, because it is powerful enough, I think.

Perhaps most straightforwardly, color is now sometimes conceived as directly expressive of feeling. Gloria also says:

> A lot of times color can show stronger, like bright red, bright purple, or something, can evoke stronger feelings than something that is light and mellow. But I think both can be significant in a painting.

Here color is itself expressive of feeling: It evokes feeling directly. This contrasts with the understanding we had at stage two, that color was associated by convention with feeling, that black, for example, was the color of mourning.

Searching for meaning

Color, however, is an exception. No other aspect of medium, form, or style is easily connected with expression. At stage three, we find expression in a painting in a global way, or when pressed for details we look at the subject and the color. I have already quoted Faustine's analysis of the *Guernica* to illustrate the point. In fact there is a considerable variation in our willingness at this stage to spend time analyzing a painting – looking at its details and trying to relate them to expression. At our best we are very willing to do this. This is especially true when the theme puzzles us. At stage two we often reacted with impatience when we didn't know what the painting was about; now we may be intrigued, and engage in a kind of searching, a noting-and-relating behavior. The connection of this willingness with the view that it is a virtue of paintings to provoke imaginative activity is obvious. Here is an example. Henry, an undergraduate, is talking about the Chagall:

> Well, OK, you've got all the performers and everything else – but I think it has a deeper meaning than simply it being a circus. I get the sense that it isn't quite even close to being a circus. Such as this violin or bass, with a bird's head and wings, the candelabra, the two-faced

figure – that's different – the head on the bottom of the figure with the
woman's head on top. This doesn't represent anything you can say.
Why are all those things there, do you think?
That's – I think he is trying to say something about the circus itself,
but I can't pick out exactly what he is saying from it.
It is complicated.
OK, there's something in here he's trying to say with the juggler, or
whatever, with the head. In fact it looks like he's juggling his own head
there. And the colors, too. The audience in the background is more of
a muted, darker blue-purple color, whereas the performers are in the
colors that kind of stand out from the rest of the audience and everything
else. I kind of get the impression that it's the performance itself that's
important, and the audience is more or less secondary to the whole.
Does it have any overall meaning?
I get a ... I don't know how to describe it ... more or less a confusion,
or, because there is all this going on all around them, and it doesn't
look like anyone in the audience that he's got painted is particularly
attentive to what's going on.

This extract is typical of stage three in several ways. One is the conviction
that the painting has some "deeper meaning" than just representing a
circus. For example, the headless juggler is seen as significant – instead
of being a mistake – though its meaning is not clear. It is typical also in
that the scrutiny is conducted in terms of the subject or the color, but
not the medium. And it is typical in its attitude, a kind of puzzled
willingness to continue looking, even though the painting does not make
much sense. Henry shows himself, here and throughout his interview,
willing to scrutinize a painting in detail, even where he doesn't understand
it. The success of such a scrutiny is by no means guaranteed. It requires
a hypothetical attitude, one not overly concerned with certainty, but
willing to adopt and abandon interpretations as they are suggested or
denied by what is discovered in the painting. It requires a tolerance of
ambiguity, a nonirritated awareness that a variety of different interpre-
tations might make sense. It requires us to be hypothetical, tolerant, and
imaginative.

Let us for the moment call this attitude "open-mindedness." Open-
mindedness contrasts with another attitude found at stage three. This
contrasting attitude seeks certainty, is intolerant of ambiguity, and is not
willing to persist in the search for meaning. These features are more
common at stage two, where they center around the concern for clear
representation. There are of course degrees of open-mindedness, and
most people thinking in stage three ways are somewhere in the middle
of the range. The response of Hilda to the Chagall is more typical:
uncertain, wanting the security of the obvious, tempted by the difficult,
not knowing how to proceed:

You almost feel like he's trying to say something about this floating kind of head and hands above the crowd. I would say that he's trying to say something, but I couldn't put guesses to what he's trying to say. It's not a painting I would hang on a wall in my home. It's not one I would ever look at and relax and enjoy. I would look at it for ever and be very frustrated, and never be able to figure out what he is trying to say.
Does that make it less of a good painting?
No. Because I don't react to it positively, I don't think that means that someone else won't. Obviously it's a painting that some people, some people like abstracts, and like things like this that they can continue to look at and think.

There have been a number of studies of the question whether some personality trait such as open-mindedness characterizes people with good aesthetic judgment. A notable study by Child (1965) seemed to confirm this. Child found a significant correlation between scores on a test of aesthetic judgment (measured by agreement with the judgments of art experts) and "tolerance of complexity" (measured by agreement with nondogmatic statements). This study has been replicated in several cultures. There are also a number of studies showing that artists prefer more complex patterns than do nonartists (Winner, 1982, p. 71).

These results are not surprising. They support the idea that people interested in the arts tend also to be open-minded. The developmental question concerns the status of such traits as "tolerance of complexity," or "open-mindedness." Are they a permanent part of a person's nature, or do they change? And if the latter, do they vary with experience, education, or stage? The kind of open-minded puzzling I have tried to illustrate – the persistent noting-and-relating behavior – becomes more frequent at stage three, though it is not common until stage four. The reason for this could be simple: It is not until stage three that this kind of response makes sense, and only at stage four that it regularly pays off. Only at stage three do we assume that paintings have a purpose beyond representation, that they carry a message that might not be obvious – "straightforward yet disguised" – and that might justify searching. Only at stage four do we have a good idea of how to search. And when we search there is a positive learning cycle: The more we search, the more we understand, and the more we are inclined to search. So it is possible that open-mindedness, though it is a personality trait, is nevertheless related to developmental stage because it requires a certain understanding before it is reasonable to exercise it.

In summary, at stage three we are uncertain how to search a painting for meaning. We conceive its significance as a subjective insight that is not easily pinned down. In particular its relation to the objective handling

of the medium, the facticity of the paint, is not clear; and so interpretation is hard to sustain. We try, of course, but are better at "putting guesses" to paintings than at checking them out. We have little sense of method and are subject to bursts of frustration.

Technique

The same uncertainty about the relation between the detail of the medium and the overall meaning of the painting shows up in discussions of "technique." Technique is an idea that at this stage replaces the idea of skill at the previous one. Whereas skill is primarily dexterity and patience, technique is know-how. We think of the artist as making choices about the medium in order to get her message across, and knowing which choices will produce which effects. Technique is governed by a set of rules for the use of the medium that are known to the artist but not to us. We may acknowledge that these rules are valid, but our grasp of them is vague. They are not criteria that we use; they are other people's. Our own criteria have to do with expressiveness. And these two sets of criteria – technique and expression – do not easily relate. Consider what Irene says:

> (How do you judge if a painting is good or not?)
> To me a painting has to be honest, in that the artist has said what he wants to me.
> It must be expressive?
> I want true feeling. You can also look at the composition, at the way the colors are used, and how he has filled up the space, in judging a painting.
> Do you do that?
> Sometimes I do, mostly with abstract paintings. They've never been my favorite. I look and I think he's utilized the space well. The color is really nice. But it doesn't give you a feeling like this [the Albright].
> Are art critics concerned with honesty?
> I guess it would depend on the critic, but I do think you could look at a painting without that, and just judge it on the form, on the technical stuff. I'm not sure how critics do that. They're objective. It's hard without your own personal feelings.

We see here the connection of expression with honesty and feeling in both the artist and the viewer. In addition there is the "technical stuff," which includes the composition, the way colors are used, and filling up the picture plane. These things are objective, but they don't give you feelings. They are used by critics, but Irene is not sure how. Fortunately, for her they are only a secondary concern, something to use when you can't use the expressive criteria. In practice, throughout her interview, Irene responds to paintings only in expressive terms, and does not relate

these to the technical stuff. In this she is typical. In Chapter 3 we saw Harriet compare talk about "great artistic brushstrokes" unfavorably with a feelingful response. In the same spirit, another undergraduate said:

> I could see something, and even if the critics said it wasn't that great, I could still like it. Maybe it doesn't have great artistic qualities, but...

Ivy, an undergraduate, is unusually specific about the kinds of things those nameless critics look for:

> (How do you think critics make judgments about paintings?)
> I'd say they took form, personality, color, stroke – technical types of things. I think some of it has to do with form. I think it would be interesting to take a work of art by Picasso that nobody had ever seen before, and see whether they liked it... It would be interesting to ask them how they honestly feel.
> You think that without his name they wouldn't think his work so good? Exactly.

The items in Ivy's list of "technical types of things" represent a mixture of stages, but the extract is characteristic of stage three thinking. "Color" could be meaningful at any stage. "Personality" has the ring of stage three, though it is hard to see how this is technical. "Form" and "brush-stroke" are the kinds of things we find meaningful at stage four. What is characteristic of stage three is that Ivy is aware that they can be meaningful, but not sure exactly how. She knows that others take such things into account, but she herself does not.

Note too that Ivy contrasts the use of these technical things with asking the critics how they honestly feel, and is skeptical that the one would lead to the other. In fact, these technical aspects are often thought of as opposed to what is really meaningful. Technique and expression tend to be contraries. One is intellectual, the other emotional; one analytic, the other intuitive; one a matter of detail, the other the "big picture." Moreover, the two sets of criteria may lead to different conclusions. We are very aware of this possibility; at times it may seem like a probability. Ingrid, an undergraduate, knows that Picasso has a large reputation – she thinks it is for "technical" excellence – but she doesn't find his work expressive:

> (Do you think someone who has studied Picasso could take you through his works, and talk about them, and change your view?)
> I don't know that it would change. I think that my bias might be deeply enough embedded that I would probably say: "Oh, I'm sure he's a very good painter, but I still don't like his work..."
> Do you think you could be brought to say: "Yes, that is a significant work of art, even though it doesn't connect with me"?
> I think a lot of that would be just kind of going along with the flock.

If everyone says it's great, then you kind of join in. I guess you could look at something on a technical level and say: "Yes, technically it's a wonderful work of art."
And what about expression?
If you don't see it, I don't think you see it . . . For your personal feelings I don't see how you could say, "I don't really like this, but I'll keep it around anyway to look at because it's technically perfect."

The conflict expressed here is characteristic. On the one hand are the technical criteria, which – if we understood them – would allow us to say that something is a wonderful work of art. On the other hand is our direct, intuitive response. And they give different results. In honesty we must prefer the latter since that is what we experience. Our attitude toward the former can range from the decent respect of Irene to the overt cynicism of Ivy, but it does not rise to the level of understanding. We could conclude that at stage three the heart is more important than the head, but this would not be right. For the head is not pitted against the heart in this situation, though we think it is. Actually head and heart are on the same side, the expressive one; and the technical side is neither felt nor understood.

Style

In much the same way, we can be aware that there are many styles of painting. There are, for example, Cubism and Impressionism. Styles of this kind are defined technically, i.e., in terms of form, brush-strokes, and the use of space. Artists create these styles deliberately, and we realize they are important. But our understanding of their importance is exactly as vague as our understanding of the technical stuff. For example, Jeremy, an undergraduate, says, haltingly:

I think there have been some good paintings, though, that aren't par-ticularly expressive, and yet were still . . .
Like what?
Well, I don't know, I think you've got your – more or less what I was reading about Cubism – when they first came out there was a large majority of people that weren't particularly impressed with it. They didn't think it appropriate. And yet now, that's a major – the book I was reading says that now every art student that goes through has to paint his way through Cubism. Whereas before, it didn't even –

Jeremy knows about Cubism, and perhaps can recognize examples of it. But he doesn't see why people are "impressed with it."
An alternative is that we identify "style" not with technical things but with particular expressive qualities. This happens most with the Renoir. Joan, an undergraduate, thinks it is a good painting for two kinds of

reasons. Primarily she likes it because it expresses a pleasant feeling between the girl and the dog. In addition, she likes the style, which is soft and pleasant. She understands the style in terms of a generalized feeling tone that the painting has. This feeling tone is not connected with the technical details in more than a vague way. Joan says:

> (What about the style?)
> I kind of like the appearance of Impressionism a little bit because it doesn't – it leaves something for you to think about. It doesn't outline everything so precisely that it takes away your – it softens it a little bit, I think. Maybe that is what he is trying to do here.

Jennie, a teacher in her twenties, presents a similar case. More clearly than Joan, she has a sense of the style of the Renoir that is distinguishable from the subject; but her description of it is as nontechnical and as general. She also identifies it in terms of feeling tone, and does not connect it with particulars of medium or form. In short, her sense of the style is intuitive, nonanalytic, and personal. She says:

> I love this style of painting. The girl is in love with her dog. It is nice, that soft kind of painting. It shows nice feelings. It makes me feel good.
> You like the style?
> Yes, because it is soft and not real. I don't like things very defined and sharp; well, sometimes I do, but I like this. It blends things in with one another.
> Tell me more about the style.
> Well, it's soft, and has feeling. You can get a lot of feeling out of it, a lot of emotions, different emotions.
> Are you responding more to the subject or the style, here?
> The style. He could have picked a different subject matter and done it in the same style. I would have liked that too. We used to have one at home. The scene was like in London. It was raining, and it was done in the same style. I still like it because you could get more of the gloomy from it . . . The thing that was great about that was he kind of made everything a greyish tone. In something that was realistic, you just could not do that. That is one way I like this type of painting, this style.

In summary, at stage three, we know there are several kinds of style. Differences of style are differences either in technique or in feeling tone, but the two are not connected. Expression and technique are distinct considerations; and since expression is the meaning of the painting, technique tends to be meaningless. We may recognize a style in the sense of characteristic technique; but what we understand of a painter is the strength of her feeling, or the character of her ideas. These are grasped intuitively, as qualities of the whole, and are not related to characteristic techniques.

On the other hand, we can recognize that different works express

similar states of mind. We do this intuitively, without much analysis. Recognizing a style can be like recognizing a person, or an attitude. Arthur Danto says something similar at the end of his analysis of the notion of style (Danto, 1981, p. 207):

> The structure of a style is like the structure of a personality. And learning to recognize a style is not a simple taxonomic exercise. Learning to recognize a style is like learning to recognize a person's touch or his character. In attributing a work to a person, we are doing something (like) attributing an act to a person when we are uncertain of his authorship. We have to ask whether it would have been consistent with his character, as we have to ask whether it would have been consistent with his corpus.

At stage three, we can recognize a style in this way because we understand expression as a characteristic state of mind.

This understanding is clearly an advance over that of stage two. At that stage we are aware, not of the characteristic states of mind of a person, but of their usual behaviors. We see them as having, not a set of feelings, but a set of habits. This limits our understanding of style. I have described how we understand realism and subject matter, and construe their opposite, abstraction, in terms of mistakes, avoiding unpleasantness and wanting to be different. These are also the terms in which we understand style. For example, June, nine years old, sees plainly enough that the style of the Klee is not realistic, but does not find it intelligible. In particular, it says nothing about the painter. Style, as she sees it, is habit:

> (Why would an artist paint a painting like this?)
> I don't know. I guess that's what he paints. Some artists paint trees, some artists paint lines. Depends on the artist.
> How do they decide how they are going to paint?
> I guess they just get into it somehow . . .
> Why would he want to paint it like this?
> It's his style.
> Why choose this style rather than another one?
> It's what he's used to.
> How did he get used to it?
> I don't know. I'm not him.

June understands that people paint in different ways, and that their paintings look different. But she does not expect the differences to be meaningful. Rather, they are accidents of socialization: "They just get into it somehow."

A slightly older girl has an interesting way of connecting a nonrealistic style with the idea of mistakes. The style, she thinks, could be the result of making a mistake, and being consistent. Janet, twelve years old, says of the *Weeping Woman*:

I think she's got the hand backwards. It can't go like this and be showing these knuckles right here.
That's right. Why is it done that way?
Cause it's mixed up.
Would it be better if the knuckles were on the right side?
No, because if everything were perfect in the picture, it wouldn't be – it wouldn't have the same style as it does.
It's a style that's meant not to be perfect?
Yeah.
Why would the artist do it that way?
Maybe the artist knew – found out that he did it wrong, and then made the whole picture the same.

We could call this a consistency theory of style. Janet is aware that the painting is done with a particular kind of line. She also sees that it would be unfitting to do the hand differently from the rest. However, she can see no point in this line other than consistency itself, and suggests that it started by mistake. This interpretation is confirmed when she talks about style directly:

> (What does style mean to you?)
> Well, in this one [the Bellows], like, they think instead of making the faces look like getting every line in the faces, and everything, they just take the general body and face, and then some of the others really take every single line, especially this one [the Albright].

Janet shows herself to be quite sensitive to the artist's handling of the medium, though she describes it in terms of the items represented. But what she notices means little to her. She says, of the Chagall:

> (Why do you suppose he painted it like this?)
> Because he's done so many realistic paintings he's sick of them.

Detecting and understanding style

With the contrast between stages two and three in mind, it is interesting to look at what research has said about children's abilities to perceive styles, and to ask what follows from them. There have been several such studies. In general they show that preadolescent children do not pay much attention to aspects of form and medium – i.e., to stylistic features – with the exception of color. This accords well with the material presented in Chapter 2. A good example comes from the "sorting" exercises conducted by Howard Gardner. In a well-known study (Gardner, 1970), people of different ages were presented with reproductions of six paintings, three of which were by the same artist. Two of these latter were identified and subjects were asked to find the third. The result was that, as a group, children below fourteen years made their choice in

terms of similarity of subject, and not of style; older people had the opposite tendency. But Gardner found also that when the paintings were nonrepresentational – and subject matter was therefore unavailable as a clue – children as young as six years old could often make the right choice, presumably using stylistic clues. In a further study (Gardner, 1972), therefore, he set out to train children to sort paintings by style. The training was conducted in seven half-hour sessions, during which time the children practiced grouping different sets of reproductions and were reinforced for using stylistic clues. Gardner showed that, with this little training, children at ten years old could successfully sort paintings by stylistic clues. Conclusion: Young children can be trained to notice aspects of medium and form that they do not normally notice. For example, a common successful strategy reported by the children was to look for similar textures – to imagine how the paintings would feel if one touched them with the fingers. This indicates that they were more aware than usual of textural differences. There are other studies to the same effect (e.g., Silverman et al., 1975).

How do such findings fit with what I have been saying? Do they not suggest that children's response to the stylistic features of paintings is more a matter of training than of cognitive development?

It is helpful to make a distinction between two kinds of abilities: abilities of visual discrimination and of aesthetic understanding. Gardner makes a similar distinction (Gardner, 1972b), relating it to two different research traditions as they approach the question how children learn about styles. One tradition is interested in fineness of discrimination, and tends to interpret "concept formation" as a matter of visual differentiation. The questions asked in this tradition are basically two: Do people possess the "raw perceptual ability" to make fine discriminations? And can they be persuaded to group paintings in terms of these discriminations? Good examples are the studies by Walk (1967,1971), where persons are taught to match an artist's name with his paintings. To do this, they must recognize some feature as recurrent in his work. Walk has shown (1971), in a finding similar to Gardner's, that indeed young children can be trained to do this. Walk would say that they "have the concept" of an artist's style when they can reliably identify her paintings in that way.

This research tradition assumes a definition of knowing a style that is consistent with its general account of "having" any concept. An account of this definition comes from a discussion of style by Margaret Finch, an art historian (Finch, 1974, p.1). She says:

> When you see a painting by Van Gogh, the chances are you can guess the name of the artist without being told . . . You can recognize certain traits that are peculiar to Van Gogh's work. Just what traits, specifically, do you recognize? For one thing, you may notice that the painting is

done with very bold brushstrokes, and you may happen to know that this type of brushwork is typical of Van Gogh. This distinctive brushwork identifies the work for you as clearly as a signature. In this case we can say you have recognized Van Gogh's style.

Style may be defined as those distinctive characteristics that enable the observer to link an artwork with other works.

I will call this idea of style the "art historian's" idea. This may not be fair to actual art historians, including Ms. Finch; but the label refers not to individuals but to their specialized function. For it is one of the functions of art historians to put paintings in groups, whether by individual artists, movements, or periods. These groupings play an important role in our understanding of our tradition; and this idea of style is an important professional tool for art historians. It is this idea of knowing a style – "style detection," as Gardner calls it – that Gardner, Walk, and others, investigate. The primary task in their research is very like the art historian's task: grouping works together in terms of whatever clues are available, such as Van Gogh's brushwork. And there is little doubt that elementary school children can be trained to recognize Van Gogh's brushwork.

The other research tradition identified by Gardner is the cognitive-developmental, stemming from the work of Baldwin and Piaget, to which this book belongs. This tradition asks questions not about the recognition but the understanding of style; that is, about what meaning we make of it. As far as I know, there are no previous studies of understanding style in this tradition, with the exception of the work of Machotka which I reviewed in Chapter 2. But I have said enough to suggest how such studies would differ. They would ask, of children taught to recognize the brushwork of Van Gogh, what it means to them. Presumably the answer would be like June's and Janet's: The brushwork is Van Gogh's because that is the way he paints, and he paints that way because that is his habit. In short, at stage two they would not understand Van Gogh's style except as detectable behavior. By contrast, at stage three we can see a style as an expression of an artist's inner states; e.g., as expressing Van Gogh's characteristic turbulence of feeling. This idea of style Gardner calls the traditional view. He says: "According to the traditional view, a gifted connoisseur can 'feel' himself into the artist's place, where he experiences the artist's emotions, ideas and creative processes" (Gardner, 1973, 32). In this version, each stylistic nuance we notice carries a significance deriving from the artist.

We can see that the training studies of Gardner and others are not at odds with my own findings. There are two different, though related, abilities: of visual detection, and of aesthetic understanding. On the one

hand, at stage two we do not understand styles as meaningful. On the other hand, we can be taught to notice their details. It is not surprising that we do not normally notice what has little significance for us; that, e.g., that elementary school children do not normally bother to distinguish textures in paintings. From this point of view, we can say that Gardner not only taught ten-year-olds to notice stylistic features, but he made it meaningful for them to do so by reinforcing such choices. But the meaning in this case stems from the reward system used (adult approval) rather than from an appreciation of the painting.

Then what, we may ask, is the value of teaching elementary school children to recognize Van Gogh's style? The answer, if there is one, surely lies in a developmentally later conception of "style," one in which it is meaningful. Learning to notice what is not itself meaningful is valuable only if it helps us later develop a more sophisticated understanding of style. There is presently no evidence that it does.

There is of course a scientific value to Gardner's training exercises. They contribute to our knowledge of the acquisition of discrimination skills in general. And, as Gardner remarks, much of human cognition may rely on our subliminal grasp of detail, somewhat like the grasp of style explored in his sorting studies. In that way these studies are valuable. But do they have value for art education? It is not clear that Gardner thinks so, though many art educators assume it. It seems that the educational value of teaching the meaningless recognition of style needs to be established before it is advocated. It does not seem worthwhile to have children memorize factual items as if art were a true-false test: memorizing that, for example, it was Van Gogh who made those brushstrokes. We should beware reductionism. Otherwise we risk teaching that style is a set of behaviors, and reinforcing the idea that the recognition of styles that are not understood is aesthetically valuable.

STAGE FOUR

The expression of nonsubjective qualities

At stage four, form and medium are important in a way they have not been before: they bear directly on the significance of the painting. If at stage two we found significance chiefly in the subject matter, and at stage three in the artist's intentions, then at stage four at last it is in the detail of the form and medium. In Chapter 3 I cited Olive's discussion of the organization of the Chagall and Pamela's of the hands of the *Weeping Woman* as examples of this. There is in them a completion

of the hermeneutic circle, a checking of the interpretation against the painting itself. This is possible, I claimed, because the expressiveness of the painting moves from the private world of intuition to the public space of the canvas. The details on the canvas are the bearers of meaning, which itself belongs to the community that continually reconstructs it. In short, if stage three was the stage of intuitive feeling, stage four is the stage of the shared significance of form and medium.

Here I will discuss the main consequences of this change. They may be grouped under two heads. The first is that what paintings can express is now more varied than before because it is not limited to the conscious states of individuals. The medium itself as it appears in actual paintings determines the expressiveness, regardless of whether the artist intended precisely what it expresses. This means that the artist can express things that she was not aware of, things that have to do, for example, with her character or with that of the times. The second point is that paintings are now understood in a social, and therefore historical, context; in particular the history of the art world affects meaning.

Olive found a childlike wonder in the Chagall, and Pamela anguish in the *Weeping Woman*, qualities that can readily be understood as subjective states of the artist or the viewer. But a painting may also express other, nonsubjective, qualities. Its meaning can reach beyond the content of an individual subjectivity to include whatever qualities are publicly in the work itself. Comments on the Klee reveal this difference rather well. At stage four it is seen as a symbol, not of a state of mind, but of mankind in general, as an archetypal image. For example, Olive says:

> One thing I like about Klee is his people. They're people in general. They're sort of like Munch's *The Cry*: You can't tell whether they're male or female. They're sort of a generic concept of a human, a universal symbol. They strip away all the superficial features, but it still communicates. It's a very simple, but very sophisticated symbol.

What is interesting is the way the image is accommodated to the medium, the way the medium is present in it: its flatness, for example, and the way it is broken into patches. Kenneth, a university art professor, says:

> What from one point of view is a strange stylization of a person becomes from another quite a universal, almost mathematically precise realization of a symbol. It's flat on the canvas, circle for a head, circles for eyes, broken up into planes that are still flat. So, in a way, to me, it's partly a design problem – what sort of shade or tint of color, rearrangement of the image into planes, to accommodate this flatness? An exercise in translating an image into a symbol, done with a wry sense of humor.

The textures are also significant. Karen, another professor of art, says:

Look at his textures, the control of his textures. He's looking for contrasts, even with these pale tones. It's applied here – I can't tell whether over or under the light color here – so that it just – it doesn't sing, it doesn't exactly vibrate, it has an active quality because of the way he's handled the surfaces. This is really interesting here, look here!

This may remind us of the interest we take in color at stages one and two. But at those stages we do not attend as closely as Karen does; we do not give colors her kind of scrutiny and are not sensitive to their precise qualities. Karen focuses on the qualities arising from the contrast in tones: "It doesn't sing, it doesn't vibrate, it has an active quality." Such qualities belong to the paint itself, and taken together they constitute the significance of the painting. And it is pointless to ask whether this active quality belongs to the paint or to the universal symbol that the paint constitutes.

Karen also finds the simplicity of the Klee significant, something else characteristic of stage four. She says:

More than anything he's working at utter simplicity. How little can you say and still have a painting? It's the kind of question that has reached a maturity – I think – with Minimalism. How much can you leave out and still be expressive, still be analytical? It's an attempt to be simple, to be pure, to say as little as you can, to let the paint say it for you, and still have it exist as a work of art, as a painting.

At stage two we admired the opposite of simplicity; we liked plenty of realistic detail. This detail required skill understood as the mastery of a recalcitrant medium. At stage three skill turned into technique: knowing how to do things with the medium to get our ideas across. Only at stage four can we delight in simplicity. The idea of technique is replaced by a more positive understanding of the interaction of the artist with the medium, one in which the medium is more active, supplying significant qualities of its own. Serendipitous discoveries are possible, effects unanticipated by the artist. The medium is in a sense a collaborator with the artist, having its own character, bigger than her, a sea in which she fishes. Only when we see the medium in this way can we appreciate simplicity as Karen does, as the deliberate attempt to get the medium to do the singing.

This conception of the medium suggests mutuality rather than means-to-ends, equality rather than servitude. In fact, too much predictability and obedience on the part of the medium can be seen as negative, as tending to emptiness. Katie, a graduate student in art, finds in the Bellows too much emphasis on the artist's intentions, and not enough richness in the medium:

It's a little slick, refined. There's no symbolic overtones like with the Klee or the Chagall . . . It doesn't have, for me, the emotion that the

others have . . . The color helps keep it from being a total loss, as far as
I'm concerned, here, and under here – the color is rich through there
on the shoulders – [but] it's just too smooth, too slick, and got-an-
answer. I would get tired looking at this in a hurry . . . It's all preplanned;
there isn't anything in it.

Katie prefers the Klee, because she also appreciates the sophisticated
combination of control and spontaneity that is so much more than tech-
nique. She says:

I like the primitive rugged feeling that he gets and the childlike quality.
It's like it's coming from within, and he's kind of letting it flow . . .
You spoke of a rugged feeling. What do you mean?
It's the textural looseness. He doesn't define all the forms. And the
negative space around here, it's receding, but here you lose that, and
the gold comes forward and blends with the white. The ruggedness, I
think, that has to do with the use of a palette knife. The handling is
very direct. There's no going in and being real careful how he controls
it. But then he does, you know. When he comes up here, he does this
in such a beautiful way, so it doesn't look like it's contrived, but it is.

It is notable that Katie here, and Karen above, are both aware of the way
the painting is done. Katie speaks of the handling of the palette knife,
Karen wonders which color lies on top of the other. It seems that to be
aware of the qualities of the medium – the rugged feeling for one, the
active quality for the other – is also to try to see how exactly it was
produced. The medium is not just in a certain state, but also bears traces
of the interaction with the artist that brought it to that state.

"Traces" is not exactly the right word here; we do not have to search
the Klee for clues as to how it was painted. It is rather that something
of how it was painted lies in the properties it most clearly presents: the
directness of the handling, the overlaying of one color on another. In
this sense we can say that it expresses some characteristics of the artist
himself: Klee's directness, his calculated spontaneity, his sophisticated
simplicity, his quirky humor. We can see these things in the painting
itself, though they belong to the artist; they are part of what it expresses.
This kind of expressiveness is not of the same sort that we saw at stage
three. It is not an emotion or idea of Klee's, a subjective intention, that
we see; it is something more like his character, something of which he
may himself not have been aware. It is an aspect of the artist himself,
his personality, the way he does things: his characteristic style.

Katie sees the same sort of interaction with the medium in the *Weeping
Woman*, which she expresses in the notion of "playing games" with it:

[I like] the way he's done these fingers, and how he's spatially – although
it's a flat drawing – he's made this heavy, and got this faded line receding.
It appears – although it's not – as though this hand comes in front of

this one, I suppose because it's a little bit larger than this. And the way he plays with his texture, the way he handled this surface versus this, versus this one. They're all handled differently. Sometimes he's got heavy lines, sometimes he's pulled them off, and everytime he does something, you see something new and different. I rather enjoy the game playing, like with the eyes, and still have it read as a person.
Could you say more about game playing?
He uses the eyes as a form and changes them into something else, kind of a metaphor for something else. You can read them as eyes and yet they aren't eyes, and he does it and pulls up something new. And I think he's playing games with these fingers, with their shapes and how they work . . .

The notion of playing with the medium is also respectful of its character: It suggests the pleasure of the interaction, and the possibility that something not planned by the artist may happen as the game proceeds.

At stage four we do not depreciate technique per se. On the contrary, we have a healthy respect for it, because we are aware of it in a much more specific way than before. It is no longer a vague set of criteria used by others, nor a general knowing what to do. It is the possession of specific skills, the mastery of certain effects, a knowledge of particular styles. This continues to be valued, in the right places. Simplicity and spontaneity are not the only values of stage four. But if technique is not significant, in the end it is not sufficient. If it supplants significance, as perhaps it does with the Bellows, it is meretricious. The Albright presents a more difficult case. Kathleen, a professor of art, is explicit about Albright's technical competence, and has no doubt that it is admirable. She says:

I can appreciate the technical competence, but I don't like it, I don't like it.
Can you say more about the technical competence?
Just in the sense of modeling forms, giving you a sense of the way the form might feel, the textural quality. Look at the shiny quality of the fabric. You know her flesh is not smooth, there's something underneath that's making it bumpy and lumpy. It's that feeling for texture, and his ability to model that precisely and carefully, and the one light bulb, the theatrical quality . . .

But Kathleen finds the painting drowning in the virtuosity of the technique. There is too much control, too much concern with getting the viewer to react in the right way. She says:

I'm inclined to want to be required to put more of myself in a painting. With Albright you don't have to, he just reaches out and hits you between the eyes. He says: "This is the story, it's about mutability, about decay, about aging." Everything is aging, the chair, the woman.
You're saying it's overstated?

It's too obvious, far too obvious. I think at one level, maybe, yes, it expresses a concept of aging. But it needs more, there's no, well, it really needs less. It needs more in the way of subtlety, more restraint. He uses paint excessively, light and dark excessively. There's nothing left for you to wonder.

The public meanings of the medium

I have been illustrating the detailed awareness of the medium that is part of stage four. It is closely related to the second topic, the awareness of the social character of the painting. These two topics are related because they both reflect the new realization that we interpret paintings in a community of viewers. This is why the medium is public, and can be cited in detail. It is also why the meaning is social, more than individual. A painting is no longer an isolated object. It is part of an artworld that consists of many other paintings and painters, and it gets much of its meaning from that world.

This is not to say that we take into account things external to the painting. It is rather that it is more difficult to decide what is external to it, just where its boundaries can be drawn. Ideas that earlier might have seemed extraneous are now part of what is to be seen. The color of the Chagall provides an example. Many people comment on it. The burden of the comments quoted so far has been either its lack of realism or its expressive character, particularly its expression of mood. Kathleen, guided by a sense of art history, speaks of its contribution to form:

> The color is childlike, bright and surface... like, well-chosen. There's this intense yellow, and this figure on the horse here, that's nice, and it's reflected over here in these images. The contrast, the blue, is not so much to evoke a mood. He's using it to push some things back. See, he's not using perspective to suggest space. You can do the same thing with color, and Chagall was probably aware that Matisse and the Impressionists were doing that – that cool colors recede and warm colors advance.

This is a simple example of perception guided by knowledge of style – in this case, of a characteristic way of using color. It is a case where a knowledge of style helps one see what is in the painting.

Another example has to do with the eyes of the Klee. Most people have something to say about them. Often, at earlier stages, it is to the effect that they are not expressive: They are "just there," staring, doing nothing. Others find expressiveness in them, reading the painting as if it were a picture of a person; at stage two we may find them mad, or weird; at stage three, watchful, anxious, one of them asleep and the other one awake. Kenneth sees something different. He says:

There's a confrontation in dealing with the head. He builds up the picture plane quite a bit. Though the eyes are kind of Cubist – there's two or three different views of them – there's kind of a full-front effect. So one thing is, the subject is looking at the spectator, so there's almost a relationship there, one-to-one, rather than just a person observed . . . Could you say something more about the eyes being kind of Cubist? Well, he's stylized them, with that universal almond shape, but in a way with a Cubist attitude. The eyes are approached from different points of view. Let's see, this one is a side view, and with the eyebrow element here, and the triangle is definitely frontal. So he's not giving us much information elsewhere, but here he has. And so you've got the frontality of the circle, and the different points of view on the eyes. . . .

It is clear in this case too that Kenneth sees what he sees because of his awareness of art history. Knowing Cubism as a style, and knowing that it was available to Klee, he can see more accurately and meaningfully how the eyes are painted. Their qualities are a use of, as well as a reference to, Cubism.

This example also illustrates how the meaning of a painting is influenced historically. Communities have a history; artworlds have traditions. A tradition may be stable and slow to change, as may the society that it reflects. In such a case our knowledge of the tradition may be taken for granted, and its value is less noticeable than in the cases just cited. Our tradition, of course, is the opposite: ever-changing, varied, full of movements, a rich mixture of styles and values, with a fast-moving history. In either case, such traditions shape our art world, and determine the meanings of paintings within it. George Dickie has discussed a part of this, using the example of theater. What he says of theater applies also to painting, the dance, the novel, music, and so on. He says:

There is a long tradition or continuing institution of the theater which has its origins in ancient Greek religion and other Greek institutions. That tradition has run very thin at times and perhaps has ceased to exist altogether during some periods, only to be reborn at a later date out of its memory and out of a need for art. The institutions that have been associated with the theater have varied from time to time: in the beginning it was Greek religion and the Greek state; in mediaeval times the theater of the morality plays was associated with the church; more recently the theater has been associated with private business and the state (national theater). What has remained constant is the theater itself as an established way of doing and behaving. This institutionalized behavior occurs on both sides of the "footlights"; both the players and the audience are involved and go to make up the institution of the theater. What the author, management, and players present is art, and it is art because it is presented within the theater-world framework as a candidate for appreciation. Plays are written to have a place in the

theater system, and they do not exist as plays – that is, as art – except in that system. (Dickie, 1974, p. 30)

We must add to this that the institutionalized behaviors that constitute a tradition are themselves governed by ideas. These ideas are sets of understandings and expectations that we hold in common. In the case of painting the art world and its traditions consist not only in institutions and a stream of works, but also in our common interpretations and understandings of those works. It is a matter of our accumulated ideas about what art has done and can do, what kinds of qualities are significant, and what should be. In this way the work of critics, connoisseurs, and historians of art constitute the artworld, as much as the works of artists. Artworks can exist only in the context of a set of publicly shared meanings by which we interpret them.

In order to understand a tradition effectively we need to understand some of its ideas, and the concept of "style" is designed for this purpose. Styles relate paintings together by referring to the tendencies they share. We see examples in the remarks quoted above: to see Cubist elements in the eyes of the Klee is to connect it with Cubist paintings; and Kathleen explicitly connects Chagall's use of blue with Matisse and Impressionism. So understood, as connective ideas within a tradition, styles encompass more than the work of an individual: They identify groups, movements, tendencies. In this way the concept of style at stage four is more encompassing, and more useful, than at stage three. At stage three, it is restricted to similarities of feelings. What is common to a style is the subjectivity of the artist. The artist is understood, as it were, as a free and individual agent, doing what she wanted in her paintings. She is not understood as a product of a culture, of a time and place, having problems and tendencies specific to a time and generation. At stage three we do not think much of cultures and generations, nor of styles and influences. But at stage four a style belongs to a group, and expresses meanings held in common by them. This is true even where the style belongs to the works of one artist only, because it expresses the values of the group of which the artist is a member. We are carved from a common block, and our individuality displays the grain of the wood, no matter what shape we give it. An artist inevitably speaks for her time, expressing often more than she knows. As Panofsky says (1955, p.14), any good painting expresses "the basic attitude of a nation, a period, a class, a religious or philosophical persuasion – all this, unconsciously qualified by one personality and condensed into one work." I remarked earlier that the medium was the sea in which the artist fishes. I might better have said that the artworld is the sea that supports and feeds the artist on her voyage. But, in the end, the art world and the medium cannot be disentangled.

These reflections of the importance of an awareness of style and the

rapidity of change in our artworld raise some obvious questions about education in the arts. The average viewer can no longer assume that she will share the same interpretative framework as an artist, or other viewers, just by virtue of living in the same society. We cannot understand the major works of the twentieth century by looking at them – as we do at stage three – as if they were painted by a friend with whom we have an intuitive understanding. The differences in assumptions, understandings, techniques, are too great to be bridged intuitively. We cannot understand contemporary art through simple socialization, without a deliberate education in the arts.

One could make this the basis of a complaint against our society. One could say that, as a society, we do not value art enough to make it a topic of everyday interest; and that therefore children do not learn much of it from our daily conversation. Or one could claim that it is in the nature of sophisticated societies that their serious achievements cannot be understood just by socialization. In either case, it seems likely that few people will reach a stage four understanding without more serious schooling in the arts than is usual. This is a claim for which I do not have sufficient evidence, but the data I do have supports it. For example, out of the sixty-odd undergraduate students I have interviewed (none of them students of art), only a handful used stage four structures to discuss the paintings. This suggests that art education in our high schools is not fostering a stage four understanding. Yet only with that understanding can we hope to appreciate much contemporary painting. Perhaps developmental theory may help us better define our educational goals.

The style of the Renoir

One can compare these different understandings of style by looking at typical responses to one painting. Earlier I quoted the remark by Margaret Finch that if you identify the bold brushwork of a painting as Van Gogh's, you have recognized his style. We saw that children at stage two could be trained to do this. At stage three, we may suppose, we see more in the brushwork – for instance, Van Gogh's characteristically hectic emotionality. At stage four we may also see the trend, characteristic of so much late nineteenth century painting, to emphasize the two-dimensionality of the picture plane while at the same time keeping the three-dimensionality of pictured space. But it happens that we need not be content with guessing like this. We can look at what people actually said about the brushwork of the Renoir.

At stage two we usually do not pay attention to the brushwork in the Renoir. We like the painting because the subject is happy and the style is realistic. For some, though, the style gets in the way of seeing the

subject matter clearly, and they both notice and dislike it. For example, Leonard, ten years old, said:

> I like the bright colors, the yellow, the green, the white. It looks nice.
> Is there anything he could have done better?
> Yes, he could have painted it a little neater. The glass looks like a real glass, but it could look better.
> What would it take to make it look better?
> Not to smear everything.

The brushstrokes of white on the glass on the table come in for frequent mention. They are not so easy to see representationally, because they draw attention to themselves, and break the convention of the picture window. They are a kind of minor climax in the painting, a place where the tendencies of the style crystallize most clearly, and where differences of interpretation are most obvious. For Leonard, they are smears, an obvious failure of a realistic style. Lee, five years old, also dislikes it:

> (What else do you like in the painting?)
> I like the glasses, but I don't like the stupid colored ones.
> Which ones?
> There.
> The one with all the colors?
> Yeah.
> How come?
> Cause it has grapes and stuff in it. It looks kind of yucky.
> It looks yucky?
> Yeah. I never saw a glass like that.
> With colors in it?
> With all the stupid colors.

Leslie, twelve years old, also dislikes the brushstrokes for their lack of realism:

> I like the painting in general, but I don't like the kind of paintings that are so harsh.
> What do you mean by "harsh"?
> Well, how they kind of – how they use the paintbrush. You know, like they make it all in one big brush mark.
> You can see the brushstrokes, you mean?
> Yeah.
> It would look better if it were how?
> Well, kind of soft, and all one color that's mixed properly.

On the other hand, those who see the painting as realistic give the glass special commendation. Larry, twelve years old, said:

> I like the glass. I mean, it's not just glass, like the little thing down here. It has, like yellow – it has all different colors blended to make it look like real crystal. I also like that little bit of white just in there to show the light is coming through.

Uh-huh. I see.
And on the dog's eye, it makes it sort of sparkle. Because if he didn't
have it there, what would you think? I mean, you wouldn't know he
is looking toward here.

This admiration is based on stage two criteria: showing exactly what
is happening in the picture. There is a different admiration that comes
with a stage three understanding. We see that the artist is trying to be
faithful to how things look on a quick glance, to capture the sense of
"looking through a keyhole." For example Marsha, an undergraduate,
says:

> I've always loved Impressionism . . . I like the idea that it's peeking. I
> remember . . . that this is the "keyhole" style. When you look through
> it, you feel like you are looking through a keyhole. I really like that,
> caught in a moment when they don't know. It's tender.

This is a refinement of the notion of visual realism, a further understand-
ing of it that matches part of the achievement of Impressionism. John
Russell, for example, says, speaking of Impressionism and especially of
Renoir: "Impressionist painting was true to everyday experience in a way
that painting had not been true before. This is how light falls, this is
how color is broken up, this is how the fugitive moment presents itself
. . . . "(Russell, 1981, p. 18). Marsha has seen that the painting is con-
cerned with "how the fugitive moment presents itself." This requires at
least a stage three understanding of the painting.

It is probably more common, however, at stage three, to notice the
brush marks and find them pleasant – they are too gentle to be offensive
– but to see no significance in them. Maureen, an undergraduate, says:

> She looks more like a young girl than a lady. She definitely enjoys her
> dog. He used a lot of bright colors – yellow in the hat and orange in
> the scarf. The thing I noticed about Impressionistic painting the last
> time I visited the Institute was that they don't seem to have definite
> lines. Everything seems to blend together.
> What do you think it is all about?
> The kind of feelings you have for your own animal, a kind of love that
> is more part of the family . . . It gives you a good feeling, and doesn't
> leave you wondering what it is.

Here it seems that the significance of the painting is in the feelings it
expresses, and not in the style in which it is done.

At stage four, things become more complicated, because of the his-
torical context. In many different ways, modern painters have sought to
remind the viewer of the two dimensional character of their paintings.
The two-dimensional plane has been as important as the three-dimen-
sional picture space. Impressionism is a style in which this tendency
reached a certain stage. The brushstrokes on the glass are an obvious

case of this. They force the viewer to become conscious of the paint on the two-dimensional plane. At the same time that they can be read as reflected light from a glass, they remain obviously and obstinately strokes of paint; and in doing so they remind us that the painting is only a painting made up of such brushstrokes. Thus they make the whole painting ambiguous, needing to be read both ways at once. The passage just quoted from John Russell is followed almost immediately by:

> It was the truth about what the eye saw, and it was also the truth about what happened on the canvas. The all over flicker of Impressionism mimed the very act of putting paint on canvas, when the suaver, blander and, in intention, seamless procedures of earlier painting had tended to conceal it. (p. 18)

To see the Renoir this way is to see the minutiae of its style more richly, and as more significant. We can appreciate both the realism and the richly colored surface, seen as a flat surface. The brushstrokes are of interest because they are the intersection of two ways of seeing the painting. An example comes from Nora, an undergraduate:

> What's really intriguing to me is the colors. I am looking at the contrast between the blues and the yellows, the browns. Or, what's really catching me – I really think it's kind of cutesy, mainly because of the subject matter – if I really got into it, I'm interested in how the glasses are painted. Very interesting. It looks almost like it's becrackled. To me that's very realistic, yet, at the same time, it has a really different quality . . . Immediately, when I looked at it, I totally blocked the girl and the dog out, right down to the glasses, because I thought they were really intriguing.

Nancy, a professor of art, articulates these points clearly:

> Well, what's really nice is the skin tones. Renoir loved to paint flesh because he said it was so reflective of the light. Look at the quality of the light here! Look at this on the neck, the yellows; and even the glass is reflecting things around it. But it reads as paint as well. You can see the splash. He doesn't care about defining the form too much. This is a very early step toward establishing the two-dimensionality of the painting – maybe not consciously, but that's what he's doing – so you're beginning to see everything two ways . . .

5

JUDGMENT

How does judgment relate to experience? Where do our criteria come from, and what authority do they have? How far are they reflections of our individual self? Our assumptions about these and related questions are the focus of this last chapter. My central thesis is that there is a developmental sequence in how we judge and think about judgments in the arts.

This topic has two faces. One looks toward the painting, and has to do with our criteria for judging it, and how far we think others should accept them. The other looks toward the judge, and has to do with the involvement of our self in our judgments, and how far it is reflected in them. Of course the two are closely related.

The nature of judgment becomes clearer at the last stage. It dominates stage five in the same way we have seen the subject dominate stage two, expression stage three, and the medium stage four. Judgment occurs at all stages, but it becomes a topic of self-conscious concern at stage five because responses to particular paintings are colored by an awareness of the precariousness of judgment. Stage five is the "postconventional" stage. We no longer accept judgments on the authority of the tradition, but reexamine them for ourself. This confronts us directly with the difficulties of judging objectively: i.e., of telling when judgments reflect only idiosyncratic aspects of ourself and when some universal aspects that we share with others. This question is a key concern at stage five. Judgments, though they rest on the authority of individual experience, are made on behalf of other potential viewers. The distinction has appeared in some form at each stage, but not with the importance and self-consciousness it now takes on.

Judgment is always a continuation of our experience of a painting, not something foreign to it. This is especially obvious when we look at it developmentally. At the preconventional level – stages one and two – we do not distinguish judgment from our immediate response to the

painting. It is all one. Our judgment is contained already in our perception. At stage one, we do not distinguish liking and judgment at all. At stage two, judgment rests on what we might call perceptual ideals, such as beauty and realism, ideals which are taken more as natural facts than as human constructs. We are not aware of how these ideals determine our judgments. We simply look to see whether they are met, and that is the only question we ask. Perception itself, we could say, is our chief form of inquiry. As we look we implicitly ask questions, and the answers appear as perceptual facts, as if we have no part in constructing them. We do not acknowledge our contribution to the answers, or distinguish judgment as a distinct moment within experience.

At the conventional level – stages three and four – we are more aware of our responsibility. We know that we interpret what we see and that our interpretation reflects something of ourself. The interpretation is self-consciously part of our response because it is our attempt to make sense of what we see. We distinguish interpretation and perception, therefore, as different but connected moments of the same response; but we do not yet distinguish interpretation from judgment. We are aware of the ideals in light of which we make interpretations, but accept them without criticism as socially established norms. We know we use them to critique paintings, but see them as themselves beyond critique. This is a way of saying that our interpretations carry judgments unacknowledged within them; we approve whatever meets the accepted norms, and disapprove what does not, and do not recognize that we are responsible for the norms. The combined interpetation and judgment at stage three consists of an empathetic grasp of some inwardly felt states of mind. At stage four we use more of the resources of the art community. Our attitudes toward paintings are now quite complex, since they are based on objects that are complexly meaningful for us. They span a great range; and include a love for what is intrinsically valuable, awe for what transcends our personal boundaries, and identification with the great works of the tradition. These all imply a recognition but not a critical scrutiny of the accepted norms.

It is true that some of us feel the categories and judgments of the artworld as an imposition. This happens mostly at stage three, where those judgments are not understood and are contrasted with the reality of what we experience. This is the source of the idea that judgment is foreign to experience, an activity that somehow tries to impose itself on genuine response. The idea of course contrasts with my assumption that judgment is continuous with aesthetic experience, though distinguishable within it.

At the postconventional level – stage five – judgment both continues and questions our experience. It is both an articulation and an examination

of our interpretation. We use traditional ideals to interpret paintings, but we also assess the worth of those ideals. For example, we may see that a work exemplifies a style, and we ask also about the value of the style: How well does it articulate the tendencies of our inner nature? This judgment is made in light of our reflection on our experience and our best understanding of our self, informed as they are by conversation with others in the artworld. Moreover, we take our experience – the relevant aspects of it – as representative of others' who might see the painting. We judge in light of our self, but on their behalf. We imply not that others will agree but that they should do so. They should agree because our judgments are based on reasons. A reason derives from some part of our response that is based on some aspect of the painting; it has interpersonal validity and potentially applies to us all. For we imply that the same aspect of the painting should occasion similar responses in us all. Judgment presupposes consensus as an ideal, not as a fact. Because we are passing judgments on the present ideals of our community, we are responsible to a potential not an actual community, to an imagined not a real consensus.

Judgment, then, at stage five, is the self-conscious articulation of the meanings we find in the painting and of our sense of their value. It is a cyclical process, a going back and forth between description, interpretation, and judgment, sometimes the two or the three of them all at once, much as the hermeneutic circle cycles around and around. It follows that our judgments will be as varied as our descriptions and interpretations. Judgment at the later stages is rarely a matter of saying that something is good or bad, graceful or sad. The more complex our response, the more complex our judgment. It could hardly be otherwise. There are many examples of complex judgments in this chapter.

One way to summarize this progression is the following. At the preconventional level we take for granted what we see. Description, interpretation, and judgment are all present undifferentiated in our account of seeing. At the conventional level we question what we see with the aid of the ideals of our community, and are aware of our own activity of interpreting. We can, therefore, distinguish interpretation from description. What we take for granted, however, are the received ideals; they do not need examination. At the postconventional level we can distinguish judgment from interpretation because we can question the ideals used in the interpretive phase. In this way, judgment becomes fully explicit and individually responsible.

Psychological studies of the arts usually distinguish between judgment and preference. Most of us can judge that a painting is a good one, and at the same time dislike it, or vice versa. It seems obvious that studies of judgment will be better if they mark the distinction. But when we

look more closely we see that the opposition is not an ultimate one. It cannot be if judgment is continuous with response. It is better to say that there are several kinds of liking. For example, there is the liking of what we find valuable in the painting, and there is a more idiosyncratic liking. A more accurate distinction – but it becomes clear only at stage five – is between those aspects of our response that are based on the painting, and those that are not. We can call this judgment and preference if we like, but it is misleading if it suggests that judgment does not include liking. Our judgments are ultimately based on what we like, and at least some of our liking is based on the actual character of the painting. This connection cannot be lost, though it can become remote. It makes nonsense of judgment to suppose otherwise.

It is this connection that ties judgments to the self. As we clarify our response to a painting, we also clarify our self – our own feelings, meanings, ideals. As we decide on an interpretation, we decide what some of these feelings, meanings, ideals are. We become aware of them as different elements of our response, and we examine them in an effort to get them clearer. And as we judge a painting, we judge the elements of our experience and hold their character and value in question. If we adjust them in light of our sense of their value, we adjust, we could say, our self.

STAGE TWO

The objectivity of judgment

Most of the time, at any stage, our intuitive likings and our articulated judgments run in the same direction. We like what we think good, and we think good what we like. This is notably true of stage two; rarely do we find a conflict. Indeed we frequently have to be reminded that there is a distinction; otherwise we speak as if the two are the same. For example, we are likely to respond to the question, Is this a good painting? with an answer like, Yes, I like it. This is true at all stages, but is especially so of the second.

On the other hand, at stage two we can grasp the distinction. We can, when reminded, tell the difference between, Do you like it? and, Do you think it is good? The reason is that we now have criteria to judge with. These criteria were discussed in Chapter 2, where they were grouped under two heads: those having to do with beauty and those having to do with realism. These are the crowbars with which we can lever judgment apart from preference; not far apart, but far enough to see a distinction, and far enough that sometimes, in particular cases, the

two can conflict with one another. At stage one, there was no logical
space between the two ideas; what we liked was identical with what was
good. There was only the one idea of being for or against something
because we had no criteria.

At stage two we can distinguish the two ideas. Here is an example.
Anna, nine years old, says of the *Guernica:*

> (You said you don't like this. Do you think it's a good painting?)
> I don't know if it's good or not. It's OK for some people, but I don't
> like it.

Anna shows that she understands the difference, when she is reminded
of it. She has said she does not like the *Guernica,* but is not willing to
call it a poor painting. At the same time, she repeats that she doesn't like
it, implying that that fact is somehow relevant to the question, though
it is not clear how. In this, of course, she is right.

Where do our criteria come from? They reflect our understanding in
general of what pleases us about paintings. But they are not just gen-
eralizations derived from looking at a number of paintings, for they have
a normative force; they are ideals. This normative force, we may say,
comes from society's values, and is the product of socialization. But this
does not mean that our criteria are somehow imposed on us and do not
reflect our feelings. It means rather that we are inherently social creatures
and accept society's criteria because they do so faithfully mirror our
feelings. Their normative power comes from this fact, and was implied
in stage one judgments too. It is now given a clearer articulation and an
added objectivity by the awareness that others share our perceptions and
judgments. This increased objectivity, the product of articulated criteria,
is the chief difference between judgment at stage one and at stage two.
It is the difference between saying that a color is our favorite and that it
is beautiful.

In Chapter 2 I said that thinking something beautiful implies liking it
in a certain way: the way beauty deserves to be liked. It implies the sort
of respectful liking of beauty that we call admiration. When we construct
the idea of the beautiful, we also construct the capacity to admire beautiful
things. At stage one we liked things in a rather global way, as when we
had favorites. At stage two our likings have differentiated along with
our ideas. We can still like things in the old way; but if something is
beautiful it no longer matters much whether it is our favorite. Our criteria
have lent objectivity to our feelings too.

This frequently lends a tone of certainty to judgments made at stage
two. For example, Andy, age six, thinks that if you will only look, you
will see which paintings are good ones. He says:

> (If you were the director of a museum, how would you choose the
> paintings for the museum?)

The ones that look the best.
How can you tell which ones look the best?
I'd look at them real carefully.

For Andy, judging is all one with looking, and so is feeling admiration for "the ones that look the best." The most characteristic judgments of stage two are confident ones where it is obvious that a painting is pretty or realistic. The reverse is also characteristic, where it is obvious that something is poor because it is ugly or sloppily done.

It is more illuminating, however, to look at cases where liking and judging run in opposite directions. Sometimes we dislike a painting but think it good; other times we like it but think it poor. Here is an example of the first situation. Adeline, ten years old, compares the Renoir and the Bellows. Her response to the Renoir is straightforward: she both likes it and thinks it good. But the Bellows is more difficult:

> (If you look at all of these paintings that we've seen, which one is best?)
> This one [the Renoir].
> How come?
> It's got nicer colors. I like it best. I like happiness paintings.
> You like it best? Which one do you think is painted best?
> The boxer one. You can see all his muscles and stuff.
> But you don't like it best?
> The only reason I don't like it, boxing is rough. They're hitting each other, and it's not nice to do that.

Adeline's response to the Bellows contains a conflict. On the one hand, it meets the criterion of realism and for that she admires it. But the subject matter is not "nice" and for that she does not like it. Her dislike is not the unstructured rejection characteristic of stage one. It is more specific than that. It is disapproval, the negative form of admiration. Adeline has a reason for disapproving of hitting, and of pictures of hitting: It is rough. Being rough is a particular form of ugliness, and so a reason for disapproval. That as a criterion it conflates moral and aesthetic considerations is a side issue, one that I discussed in Chapter 2. The main point is that disapproval is a structured form of disliking, just as admiration is of liking; they both rely on the kind of criteria that belong to stage two. If boxing is rough, everyone should dislike it. So Adeline's conflict over the Bellows – a good example of the conflict between judgment and preference – turns out to be a conflict between two sets of criteria. On the one hand, the Bellows is realistic; on the other, its subject is ugly. And Adeline has two corresponding sets of feelings: admiration for the realism and disapproval of the ugliness.

The opposite situation is where we like a painting but have reasons to think badly of it. An example comes from Andy, whom I have already

quoted. He is looking at the Klee. It clearly does not meet his criterion
of realism, yet he says he likes it. He says:

> (Would it be better if it looked more like your face?)
> Yes.
> How would he do that?
> They look at you to paint.
> How would it be different if he did that?
> I'm not red and brown and white and purple, violet and pink and grey.
> Then you don't think it's a good painting?
> No, it's OK. It's got two good eyes, and you can see where they joined
> it. It's a good way to do a man.
> Anything else?
> I like it. I like the colors, they are pretty. But they could do his mouth
> better.

Andy sees that the painting is not realistic, especially with respect to
color. In that way it is a poor painting. But he likes the colors because
they are pretty, and the eyes because they are drawn well. This liking is
based on stage two criteria – beauty and realism – just as is the disap-
proval. So again there is a conflict of criteria rather than just of judgment
with preference. This accounts for Andy's reluctance to call the painting
poor. When a painting does not meet one of our criteria, we often find
other reasons for praising it. Where it is not realistic, we find it pretty;
where it is not pretty, we find it interesting; and if it is not interesting,
perhaps it is full of detail, or historically true. One of the advantages of
having several criteria is that we can usually find something good about
a painting and avoid making negative judgments.

Sometimes we are aware of a conflict of criteria and can talk in general
about what to do with it. We recognize that our judgment must vary
with the criterion we are thinking of, though not that we can have
grounds for choosing between criteria. Brian, eleven years old, states
this quite clearly. He dislikes the subject of the Albright, but admires its
realism. What he says could easily be the conclusion to Andy's prevar-
ication with the Klee:

> (How do you decide whether it is good?)
> It would depend on what level you were talking to someone about it.
> It would depend on what they thought: if they were talking about the
> subject, or if they were talking about the way it's drawn.

Most children at stage two agree with Brian. In cases like this, "it would
depend." We can choose either criterion, beauty of subject, or realism
of treatment. This appears to be a free choice, undetermined by the
character of the painting itself, one for which we can offer no reasons
and must therefore be taken as a kind of natural fact. We do not ac-

knowledge responsibility for the criteria we use, and do not see them as connected with the self.

The natural criteria reversed

Brian's point can be taken further. It is possible not only to choose one criterion over another but to reverse one of them. At stage two this reversal is also accepted as a fact for which no reasons can be offered. The reversal of our criteria is as much beyond critique as our criteria are, though it is more surprising. For example, some people prefer ugly or violent paintings to beautiful ones. Bernard, thirteen years old, says of the Albright:

> (What could he have done to improve it?)
> I think he could have done something more with the lady; she didn't have to look like that. He could just have the face without the legs, and the weird stuff there. Or he could have made her legs look halfway human. I mean those don't look very – all the flesh, the whole thing! Possibly he could have got a different subject instead of this lady.
> Something less depressing?
> Well, not actually. If he was looking for something depressing, he did a good job.

Bernard is not quite saying here, as perhaps Adeline would, that the ugliness conflicts with the realism. He is saying that Ida is ugly, and if you can make that your criterion then it's a good painting. He also makes it clear that ugliness is not his criterion; he does not share it, and is surprised that anyone could adopt it. Nevertheless, he supposes that ugliness was a criterion for the artist, that the artist thinks the painting is good because it is ugly. Bernard accepts this reversal of the usual criterion, but his tone suggests that it is an alien fact, hard to believe and impossible to share.

In the same way some people prefer abstract paintings because – and not in spite of – the fact that they are nonrealistic. They also have inexplicably reversed the shared and obvious criterion. For example, Bennie, twelve years old, says:

> Sometimes art is – I don't think it's art.
> What kind is that?
> Well, like I said, Modern Art. All it is is just splattering paint on a piece of board or scribbling with a pencil. I mean, anyone can do it. And there's no artistic form to it . . .
> They just sort of scribble?
> Yeah, it's just whatever comes out. Now, I know some people like that sort of art, but I personally don't.

In this passage, Bennie asserts two apparantly contradictory things. One

is that there is no good reason for thinking well of Modern Art. The
other is that, as a matter of fact, some people do think well of it. This
is paradoxical. The conclusion can only be that "it all depends" on which
criteria you choose and on whether you reverse them.

The relativism of taste

In such situations the judgment depends on the criteria of
whoever is looking at the painting. It will be valid for them but not
necessarily for others. Validity depends on the criteria chosen, and the
choice is simply a behavioral fact for which one can offer no reasons.
This permits an indefinite number of criteria. Consequently the most
common answer to the museum question (How would you choose the
paintings for a museum?) has to do with the number of people who are
pleased. An extreme, but not unusual, example comes from Bertie, eleven
years old:

> (You were saying that sometimes an artist has a bad painting. How do
> you know when it's a bad painting?)
> I don't think an artist – I may have said that – but I don't know, now
> that I really look at it. I think no artist really doesn't do a bad painting.
> Some people may think it's bad, but it's never really bad to some.
> Somebody's always going to like it?
> Yes, somebody's always going to like it. There's a thousand billion
> people; I mean somebody's going to like it.
> And as long as somebody likes it, it's a good painting?
> Yes.

This a typical case of stage two relativism. But "relativism," we must
notice, is not one view only: It has many varieties, at least one for each
stage. This is a behavioral relativism. Bertie is not claiming that it is
meaningless to say that a painting is good. He is saying that it means
that it meets someone's criterion, and that therefore someone would
choose it. This leaves the logical possibility that there is a painting that
meets no one's criteria and that therefore no one would like, including
the artist; and which therefore would be a poor painting. This possibility,
which might seem rather abstract, is suddenly realized, for Bertie cannot
imagine anyone liking mere scribble. He goes on to say:

> Yes. Though if you take a picture and scribble on it, no one is going
> to like it. I mean out of a thousand billion people, no one is going to
> like the scribble.

Bea, nine years old, has a similar idea. She also would take votes on
which paintings to put in her museum because every painting may please
somebody. However, the *Guernica* is so ugly that she cannot imagine
anyone voting for it. She says:

(If you were a museum director, how would you choose which paintings
to put in your museum?)
The ones I like best. No, I'd have all the people in the city and have
them choose which ones they like best.
Which ones would they choose?
This one [the Chagall], and the girl and the dog.
Would they choose the *Guernica*?
No, everything but the *Guernica*.

Liking the *Guernica*, it appears, implies a behavior so strange that she
cannot imagine anyone doing it. Its ugliness, we might say, is so extreme
that it could not be liked even by those who otherwise reverse the natural
criteria.

I will call this understanding of criteria and our freedom to choose
them the relativism of taste, or "ice cream" relativism. Most of our
likings are reasonable and do not require a relativist view to explain
them. For example, we like paintings that are beautiful and realistic.
These criteria are self-evident and virtually everyone shares them. Their
obvious and shared character lends them a validity for which we need
give no further reasons. We agree intuitively on the criteria for judgment;
we need think no further. The problem occurs when others reverse our
criteria. We can explain this situation by using the word "taste." My
teacher likes paintings *because* they are not realistic? It's his taste, we say.
And, yes, it's good – for him – if he likes it. For example, Bruce, ten
years old, says of the Renoir:

(Is it a good painting?)
Depends on your taste.
What does that mean?
If you like sloppy art, where they splash the colors on.
Do some people like that?
Yes.

"Taste" here appears to be a metaphor from the eating of food.
Whether it is intended or not, the metaphor seems quite appropriate.
When I say that I have a taste for strawberry ice cream, we understand
that I am talking about what pleases me. I am not focusing on what is
good ice cream, but on my liking. Nevertheless, I do imply criteria. For
instance, the ice cream must taste like strawberries, or it will not meet
my taste. Also it must be made reasonably well, so that it looks and
tastes like ice cream. In much the same way, if I say I have a taste for
beautiful paintings the criteria of beauty and realism are implied.

But I know someone else does not like strawberry ice cream. Perhaps
the more it tastes like strawberries, the less they like it. On the other
hand, they like some other flavor: coffee, perhaps. The difference is then
a matter of taste, though our taste in both cases implies criteria.

My own criteria are taken as self-evident and widely shared. It is odd when people do not like strawberry ice cream; I am surprised when they do not. If I were to find that most people do not share it, I might drop it, that is, on examination come to see that strawberry ice cream is not really good and that I don't really like it. But of course there would be no strawberry ice cream to start with, if that were the case; it would not have been out there in my social world to be discovered.

These remarks apply to beautiful and realistic paintings. We have developed a taste for them because there are beautiful and realistic paintings out there to be discovered. We share the taste with the indefinite plural other who populates our social world, and regard it as a fact about human nature. As we see more kinds of paintings we gradually enlarge our taste; more things come to be beautiful or realistic as art teaches us to see them so. And we can understand some differences of taste as reasonable; i.e., as based on the same kind of natural tendencies as our own. Some prefer the Bellows to the Renoir, whereas we reverse the preference. This means that they weigh realism more heavily than beauty; but they do acknowledge both criteria. But there are other paintings – the Albright and the *Weeping Woman*, certainly – that we cannot encompass in our growing taste, which do not appear to be naturally likable. Liking them requires liking ugliness not beauty, sloppiness not realism. A parallel might be gasoline flavored ice cream. A taste like that we might recognize but cannot share, cannot imagine sharing. We cannot accept the reasons that justify such judgments; we can hear them only as facts, and not as reasons. "Ida is ugly" is no more a reason for liking the Albright than "it tastes like gasoline" is for liking ice cream. Such a taste is opaque, an uninterpreted blob on our social radar scanner: something we know about, but cannot understand. Relativism at stage two is an attempt to account for this situation. Indeed, this is true of relativism in general. Relativism at each stage is an attempt to account for what we cannot understand in others.

There is an important principle here. We understand the judgments of others by reenacting them for ourselves. Where we can grasp their reasons as reasons, we understand their judgments. Where we cannot grasp the reasons as reasons, the judgments are opacities. We can understand in others only what we can find in ourself. The reverse is also true. We can understand aspects of ourself as we find them in paintings. We clarify our feelings by discovering that they respond to the character of the painting. Consider again the dog in the Renoir. Before we saw the painting we loved dogs perhaps, but were not clear why. After seeing it we can see why, because the painting shows us. It is because of the lovable character of the dog, his playful air, and so on. We can see that our feelings are based on these objective qualities, and in this way they

become clearer to us. We understand them insofar as they are based on the painting and can be shared with others. If they cannot be shared, they remain private, whether in ourselves or others: uninterpreted idiosyncrasies, alien "tastes," dark patches on the screen.

STAGE THREE

The criterion of genuine feeling

In Chapter 3 we saw that the chief criterion of stage three is whether the painting expresses an experience that is felt to be significant. What does this mean for judgment? The same themes recur: the role of criteria, the temptation of relativism, the connection with self-understanding, all affected by the characteristic emphasis on subjectivity.

This criterion may mean that a painting is good if, in painting it, the artist expressed her feeling or fulfilled her intention. This captures well enough a stage three understanding of what is important about art, if we are thinking about the artist's experience; but it has problems as a criterion for judgment. The chief problem is the difficulty of telling when the criterion is met. We rarely know enough about the artist to tell, independently of the painting, what her feelings or intentions were. Craig, seventeen years old, admits this when asked the museum question. He replies that museums aren't important. The chief question is whether the artist is satisfied with her painting:

> Well, I guess, like, I don't know, a museum isn't really important. I think the main thing that is important is if the artist is satisfied with what he has done, and if he can look at this painting and, like, he sees clearly what he has tried to say. And so I imagine he would like people to look at it and try to get what he is trying to say. I guess that's what museums are for. But then it would be hard to say, like, if this picture [the Chagall] made it, or what.

Craig's logic is clear enough. We can't be sure from a painting how the artist felt. The idea of the artist expressing herself is a useful guide for appreciation because it tells us to look for something inward in the painting: "He would like people to look at it and try to get what he is trying to say." But it is not helpful as a criterion for judgment: "It would be hard to say, like, if this picture made it, or what."

As we think this through we are left, inevitably, with our own experience as the chief evidence we have for the meaning of the painting. We must grasp the meaning for ourselves if it is to be appreciated and our judgment is to be valid. This insight is fundamental to all subsequent development, and, once reached, it is taken to be obvious. Carie, an undergraduate, puts the point in a characteristic way. Even if we disagree with the artist, it is our experience that must count:

You know, I think it's all in the person who's looking at it, and their interpretation of it. The artist might even paint something and say: "Oh! This is a bad painting! I didn't put a lot of work into it." And someone else might see it and say: "Oh! That's a great painting! I love the way you put those colors." So I think it would be hard to judge. But I like this painting [the Chagall]. It makes you think about things. You could look in every corner, there is so much activity going on; you can interpret different things out of everything you see there.

This criterion of personal engagement is matched by the character of our feeling. Where at stage two we admired the beautiful and the realistic, now we cherish the deeply felt. We can tell genuine feeling from conventional admiration, the real from the routine. We prize real experience, and distinguish it from the habitual application of conventional formulae – which is the way stage two judgment looks to stage three. Words like "genuine," "honest," "real," "true" emphasize the point. We must be honest about how we feel; there must be no inattentive habit and no pretending to oneself or others.

Honest feeling is feeling that is actually felt. To see this is a step forward in disentangling aesthetic from moral judgments. It no longer matters aesthetically what subject a painting has, nor whether it has an elevated moral tone. To insist on moral elevation in art is self-deception. Of course, morality is still connected with art, but in a different way. Now it has to do with how honest the artist is, and how genuine the viewer: Honesty is the morality, phoniness the immorality, of art at stage three.

All of this presupposes that when we look at a painting we can grasp another's subjectivity more individually than we did at stage two. In the case of the Goya, for example, we must sense how it feels to fight in a war like that; in the case of the Albright, how Ida feels. This requires a new, two-way interaction between us and the painting.

On the one side, we consider what the painting tells us about Ida's situation; for example, what her body is like, her room, what she is doing. From this information we try to recreate her feeling in ourself. And from the other side we ask ourself how we would feel if we had that look on our face, sat in that posture. It is a kind of matching procedure, both a modeling of our feeling on Ida and of Ida on ourself, testing one out against the other, a back-and-forth interplay, as we try to construct how she feels. The final test is our own feeling and its coherence. We get glimpses of this process in quite ordinary passages like the following. Donna, an undergraduate, is trying to figure out Ida's state of mind:

> She looks like she wants to be – it's almost like she's here, but wants to be there, where – I don't know how to explain it – where she wants to be beautiful, and have the characteristics of beauty, and is kind of forlorn because she realizes they've gone. Perhaps one time she had

them, and can't accept the fact she no longer does. I don't know why I think that. There is just almost like a forlorn look on her face and the way she has got the powder puff.

In this brief passage we can see Donna thinking how she would feel if she were Ida, and then checking that against the gestures in the painting. Notice how different this is from stage two, where we assumed that others feel the way we do, or accepted as a fact that they feel differently. Either way we did not try to figure out their feelings. Now we do, by the process of guessing, matching, and correcting in an individual way. It is the process of intelligent empathy, much like what we do in real life, except that it is easier with art. Art, after all, is designed for the purpose. Not only are there few distracting elements, but the painting is, as it were, a device to display its expressive character. It is often easier, therefore, to understand another person from the inside in art than in the more random interactions of real life.

The colors of individual experience

As a criterion for judging paintings, though, our individual experience also has its drawbacks. Though we can be sure our interpretation is genuine, we cannot be sure it is accurate. Our life experience lies between us and the painting like a pair of glasses, and we cannot tell how much it affects our view. True, we can look closely at the painting again, and we can think about biases in our experience. But this does not go very far. For the final test is how the painting appears to us, and we cannot appeal from that to something else if we are to be genuine. Donna has a moment of doubt caused by this problem. She says:

> I refuse to think of the fact I am over twenty; I'm surprised when I realize I am. But I think it's human nature to want what we don't have. Maybe it [i.e. the Albright] is a general statement that there's always forlornness.
> You see that in the painting?
> That's the way I would interpret it, maybe.
> You are interpreting it?
> Yeah, I am. And I'm trying to figure out if I know – if I know somebody like this, or if it's just me. I kind of think it's me. I'm reacting to that very personally, and I think that's because I am where I am in my life, and I resent the fact that my life is half over and I feel like I'm nine years old, just getting discovered. I don't want to be there, and maybe that's what I'm seeing in that. That's my frustration right now.

Donna cannot be sure that her response is based on the painting and is not a product of her own glasses. This predicament is inevitable once we notice the glasses, the fact that we must interpret what we see. There is always the possibility of unresolvable differences in interpretation.

Dorothy, an undergraduate, is also aware of the problem. She sees the Klee as being about masculinity and femininity, but she is not sure that others would see it this way. She says:

> Femininity and masculinity just seem to, you know, stand out, but he really didn't take an issue either way. So, for instance, if I'm a girl I notice the femininity part first. I'm sure if a guy came in he would notice the masculinity part first.
> Is there a way to decide whether one interpretation is better than another?
> I think it depends on the person's background. For instance, I play sports; and while I was in high school I was pressured by – not pressured, but – I was afraid people would think I was, you know – so when I look at this, I see me playing sports, and then I see me being very feminine. So if some other person would come in here and they would look at this picture, because of their background they would look at it and find something completely different.

Notice how different this is from the understanding of disagreement we have at stage two. Dorothy understands that the painting is a carrier of meaning and that what differs is our interpretation. At stage two, a painting is something that we see but do not interpret. We all see the same thing, and what we differ about is whether we like it. It is not a question of different meanings; we do not interpret ice cream. As Dennis, eleven years old, said:

> A painting is just a thing. People have to decide for themselves if they like it or they don't like it. It is just a thing that you have.

Sometimes, at stage three, it seems so obvious that people may have different interpretations of a painting that questions of objectivity do not seem worth bothering with. We feel what we feel. Different people have different feelings, and so long as they are real they are what counts. The reality of feeling excludes the question of its objectivity. It is inescapably personal, and it is not clear that there is a way to share it. For example, Denise, eighteen years old, says:

> (Would you say this is a good painting?)
> I think it's hard to say if something is a good painting. If I say it's a good painting, it's because I like it, a lot of the time. If I had to look at it objectively, another reason why I might say I like it is that maybe I like the people's expressions. I really don't know criteria for painting.
> Are there criteria for painting?
> I don't think there can be certain criteria. I think a lot of criteria is a personal thing. Important persons might say a painting is great, and I might not think so.
> Is that it?
> I personally don't think there are [objective] criteria. I look at it with

my own criteria. I might listen to others and think: "That's right"; but I use my own opinion.

The conclusion to this train of thought is a stage three form of relativism. In this form a judgment "depends" on the viewer because its meaning does. A painting is good only if it is meaningful, and we must construct the meaning for ourself. Judgments are therefore valid only for those who grasp the meaning. Notice that again this does not imply that judgments are empty. Quite the contrary. To call a painting good is to say that it is genuinely meaningful.

The possibilities of agreement

At stage three, we are uncertain about the possibility of agreement in our interpretations and judgments, and about its importance. Sometimes we dismiss the question as unimportant, sometimes not. With many paintings – the Bellows is an example – the meaning is obvious enough that we do expect agreement. With others we may reach a joint interpretation through conversation. But not so with all paintings.

Consider the question of femininity and masculinity in the Klee, which we saw Dorothy discuss. It is not clear what two people would need to have in common to have the same interpretation. In her last sentence Dorothy expects that someone else would "find something completely different." But earlier she suggests that men would see the masculine elements and women the feminine. In this case, of course, what we see depends on our background; but since we must have one or other of these backgrounds, the chances of agreement are about fifty percent. And we might think that, if the painting is about the balance of masculinity and femininity, it would be sufficient to have either of these backgrounds.

This uncertainty about what is necessary to share interpretations is typical of stage three. It is a form of the uncertainty whether we can share interpretations at all, and with whom, and whether there is a usable criterion other than the reality of our own experience. The following extract is representative. It is from a discussion with Duncan, an undergraduate:

> (Do you think, if you had a roomful of art critics, that they could agree about which paintings would be the best to select?)
> I think that would be hard.
> What about possible?
> Boy, I don't know. I think it would be really hard to agree. You know, everybody has their own interpretation, everybody has their own ideas and their own feelings.

What kinds of things do you think the art critics would use to evaluate the paintings?
I really don't know what they would look for. For achieving something? I really don't know how they would do it, unless they chose it from what they thought the people would want to see, or what is popular for that time, or what would bring a lot of crowds in.
Is it possible to agree on the basis that these paintings have these and these characteristics, and we can all see them?
I guess, if they wanted to, they could categorize things like, say, this is a realistic painting and it has to have this balance, it has to have some technique, or be warm, or something. I don't know. I don't have a lot of experience with that kind of thing.

As this extract illustrates, the uncertainty about agreement may be accompanied by the thought that, maybe, somehow, there are more objective criteria by which to make judgments. This is a minor but persistent theme in my interviews. That there are such criteria is sometimes acknowledged, sometimes denied, sometimes skeptically considered. In any case we think of them vaguely and attribute them to others rather than ourself. Duncan says, characteristically: "I don't have a lot of experience with that kind of thing." In another example, Debbie, a schoolteacher in her twenties, says:

(How are paintings chosen for a museum?)
I guess because more people agree than don't. And I do think there are certain criteria that are used on a large scale that critics do use. They would look for those and try to be objective. Also because the artist has been chosen as someone worth looking at. He was a good craftsman; he has been recognized in the artworld. A lot depends on that.

These are the criteria having to do with technique that I discussed in Chapter 3. There I said technical things were often contrasted with expressiveness. Here the point is that, as criteria, they are contrasted with experience. They are other people's criteria, not ours. Notice in the above how they are attributed to "critics." We do not grasp them ourselves clearly enough to use them well; and, whether or not they are valid, they cannot substitute for experience. So they play no important part in our own judgment, though an awareness of them may foreshadow an understanding of the artworld that is still to develop.

What is important is our experience, which is to say our self. We test out the value of paintings directly in our experience. In doing so we come to know our self better by learning what feelings we are capable of. We may also change our self, enlarge its boundaries, by discovering new possibilities of feeling and attitude. There are examples scattered through this book, but I will give one more. Ernest, seventeen years old, says of the Goya:

How brutal is the expression on the man's face, even though he's about
to get him! It's like: Does he really want to? or is he just doing this to
stay alive, 'cause he has to, now that he's out there?
So it's about what war feels like?
Yes, because you can get pictures in a movie or magazines, but I imagine
it's quite different when you're out there yourself.

This is an imaginative expansion of the self. It suggests the same paradox:
that self-understanding occurs when we discover what we share with
others. At stage three, the circle of people with whom we can do this
consists of those with whom we can genuinely empathize, those with
whom we can have a one-on-one understanding, a sharing of attitudes.
The range of this circle of people is unclear to us, but it constitutes the
limits of the possibility of agreement in judgment, and also of our ex-
panding self.

STAGE FOUR

The offering of reasons

At stage four interpretation becomes a public process in which
we check our sense of a painting against its details and against the inter-
pretation of others. This implies dialog about the painting. Talking is a
continuation of looking at the painting, an articulation of our experience
of it, an attempt to get at the major qualities of the work. We describe
those qualities, we interpret them, we reason about them, all in the effort
to see the work more clearly.

Judgment and talk are no longer seen as contrasting with experience;
they are its guide. As we compare what we see, one may notice things
the other misses. Then we will try to see what the other is talking about;
we look at the painting again, and check her interpretation against our
experience. She can offer us reasons for her judgments. These reasons
consist in observations of particulars of the painting, connections with
ideas drawn from the artworld, and interpretations that make sense of
the whole. The test is whether we can see the qualities pointed to and
grasp the other's interpretation.

In Chapter 4 I cited several examples of reasoning based on these
assumptions, and will give one more now. Freda, a graduate student in
art, is very taken with the color of the Renoir. She says:

> But I love the color..., the wonderful color! Look at that light blue
> in there on the table! In other words, that's a white tablecloth, but it's
> got every color in it practically but white, and it models the surface.
> Here's a lot of yellows in there, and the green with the blue; look at
> the glow that comes down here! And the blue in that shadow...

Here Freda implies some of the points made above. She puts her intuitive response into speech in a natural way, offering what is both description and judgment together. Considered as description, the passage offers plenty of facts to serve as reasons for the judgment. Freda describes not her feelings but qualities that anyone could see, public features of the painting. And the description is also a judgment, for which these qualities serve as evidence. It is not just that Freda finds the colors wonderful; she expects us also to see them that way.

When Freda calls the colors wonderful, she invites dialog on the description of exactly what colors and qualities are there, but not on the ideal by which she praises them. She assumes that colors should be rich, glowing, varied, subtle. She does not state this ideal, but takes it for granted. It is for her a standard kind of excellence in paintings, one whose validity is unquestioned when we look at relevant kinds of paintings. It does have a particular origin in the history of the art, but is nonetheless inevitable now. We take such standards for granted because they are so familiar and are an accepted part of the artworld.

Other ideals may be more specific. A small example is Freda's interpretation of the tablecloth in the Renoir; she sees it as a standard device, an expected showplace for virtuosity with color, which at the same time keeps some faith with its representational function: "It's got every color in it practically but white, and it models the surface. Here's a lot of yellows . . ." We need some specific knowledge of the style to see a white cloth as an opportunity for the colorist. It might seem that this is not true; we might think that, even if we were innocent of the artworld, we would see what Freda sees in the tablecloth. We might think so, but there is plenty of evidence to the contrary in this book.

With the Renoir it is not enough to grasp an ideal of richness of color or to understand that the white cloth is a colorist's opportunity. The color is also significant in a way that requires a more particular knowledge of the artworld. We must know the attitudes that lie behind the painting and that typified the Impressionist movement: the idea of capturing the way light falls on objects, especially its local reflection of colors; the idea of putting down only the retinal image of the fleeting glance; perhaps the conception of reality that these ideas imply. "This is the way light falls, this is the way the passing moment presents itself." When we have understood these ideas, the color of the Renoir becomes not just rich, but also revelatory of reality – or at least of what Renoir thought was reality. It gives us a way of looking at things that previously we did not have. This is part of its significance. Frances, an art professor, says it well:

> Look at the skin tones! Renoir loved to paint flesh because it is so reflective of the light, the quality of the light. Look at this on the neck,

the yellow; and even the glass is reflecting things . . . He's not terribly concerned with correct perspective, correct modeling. He's more concerned with putting down exactly what his eye is recording; he's recording precisely what his eye sees, not what he knows to be true.

To speak this way presupposes an ability to relate the details of a painting to ideas of the artworld that is available only at stage four.

There is also the fact that Renoir, along with other Impressionists, pioneered this use of color. To understand the significance of this we need some sense of what came before and after Renoir. Then we can see his use of color as historically significant, as revolutionary in its time, and as leading to various further developments. We can appreciate better the immense intellectual effort and the independence of spirit required to produce it. This is a different understanding of originality from what we had at stage three, where we had in mind mostly strength of feeling, or unusualness of technique. Now originality implies a shift of style, a new vision of reality, a change of assumptions about what paintings should be. This is a matter of changing cultural ideals that transcend individual biographies and are unintelligible without a sense of the artworld as a whole, of what came before and after.

This is to say that the Renoir is a classic. A classic is a work that presents its own qualities in so compelling a way as to constitute itself as a new style. It is so persuasive that it defines its own standards of excellence; it comes to exemplify a new ideal of painting, and to suggest a new version of reality. It is in *The Boating Party*, in part, that we find the ideal of a particular use of color. There is no natural law that says that color must be rich and complex, that tablecloths must be subtle and varied, or that paintings must present the passing moment; but anyone who has seen the Renoir as Freda sees it will honor those norms intuitively. We learn how to look at paintings in a stage four way by becoming familiar with classics, not by remembering rules. In short, the Renoir sets standards that other paintings have to live up to.

There are other cases where the significance of a work depends on yet more specific knowledge of the artworld than does the Renoir. With many we must learn something reasonably specific about the artworld. An extreme example occurs in a discussion by Danto. He talks about the works by Warhol that are exact facsimiles of Brillo boxes, and asks what it is that makes them art. His answer goes like this:

> What in the end makes the difference between a Brillo box and a work of art consisting of a Brillo box is a certain theory of art. It is the theory that takes it up into the world of art, and keeps it from collapsing into the real object which it is . . . Of course, without the theory, one is not likely to see it as art, and in order to see it as part of the artworld, one must have mastered a good deal of artistic theory as well as a consid-

erable amount of the history of New York painting. It could not have
been art fifty years ago. But then there could not have been, everything
being equal, flight insurance in the Middle Ages, or Etruscan typewriter
erasers. It is the role of artistic theories, these days as always, to make
the artworld, and art, possible. It would, I should think, never have
occurred to the painters of Lascaux that they were producing art on
those walls. Not unless there were Neolithic aestheticians. (Danto, 1964,
581)

Relativism and the artworld

The structure of stage four does not encourage relativist views.
Judgment is closely tethered to the factual peg of the painting, which is
itself anchored in the public world; and it can graze only in the area
surrounding that peg. At stage four we expect people to agree, if not on
judgments, at least on the reasons that are relevant to them. We expect
discussions that consist largely in the offering of such reasons.

This implies, incidentally, that we can distinguish aesthetic consider-
ations from moral ones in the traditional way. Moral questions have to
do with practical actions affecting others; aesthetic ones with the qualities
of works of art. From the aesthetic point of view, therefore, there are
no moral considerations relevant to the judgment of art – unless they
are themselves part of the subject matter, as we might say that the Goya
and the *Guernica* express moral outrage at the horrors of war. If there is
a question, it is rather how to protect art from the moralistic intrusions
of those who do not understand the distinction, who would, for example,
ban a painting because it pictures nudity – the sort of judgment we might
make at stage two.

Another way to put the point about relativism is to say that the circle
of people with whom we implicitly share our judgments has expanded
to include all those who are touched by the artworld. For example,
Geoffrey, a graduate student in education, talks about the sorrow in the
Albright. He has said that it is a painting about loneliness, and for that
reason it is a good painting:

> (If I were to say it's a poor painting, then, would I be wrong?)
> Yes, I really do think you are wrong... Whether you enjoy it or not
> isn't the question. He's not asking you to enjoy it. Nobody's enjoying
> anything in this picture.
> Why can't we just agree to differ?
> My feeling tells me that relativism just isn't a valid philosophy... It's
> hard to explain why, though.
> Do you think I should recognize your bit about loneliness as a reason
> for me?
> Yes, I think so. I think mainly because loneliness is a part of every

human's experience. Definitely it is, and this is about loneliness. Any
way you can understand your life better, any way an artist can help
you do that, is a good painting.

What Geoffrey thinks we share is not just views about art, but some
basic human needs and experiences. The people he identifies with are
not friends, nor just art-lovers, but those who can be lonely. In the same
way, Greta, another graduate student, says the *Weeping Woman* is based
on the universal experience of grief, and is therefore objectively good:

> This is another one I absolutely used to hate, but now I like it. I like
> it because I learned to understand it a little more, how he showed so
> much, like, grief in this woman. Like with her eyes just both on the
> one side of her head, and just coming out of the socket... If you took
> this and put it next to a realistic painting, something you can really tell
> it's a woman crying, I think this woman would be more emotional,
> because it's like when you are upset, you just go to pieces, and that is
> like what she has done, literally. Like her eyes are in places they
> shouldn't be...
> Do you think he is portraying a particular person's grief?
> No, not just one, not just herself, but anybody's. He's saying: "Look
> at this. Everyone goes through this sometimes; and it is OK you have
> these bad times." Some may be real bad, like she is going through; a
> lot of them, I guess.

The thought seems to be that the artist can be understood only if she
expresses what all people feel. If she does that we can all share her feelings.
If what she expresses is idiosyncratic we will not recognize it. The feel-
ings, of course, do not have to be ahistorical, like grief, to be "every-
body's"; for "everybody" means our contemporaries. For example,
Robert Hughes says somewhere that any serious contemporary work
must express a sense of anxiety, because "everyone" is anxious since
nuclear war was invented.

Our artworld today is international in scope, vague in its limits, but
far exceeding any state boundaries. It is somewhat like, though not
identical with, the democratic world. It draws on many sources and
traditions, contains many variations and movements, but in an important
sense it is one world, roughly as large as all those societies touched by
the Western tradition. It is perhaps not as large as the world of modern
science. For example, it is not clear whether Russia and China are really
a part of our artworld. The test is whether one can discuss contemporary
painting with people in those countries, offering and receiving reasons
of an appropriate kind. Anyone who can do this is a part of our artworld.
Others are not, because we cannot share their judgments.

This thought, if we follow it out, could readily provoke a form of
cultural relativism: the view that judgments are valid only within an

artworld. According to this view our judgments depend, not on our tastes, as at stage two, nor on our gut feelings, as at stage three, but on our culturally learned ideals. This seems compatible with a stage four structure, though I have no example of it to quote. And, like the other versions of relativism I have quoted, it is also compatible with the view that judgments are meaningful for whoever shares our situation.

None of this implies that at stage four our judgments have lost their connection with our intuitive experience. We have not become dry, academic, or out of touch with our feelings just because we have become interested in the history and conversation of the artworld. Our judgments are as related in the end to our experience as they were before. But the phrase "in the end" contains a difference. We are now more willing to be guided in the short run by the experience of others, since we understand them to be talking about something objective. We match our experience with theirs. Where the match is not good we do not conclude, as at stage three, that it is a matter of personality differences, or become cynical about the claims of others. Rather we are willing to look again, talk some more, and withhold judgment. It is reasonable to spend time on the views of others, even if at first they have little meaning. Our experience has not become unimportant, but we have become aware of its limitations, and we know the vision of others can enrich it. But "in the end," experience remains the court of judgment.

A characteristic expression of this structure is the idea of a masterpiece. The idea that the significance of a painting may transcend the consciousness of any individual makes it plausible to visit it many times, each time finding a richer experience and a deeper significance. This is true, of course, only of some works. We call such works masterpieces. They sum up the sensibilities of an age, bring to a full expression its tendencies and ideals, and offer a vision that stretches as far as the group can see. Because they embody the values of a community, they are inconceivable without that community. In them the artist has done more than any person alone could do: She has used the insights and accomplishments of others, putting them together in a new way, to speak for a generation. She has articulated the ideas and attitudes of her contemporaries, and so created a work from which everybody can learn. A masterpiece is food to grow on.

The psychological structure for which the idea of the masterpiece makes most sense is that of the good member of the community. At stage four we identify with the community because it is ours, and we understand it from the inside. We find ourselves reflected and enlarged in it. It turns what was before felt only subjectively and vaguely into something clearer and more objective. And because the conversation of the community is more than we could manage by ourself, it helps us to

grow, to reconstitute ourselves in the public air, with a wider scope and more connectedness, with horizons that stretch to the boundaries of the community. To be a good member of the community is to want to be a better one, a representative of its virtues. A great work of art is a complex image of values that we absorb, take as inevitable, and try to embody. We love its glories, adopt its ideals, and seek to capture its nuances. This makes art a powerful instrument of character education, something the ancients understood but our more efficient age seems to have forgotten.

STAGE FIVE

Questioning experience

At stage five we make judgments on our own authority and not on that of the tradition. We are independent judges in that we can question the ideals and categories of the community, and do not rely on the agreement of others to validate them. Our independence requires us to be as reasonable as possible and oriented to the public validity of what we say. While we are free of the need for an actual consensus, we imply the possibility of an ideal one.

I will start with an example. There are a number of things to notice about it. One is the self-awareness we bring to the painting, and the willingness to examine our experience of it. It comes from a conversation with Henry, a professor of art, about the Chagall. Henry is familiar with the traditional view of Chagall, but finds something in his response that does not fit that view. Henry examines his somewhat negative experience of the painting and interprets it in several ways. His interpretations circle around the question of whether it is a response to something in the painting, or whether it is due to something idiosyncratic about himself. This is a central question for him. Henry begins by attributing it to himself, and not the painting:

> My first reaction is that they made too many prints of Chagall. He has a very personal way of looking at things, partly naive, partly surrealistic, not formal, not academic – the artist as a shaman, a magician, a story-teller – very much from the personal – and normally I like those kinds of things. But I've got a habit of seeing reproductions of Chagall all over the place – college bookstores, K marts, and so on. In a way, the problem is, when culture gets filtered down to that level, you get over-saturated . . . It ruins the great and it helps the mediocre, all at the same time. So my first reaction is, I've seen too much of it. I'm jaded by an over-familiarity that kind of ruins my reactions. I see it as less disciplined and in a way as less personal, because of that.

Henry has begun by indicating in a rapid way the traditional views of Chagall, and confessing that he cannot wholly agree with them. He sees *Circus* as "less disciplined and in a way less personal." But this is because of his own situation: "I'm jaded."

It is important to note that postconventionality does not require disagreement with traditional views. Most of the time we agree with them because, after all, they are usually more or less right. It would be strange to suppose anything else; views would not survive to become traditional if they were not, by and large and on the whole, reasonable views. At stage five, we usually respect the views of others. We cannot reasonably – that is, on the authority of our own grasp of the reasons – agree or disagree unless we understand what we are to agree or disagree with. We must earn the right to disagree. Here Henry is not sure he has done so. He thinks it likely that the Chagall is both disciplined and personal, and his dissatisfaction comes from his own private situation. It is always possible that what we think we see is not really there but depends on something idiosyncratic. The difference is subtle but crucial. As Michael Fried says, in a slightly different context:

> One's experiences of works of art are always informed by what one has come to understand about them; and it is the burden of the . . . critic both to objectify his intuitions with all the . . . rigor at his command, and to be on his guard against enlisting a . . . rhetoric in defense of what he fears may be merely private enthusiasm. (Fried, 1982, p. 116)

The question for Henry, then, is whether he is talking about something "merely private." The conversation continues:

> Are you saying that it's just you, being jaded on it; or are we all spoiled on Chagall in that way?
> Some of my peers and contemporaries have had the same thing, I think, or they do that with other people. At the same time, I'm happy to go to Lincoln Center and see those big [Chagall paintings] there. So I don't know if it's – I'm not sure.
> Is that an interaction with this loose kind of style, and with a more disciplined painter it wouldn't happen?
> I don't think so, because it happens with others. There's a lot of Op artists around in reproductions, for instance. Vaserely, I think, there's too many of those around, and I can't see them anymore. It's not, you know, elitism or snob appeal I'm talking about. I look at reproductions all the time. I'm kind of a populist – well, a blue-collar elitist – but I think reproductions have both used and abused serious art. So what this Chagall is competing with at this point in time is the overexposure and the imitators that have jaded us all.

Here Henry has changed his interpretation. It is not only that he is jaded on Chagall, but that we all are – "all" meaning his "peers and contemporaries." This may not be Chagall's original problem, but it is a fact

about the historical situation in which we all now look at Chagall's paintings. In that case Henry's judgment is made on behalf of us all; it is intended as true not only for himself, as he first thought, but for anyone now looking at the painting. And this would be true even if no one agreed with Henry. It doesn't settle the matter to appeal to the experience of others, though "some of my peers and contemporaries have had the same thing, I think." It helps, but is not decisive. At stage five consensus is important in a way different from before. At stage four, the actual agreement of others, embodied in the tradition, was important as a guide to valid judgment; we wanted to see what others could see. Now it matters more as an ideal than as a fact. Others should agree with our judgment, because it is a reasonable one. Whether they do agree does not affect the truth of the judgment. There is a parallel situation in other domains. A scientist who advocates a new theory does so because he thinks it is right in light of the evidence. That is the meaning of his judgment, no matter how many others disagree. Something like this is true of Henry. He thinks there is something a bit jaded about the Chagall; and has attributed this, so far, to the influence of reproductions and imitators, influences that affect us all. But the conversation continues:

> Also I think that Chagall – that at some point in the fame-gaining process sometimes you tend to take the pressure off yourself, and I think that Chagall got a little soft at times. It's sort of the opposite with Picasso, though he was no more honest than Chagall. . . . The catch phrase is, with Picasso: Up until *Guernica*, he did art; after *Guernica*, he did Picassos. At one time I agreed with that. Now I totally disagree. He kept the pressure up by constant change, and when he made mistakes, they were glorious mistakes. With Chagall, it's not a matter of making mistakes, but from the lyricism and very personal, his overstatement becomes soft and mushy.
> You're saying this is a case of Chagall painting a Chagall, and not art, are you?
> Could be, could be. I think it's better to peak and become famous at 85, so this doesn't happen.

Henry has again reinterpreted his uneasiness, though he has not rejected his previous interpretation. He has shifted from features of our present situation to the problems of Chagall the artist. But, though he has spoken of Chagall in general, he has not yet discussed *Circus* in particular. He has not given reasons for this latest interpretation, has not pointed to aspects of the painting and described them in terms that others might agree with. So the conversation continues:

> (Could you put that in more concrete terms, do you think? Where do you see mushiness in this particular case?)
> Yes, well – in terms of color, there's some shots of bright yellow, and

a red hand, and things like that, and to me those are glimpses of a directness and more honest. The overall blue is a passive color, and is loaded with art clichés, and to me it's less decided – though I know as a painter he doesn't intellectualize things – but it's not decided enough. And part of the problem is there's so many things in here, and I don't get to see the interesting things because of them. This central figure here, juggling his head – which should mean it's important to him – well, it has a kind of whimsy and to me it's an interesting part of the whole. That and the red hand, because it's red and it's separated, and I like the musician standing on his hand. In that case I don't demand much of it, so I kind of like it. But some of these musicians down here, making little clay dolls – well, I see – it becomes too much of a full orchestra, and I don't see a sense of focus. I'd rather see a short story than a novel, here. Then the indulgences wouldn't happen. Some of these things are just filling it up and don't have enough interest.

There are several features of this conversation that are worth noticing. One, which I have already discussed, is Henry's constant awareness of the question whether his experience is "merely private"; whether he as a viewer has become tired of seeing Chagalls, or whether Chagall as an artist became tired of painting them. This requires him to hold his own experience in question, constantly to ask: "What exactly is my experience and what is it experience of?"

Another notable feature is Henry's historical awareness. He is aware of history as a stream of continuing change that affects himself and his contemporaries, and did affect Chagall as a painter. It also affects the painting. The character and significance of *Circus* may change with the context. That is why it is hard for Henry to be sure just what it is he sees, and necessary for him continually to reexamine his response. We can contrast this with our earlier sense of history. At stage four we are influenced by the history of art, but we take that history as finished, and not continuing, change. True, we no longer see a painting as a thing but as a cultural product with a historically constructed meaning. But that meaning is still in one way like a thing: It is already finished, something to be accepted as it is. Chagall's work was done at a certain time, and that determines the significance of, for example, his use of color and form. Its significance, though historical, does not change. It remains fixed, like a thing, perhaps more like an event in a novel. At stage four we do not make the distinction that so taxes Henry above, between the character of the work when it was done and its character now for us in light of our changing society and artworld. And so we do not have to do what Henry has to do: constantly to examine previous judgments and ask whether they are still valid.

Henry does not deny that we can go back and see the painting as it was. But this is different from looking at it in its current context, from

making Chagall our contemporary. The latter is what he is interested in, the changing character of his own responses. Being aware of what a painting was can help with, but cannot settle, the question what it is now.

Another feature of Henry's discussion is that he talks as much of Chagall and his works as a whole as he does of *Circus*. His main focus is the style *Circus* exemplifies. He is interested in the style's tendencies, its strengths and weaknesses, in what it can do. He looks at particulars, but sees them as representative of something more far-reaching than this one painting. This is also characteristic of stage five.

The question of style

We see the same tendency in another conversation. Hugo, also an art professor, is looking at the Albright. He sees the sensationalism that Mary previously reacted to, the attempt to "hit you between the eyes" that she deplored. But Hugo thinks there may be more to the painting than this. There is some tension in it, some complexity that Mary did not take account of. He analyzes it in terms of "traditions," a term that seems to function very like "style." He says:

> There's a very pragmatic, regionalist way Americans view themselves. Albright is someone who loads that view heavily, like a – almost like a reporter for *True Confessions*. He deals directly with the images, documents them very well. It's very traditional, excessive chiaroscuro, light logic. He's from the tradition of artists who are almost like reporters, in a way. Also, in a way, he is partly in a kind of Gothic tradition, setting a heavy mood, the Dorian Gray aspect of it.
> Would you say the painting is oversentimental, then?
> In a way, maybe – but, no, I don't go that far. I think maybe the excesses he chooses to use save it from that. OK, it comes close to that, but I think there's a tension there, because of the drama of the lighting and all that. It's as if she were on the stage. You know there's a spotlight up there, and the exaggeration in the legs is purposeful. You've got to read it as purposeful . . . So, with Ida here, she's got those characteristics, the figurative, regional rusticness. But that, along with the stage-like setting, the lighting, it's kind of like Albright would say: "I know what you're going to say. I know what you're going to say, but it's better than that. It's serious, it's more than it appears to be."

Hugo suggests that Albright was aware of the sensationalism of the tradition from which he came, and deliberately overplayed it, not to mock it but to use it. Hugo points to some of what he sees to support this interpretation: the staginess of the pose, the setting, the lighting. These suggest Albright's awareness of his own style and the traditions

embodied in the painting. Is there anything more? The interview
continues:

> Could you be more specific about that, do you think – the kind of
> tension you see there?
> The surface is very rich. The texture is a kind of needless information.
> It's a tradition that comes from Van Eyck and a lot of places, where
> excessive texture – everything is in focus in this painting: the chair, the
> floor, the articles over here, the legs, the clothes. And because of this,
> in a way, everything becomes abstracted, it becomes an abstract paint-
> ing. By giving each area 100% attention, you kind of cancel out the
> effect, and it results in a curious kind of flattening. It's keyed up to the
> fact that it really is a painting done on a flat surface, and that contrasts
> with the lighting, which is a great way to lie about the flat surface. He
> parallels that illusion by giving everything equal weight in all that
> texture.

The tension is now clearer. There are two tendencies in the painting,
two styles, or traditions, that have influenced Albright. There is the
sensationalism of the *True Confessions* type, itself exaggerated into self-
conscious staginess; and there is the emphasis on flatness brought about
by the heavily focused detail, in a tradition "that comes from Van Eyck
and a lot of places." The former invites the viewer to empathize with
Ida and her sorrows, as we unreservedly do at stage three; but the latter
makes us conscious that this is only a painting we are looking at, a stagy
one contrived to make us feel for Ida. The over-texturing and the over-
focusing remind us that we are looking at a painting at the same time
that we are drawn toward Ida. The tension is thus in the painting itself.
We could even say that this tension is Albright's "real subject." He both
uses and comments on the traditional style of presentation that Hugo
describes as "almost like *True Confessions*." What we see is a style itself:
how things are often presented to us, and how we often see them. The
"real subject" is a certain mode of perception and feeling that is both
presented and questioned, a mode with which we are quite familiar, since
it is "a very pragmatic, regionalist way Americans view themselves."

It is possible, then, not only to see paintings as examples of styles, but
as being about styles. It is a common idea that art raises into question
the way we see things and it has been an explicit concern of many artists.
A typical statement comes from a recent book about a contemporary
exhibition – both named *Real, Really Real, Super Real*. In it, Don Eddy
says about one of his paintings:

> My work presents the observer with a series of cues that stand in mutual
> opposition to one another: the assertion of space and the denial of space,
> the suggestion of imagery and the dissolution of imagery, the presen-
> tation of a logical scene and the complication of the scene to the point

of incomprehensibility, and so on. In untangling these opposing logical paths one must reflect on how visual data can be organized. Thus imagery in my painting is not the subject of the painting but the vehicle by which one reaches the subject: the nature of visual perception. (Eddy, 1981)

To question perception is the same as to question experience. It is to ask how we should interpret what we see. Don Eddy says he tries to make the viewer do that; Hugo says the Albright gets us to do it. It is also what we saw Henry doing in the previous conversation. Such questioning is important because the meanings of things change and cannot be taken for granted. Our way of perceiving also changes and therewith our self; for "how we see things" includes how we feel about things and value them. Throughout his interview Henry shows himself to be aware of his changing self. He says, for instance:

> I have many heroes. And some of my old heroes are not so heroic as they were – I keep changing my opinion. I've gone back and forth on Picasso a number of times. At one time I thought he couldn't draw. I went from that to thinking: "Oh! he is a god!" to saying, "I'm tired of Picasso" to, "Hey, wait a minute! Picasso wasn't just one person, he was a whole bunch of people, he was everybody, and you can't get enough of Picasso." I've done that with a lot of people: They go in and out of favor with me and culturally and historically.

At stage five, in short, our experience needs constant reinterpretation if we are to avoid mistakes about our needs and feelings. Otherwise we will take for granted old perceptions and interpretations of them. Art helps us to get clear about our experience, and ourself, as well as we ever can. In the end its function is to make our inner nature transparant, both to ourself and to others.

Reasons for judgments

We understand ourself by getting clear about our experience; and we do this by articulating our judgments and our reasons for them. We expect others to be able to understand these reasons, and to offer us reasons that we can understand. So we help each other, enlarging and clarifying our responses. When this happens we make ourselves contemporaries. We understand each other, and have the same experience. For being contemporaries does not mean living at the same time: It means talking to and understanding each other.

It follows that postconventional judgment is essentially social, a matter of dialog. It is not a verdict dictated from the sovereign throne of an isolated consciousness. That cannot be if we are to hold our own experience in question. The essence of stage five is the seeking of reasons

for interpretations and judgments, reasons which must in principle be available to anyone. To offer reasons implies engaging in dialog and being willing to reinterpret our experience in light of what others say about them. Neither artist nor viewer can afford to be dogmatic for we know we can always be corrected. Hugo expresses this in his comment on his own interpretation of the Albright. He says, at the end of the conversation quoted above:

> At least, this is the way I read it. I don't know if Albright knew what he was doing. You can always say to the artist: "You did this"; and he might say: "I didn't." You say: "You did;" and he says: "Oh, I didn't know that!" Because a painting is always a product of circumstances, and you can't always see what you're doing.

At stage five we distinguish judgment more clearly than before from interpretation. Interpretation is the reconstruction of meaning; judgment is the evaluation of the worth of the meaning. Previously, we did not distinguish these two. We were more concerned to establish the meaning of paintings than to judge the value of those meanings, and we judged a painting valuable if it was meaningful. At stage five, however, we want also to ask whether the meaning is worthwhile.

At stage four we often judged paintings in terms of styles. A painting was good if it was a good example of a style. The style itself was taken for granted, a fact of the artworld, something established by tradition. We did not think to judge the style itself. At stage five, however, the value of a style is a prime question: what it can do for us, what it can express, what tendencies it gives to our experience. There are many styles in any tradition, more than anyone can thoroughly explore. Each has its own character, can express some things well and others not. Each is a bias in favor of certain qualities, and affects in certain ways the person who adopts it. And in the end, we must choose between them, because there is not time for everything. It is as if a style is a direction to move in, a possible self, and we must ask whether that self is worth becoming. We can always learn more of a style, but will it be worthwhile? Would it be better to choose some other?

How can we choose? Ultimately we must choose in terms of the direction that seems most valuable to us, the self we most want to become. This is a personal choice, one that must be made for ourself and on our own authority. Nevertheless, as with all stage five judgments, it is made on behalf of our contemporaries. For the question is not only what style should I adopt, and what self become. It is also what style we should all adopt, and selves become. Is this style valuable for us all? The question is implied each time we confront a painting.

It is ultimately a question about human values, not a narrowly aesthetic question. Henry, for example, sees in the style of Chagall a certain

whimsy, an honesty and directness, and a kind of softness. These are human virtues and vices, not merely aesthetic qualities, and Henry weighs their value in judging the painting. He likes the whimsy and dislikes the softness. In the same way, Hugo sees in the Albright a kind of sensationalism, of self-awareness and of complexity. Perhaps a better – because more careful – example comes not from my data but from Robert Hughes, an author characteristically explicit about his value judgments. Hughes is discussing the paintings of Clyfford Still, and more generally the New York Abstract Expressionists. He finds a similarity with the style of an earlier generation of American painters, itself a nontraditional pairing; and he describes it in terms which refer to both the paintings and to the human values they express:

> The link between Still's work and nineteenth century landscape painting is obvious. These fissures and flames, dark promontories and turbid ravines of color inherit the theatrical, even operatic diction of Bierstadt and Moran, in the same way that Rothko's more sensitive talent took up some of the characteristics of the Luminist painters. While it is true that Still's work should not be read as literal metaphors of the Grand Canyon or the Rockies, it is equally true that they are meant to provoke the same kind of emotions as painters once looked for in such convulsions of nature: a "heroic" sense of enterprise and spectacle, a mood of pantheistic energy, and a coercive tone of voice. (Hughes, 1981)

We can see in such a passage descriptions of aesthetic qualities and interpretations of them as style, culminating in an evaluation in terms of human value. The phrases "a 'heroic' sense of enterprise" and "a coercive tone of voice" convey Hughes's characteristic depreciation of the rhetorical and grandiose in our anxious times.

In summary, the experience of art at the postconventional level is a constant exploration of our experience, a trying-out of the self that we might be, and a continuing conversation with others about both. I cannot do better than to close with a quotation from Collingwood, one of my own old heroes who has not ceased to be heroic:

> As a finite being, man becomes aware of himself as a person only so far as he finds himself standing in relation to others of whom he simultaneously becomes aware as persons. And there is no point in his life at which a man has finished becoming aware of himself as a person. That awareness is constantly being reinforced, developed, applied in new ways. On every such occasion the old appeal must be made: he must find others whom he can recognise as persons in this new fashion, or he cannot as a finite being assure himself that this new phase of personality is genuinely in his possession. If he has a new thought, he must explain it to others, in order that, finding them able to understand

it, he may be sure that it is a good one. If he has a new emotion, he must express it to others, in order that, finding them able to share it, he may be sure that his consciousness of it is not corrupt. (Collingwood, 1958, 317)

REFERENCES

Baldwin, J. M. (1906). *Thought and Things: A Study of the Development and Meaning of Thought*, 3 vols. London: Swan Sonnenschein & Co.; reprinted by Arno Press, New York, 1974; by A.M.S. Press, New York 1976; and by Scholarly Reprints, New York, 1976.

Broughton, J. (1974). The Development of conceptions of subject and object in adolescence and young adulthood. Unpublished doctoral dissertation, Harvard University.

Broughton, J., and Freeman-Moir, J. (1982). *The Cognitive Developmental Psychology of James Mark Baldwin*. Norwood, New Jersey: Ablex.

Carmean, E. A. (1983). *Bellows: The Boxing Pictures*. Washington: National Gallery of Art.

Child, I. (1965). Personality correlates of esthetic judgment in college students. *Journal of Personality*, 33, 476–511.

Child, I., Hansen, J., and Hornbeck, F. (1968). Age and sex differences in children's color preferences. *Child Development*, 39(1), 237–247.

Collingwood, R. G. (1958). *The Principles of Art*. London: Oxford University Press.

Danto, A. (1964). The artworld. *The Journal of Philosophy*, 61, 581–602.

Danto, A. (1981). *Transfiguration of the Commonplace: A Philosophy of Art*. Cambridge, Mass.: Harvard University Press.

Dewey, J. (1934). *Art as Experience*. New York: G. Putnam's Sons.

Dickie, G. (1974). *Art and the Aesthetic: An Institutional Analysis*. Ithaca, New York: Cornell University Press.

Di Leo, J. H. (1970). *Young Children and Their Drawings*. New York: Brunner/Mazel.

Eddy, D. (1981). In *Real, Really Real, Super Real*. San Antonio: San Antonio Museum Association.

Eisner, E. (1976). What we know about children's art – and what we need to know. In *The Arts, Human Development and Education*, ed. E. Eisner, pp. 3–14. Berkeley, Calif.: McCutchan Publishing Corp.

Finch, M. (1974). *Style in Art History: An Introduction to Theories of Style and Sequence*. Metuchen, New Jersey: Scarecrow Press.

Fowler, J. (1981). *Stages of Faith: The Psychology of Human Development and the Quest for Meaning*. San Francisco, California: Harper and Row.

154

Frances, R. (1968). *Psychologie de l'esthetique*. Paris: Presses Universitaires de France.

Fried, M. (1982). Three American painters. In *Modern Art and Modernism*, ed. Francis Frasinia, pp. 62–98. London: Harper and Row.

Gadamer, H. G. (1974). *Truth and Method*. New York: Seabury Press.

Gardner, H. (1970). Children's sensitivity to painting styles. *Child Development*, 41, 813–821.

Gardner, H. (1972a). The development of sensitivity to figural and stylistic aspects of paintings. *British Journal of Psychology*, 63, 605–615.

Gardner, H. (1972b). Style sensitivity in children. *Human Development*, 15, 325–338.

Gardner, H., Winner, E., and Kircher, M. (1975). Children's conceptions of the arts. *Journal of Aesthetic Education*, 9(3), 60–77.

Gardner, H. (1973). *The Arts and Human Development: A Psychological Study of the Artistic Process*. New York: Wiley and Sons.

Gardner, H. (1980). *Artful Scribbles: The Significance of Children's Drawings*. New York: Basic Books.

Gombrich, E. (1960). *Art and Illusion: A Study in the Psychology of Pictorial Representation*. Princeton: Princeton University Press.

Goodman, N. (1976). *The Languages of Art*, 2nd edition. Indianapolis: Hackett.

Habermas, J. (1971). The scientist self-misunderstanding of metapsychology. In *Knowledge and Human Interests*, pp. 246–273. Boston: Beacon Press.

Hughes, R. (1981). *The Shock of the New*. New York: Knopf.

Kellogg, R. (1969). *Analyzing Children's Art*. Palo Alto, Calif.: Mayfield Publishing Co.

Kellogg R. (1979). *Children's Drawings, Children's Minds*. New York: Avon.

Kohlberg, L. (1981). *Essays on Moral Development*, Vols. I and II. San Francisco: Harper and Row.

Langer, S. (1953). *Feeling and Form*. New York: Charles Scribner's Sons.

Lark-Horowitz, B. (1937). On art appreciation in children, II: Portrait preference study. *Journal of Educational Research*, 31(8), 572–598.

Loevinger, J., and Wessler, R. (1978). *Measuring Ego Development*. San Francisco: Jossey-Bass.

Lowenfeld, V., and Brittain, W. (1970). *Creative and Mental Growth*, 5th ed. New York: Macmillan.

Machotka, P. (1966). Aesthetic criteria in childhood: Justifications of preference. *Child Development*, 37, 877–885.

Osborne, H. (1979). *Abstraction and Artifice in Twentieth Century Art*. Oxford: Clarendon Press.

Panofsky, E. (1955). *Meaning in the Visual Arts: Papers In and On Art History*. Garden City, New York: Doubleday.

Piaget, J. (1970). *The Science of Education and the Psychology of the Child*. New York: Orion Press.

Russell, J. (1981). *The Meanings of Modern Art*. New York: Museum of Modern Art and Harper and Row.

Selman, R. (1980). *The Growth of Interpersonal Understanding: Developmental and Clinical Analyses*. New York: Academic Press.

Silverman, J., Winner, E., Rosenthiel, A., and Gardner, H. (1975). On training sensitivity to painting styles. *Perception*, 4, 373–384.

Smith, N. (1979). How a picture means. In *Early Symbolization*, ed. D. Wolf, pp. 59–72. San Francisco: Jossey-Bass.

Times-Herald. (March, 1947). New York sports column.

Walk, R. (1967). Concept formation and art: Basic experiment and controls. *Psychometric Science*, 9, 237–238.

Walk, R., Karusaitis, K., Lebowitz, C., and Falbo, T. (1971). Artistic style as concept formation for children and adults. *Merrill-Palmer Quarterly*, 17(14), 347–356.

Winner, E. (1982). *Invented Worlds: The Psychology of the Arts*. Cambridge, Mass.: Harvard University Press.

INDEX